SHADES

OF SCOTLAND 1956–1988

SHADES
OF SCOTLAND
—1956–1988—

PHOTOGRAPHS BY
OSCAR
MARZAROLI

TEXT BY
JAMES
GRASSIE

FOREWORD BY
WILLIAM
M^CILVANNEY

MAINSTREAM
PUBLISHING

First published in Great Britain in 1989 by
MAINSTREAM PUBLISHING COMPANY (EDINBURGH) LTD
7 Albany Street, Edinburgh EH1 3UG

ISBN 1 85158 213 4 (cloth)

British Library Cataloguing in Publication Data
Grassie, James
Shades of Scotland, 1956-1988.
I. Title II. Marzaroli, Oscar, *1933-1988*
941.1085

ISBN 1-85158-213-4

The publisher gratefully acknowledges financial assistance from the Scottish Arts Council in
the publication of this volume.

Photograph selection and layout by Anne and Marie Claire Marzaroli and Martin MacCabe
Design and finished artwork by James Hutcheson and Paul Keir

Typeset in 12 on 14pt Garamond by Bookworm Typesetting Ltd., Edinburgh
Printed in Great Britain by Butler & Tanner Ltd. Frome, Somerset

ACKNOWLEDGEMENTS

This Book is for Oscar.

It would not have been possible but for the positive support of Bill Campbell and Peter MacKenzie of Mainstream Publishing. Two men who definitely have a way with words – Jim Grassie and Willie McIlvanney – have provided the text, as well as their friendship, and Oscar's team – Marie Claire, Martin, Nicola, Derek and Lisa – have contributed immensely to the making of this volume.

Special mention must be made here of Marie Claire who has worked tirelessly for the past year on this book as well as on two exhibitions and a major retrospective of Oscar's work at the Royal Photographic Society in Bath. She is at present involved in setting up an Archive of her father's work, spanning thirty years, and is supported in this by the Oscar Marzaroli Trust.

Anne Marzaroli

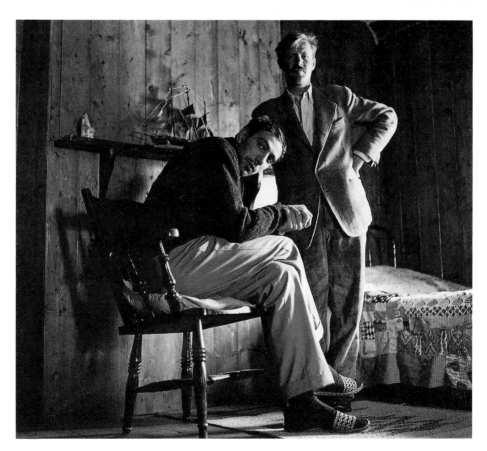

OSCAR MARZAROLI AND ANGUS NEIL, CATTERLINE, 1962

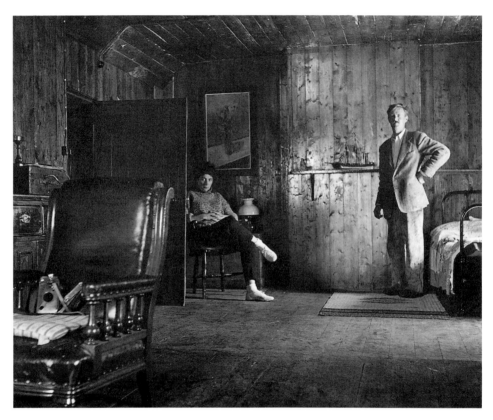

ANNE MARZAROLI AND ANGUS NEIL, CATTERLINE, 1962

CONTENTS

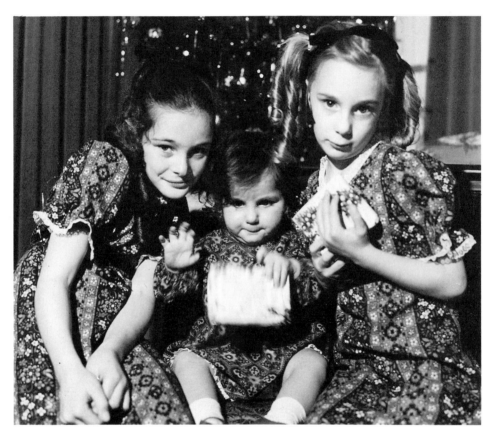

MARIE CLAIRE, NICOLA AND LISA, BAILLIESTON, CHRISTMAS, 1972

FOREWORD

BY

WILLIAM McILVANNEY

Sometimes people stay vividly in the mind precisely because we don't know much about them. The image is uncluttered. Our sense of them is not complicated by long, confessional sessions about breaking marriages or sudden soul-talk in the early hours. We never learn the astonishingly insensitive thing their father said to them when they failed their botany exam or what the girl was like who ran off with the oil-rig worker from Dingwall. They are not studio portraits but quick sketches, a few sharp lines that linger in the memory.

Oscar Marzaroli was like that for me. The significant times that I met him were few. The first was in Glasgow in the 60s. I had been hired on the strength of my first novel to write a film commentary for International Film Associates. (I used to wonder, no doubt unjustly, about the "International" bit – maybe they had the phone number of a man in New York.) I sat in a dim basement, feeling as if I was in a Taiwan sweatshop, and fed images of Loch Lomond in winter through an old Steenbeck.

While I kept introducing new words to the same old images, hoping they would eventually marry, people would constantly come and go, talking of anything except Michelangelo. For someone addicted to the padded cell of the novel, it was like trying to compose music on a traffic-island. One of the people, I was formally told, was Oscar Marzaroli.

It was a name which, once heard, was not to be forgotten. Once seen, as far as I was concerned, its owner was the same. Of course, Oscar – like the world – was young then. But I suspect that even at that stage the essential Oscar had formed.

The hair was already going. Oscar's hair: given the few, essential strokes of our acquaintance, I find myself investing an almost symbolical significance in that hair. It was dark at that time. It would go grey. What it would never do, as long as he lived, was quite go away. The strands might get strandier but they would stay.

By our externals, at least sometimes and to some extent, shall you know us. Oscar's hair was like himself. It was a vague yet substantial

presence. And from the beginning it gave me one of my key words for Oscar: mussed.

For Oscar, at least in my awareness of him, was in spirit a blessedly untidy man. I have always had a suspicion of those who are too highly organised. It seems to me that one of the biggest insults you can offer to the richness of living is to reduce it to a coherent pattern. To know exactly what you're doing is to lose wonder at the amazingness of what everybody else is doing – the endless, magical flux in which we live.

Perhaps that's why I liked Oscar Marzaroli immediately. He was not only aware of the flux. He was so patently a part of it. He had the vulnerable preoccupation of those who know that they don't know what this is all about. That made him interested and genuinely interested people are interesting.

The air of slightly dishevelled vulnerability was heightened by his bulk. Size emphasises gentleness. But the vulnerable often develop compensatory, self-protective qualities. Oscar had developed his: shrewdness of observation. At the centre of the loosely coordinated movements, the untidy hair, the gestures that tended to disperse before they had fully formed and the marsh-mist voice, that power of observation stayed true, like a compass in the cabin of a ship far out in rough seas.

I think Oscar was probably an assistant film cameraman at that time. But he was already taking the photographs that are the reason why even those who never knew him may think of him with affection. The magpie eyes were darting everywhere, instinctively and manically gathering their hoard of bright, innocent images that had no purpose but their beauty.

I saw Oscar only intermittently over the next nearly twenty years. The reason we collided so infrequently was that we tended to meet only at vaguely artistic gatherings and they are occasions I seek out with the eagerness of Dracula in search of a crucifix. But I was able to observe that Oscar remained incontrovertibly Oscar.

We were not to converge for more than a few fleeting pleasantries over glasses of acidic wine until the 80s. Oscar had been commissioned to take some photographs for *The Guardian* to accompany an article about me. He and the reporter who had written the piece arrived in Kilmarnock to photograph the author in the wilds of his natural habitat.

I enjoyed those few hours. We met in a pub and then wandered around the centre of Kilmarnock in a smirr of rain, while Oscar looked for a background that would convey the sense that he was after and I accompanied him like a mobile prop. Oscar talked a lot. It was one of

those times when you can refresh yourself by partaking of someone else's preoccupations. Oscar had a lot of those.

I next saw Oscar in a tent at the Edinburgh Book Festival. I had just returned from a year in Vancouver. Before leaving for Canada, I had been ambushed – only the terminally naïve could imagine that you ever merely meet Bill Campbell and Peter MacKenzie, the smiling Siamese twins who operate under the shared alias of Mainstream Publishing. The purpose of such meetings has been pre-decided and the decision has been theirs, not yours. But they remain benign with it. As I once suggested to a detractor who referred to them as "cowboys", they're the ones with the white hats. When they ambushed me at the pass that time, their purpose was to extract from me a promise to write a text to go with Oscar's photographs of Glasgow in *Shades of Grey*. Having for long lived in strict obedience to my personal motto ("Never put off till tomorrow what you can put off till next year"), I prevaricated until an aeroplane removed me from the problem for a year.

That day in the Book Tent I was doing a reading. At a particularly dramatic moment (at least for me), I glanced up and saw three men standing at the back of the tent: Oscar, Bill and Peter, the external trinity of my internal guilt. In the midst of my impassioned utterance, I felt the chill of nemesis. They looked like mafiosi. They weren't there to appreciate my poetry. They were there to block the exit.

At the end of the reading, while I tried to hide behind signing a few books and enjoying the always uplifting realisation that some people out there have actually read some of what I have written, they told me they would meet me in Mather's Bar. They took my son, Liam, along as a hostage. (At least they let my daughter, Siobhan, go off with her friend.)

In the pub I blustered feebly about pressure of other work. Nobody was convinced. When I turned to Oscar and suggested the year I had already wasted proved that I was a bad investment in this business, Oscar said simply that I was the one he had decided should do the words and he would wait another ten years, if need be. He said it with such steely charm that I gave up. I had always liked his photographs anyway. What was I hiding from? I agreed to hole up in a Glasgow hotel and write the text.

Oscar was already ill by then. It was easy to imagine that "ten years" might be no more than a figure of speech in his mouth. But he didn't once mention the fact. He discussed the book as the book and the reasons why I should do the text as the reasons why I should do the text. No extraneous arguments were allowed. I admired him very much for that, the self-contained dignity of his bearing.

Oscar was more seriously ill by the time Mainstream launched the book at The Third Eye Centre in Glasgow. The vividness of presence had faded further. But it was a happy night. We all knew we were there to honour someone who had received less recognition than he should have, and that's what we did. In a bright room, among the talk and the emptying wine-bottles, family and friends and admirers formed a small conspiracy of appreciation against the indifferent darkness outside.

The last time I met Oscar Marzaroli, if it doesn't seem too much of a paradox, was at his funeral. He was there in the awareness of the priest who was burying a friend, in the people who gathered, most of all in his family. Oscar might as well have been there officiating, it was all so like him.

There had first been the unexpected phone call from a mutual friend: Oscar was dead. It is usually like that, of course. Auden got it right in "Musée des Beaux Arts". Death – the big, important bad thing – is always happening in the midst of casualness. As Auden says, when Icarus died in Breughel's painting,

The expensive delicate ship that must have seen
Something amazing, a boy falling out of the sky,
Had somewhere to get to and sailed calmly on.

The mourners gathered at Baillieston. The funeral oration gave, like an unexpected candle, a quirky touch of Oscar in the gloom: the inclusion of a recent football result. The weather was dire, as if Oscar had arranged it knowing he wouldn't be there. The driver of the car that was taking our group to the cemetery got lost. We arrived in time to miss most of what was said at the grave but in time to get soaked. By the time we reached the family home, the rain had stopped. Oscar lives.

It was the first time I had been in Oscar's house. But it didn't feel like that. The marvellous welcoming warmth of his wife, Anne, and the gentle attentions of Oscar's daughters, Marie Claire, Lisa-Jane and Nicola, made it feel like a place you had every right to be. The whole family on that difficult day did what the best people do: they converted their own pain into kindness towards others. I thought I understood the source from which Oscar had drawn the strength that allowed him to be vulnerable.

It was a good funeral – and there's enough residual Irish in me to take that remark straight, undiluted with any irony. Funerals should be good, sad and good, a celebration of the person. Oscar's was. It was warm and sprawling and talkative and reminiscent and fuelled with a

little whisky. I found it a good time and a good place to take my leave of him.

I remember him well. I may only have a sketch of him but it's a clear one. I can still see him – a big, vague, nice man who looked as if his sense of himself had only just got out of bed, lived permanently in its dressing-gown. He blinked a lot but then so does a camera-shutter. And, though I may not have known him well, I knew him well enough to realise that, when he blinked, it meant he wasn't missing too much.

He never did. That's why we have this book, which is the crystallisation of a just confusion – brief, still moments of shelter from the flux.

I'm glad I knew him.

A LIFETIME OF
CAPTURED MOMENTS
BY

JAMES GRASSIE

L ook at the photographs on the following pages and you will find humour, sensitivity, drama and perhaps even scenes that fondly stir long forgotten corners of your memory. But, above all these, you will find Scotland's family.

That was Oscar Marzaroli's inspiration. For thirty years he searched every corner of the country, from the Out Skerries on their lonely guard station off the Shetlands to the huddled closes of Glasgow and the rolling spaces of the Borders, capturing and recording the land and its people in every mood. Sometimes his business was to make moving pictures but always he carried with him his stills camera, loaded and ready, as he explained, to capture the moment.

For him these moments were not structured or contrived; they were not the stuff of picture postcards but signposts to the truth. Packing the frame with easy sentiment is a soft option; the result, of course, sells well and satisfies the undemanding requirements of the public relations business and the tourism promotion trade. But to Marzaroli it served Scotland's interests ill, whereas efforts to allow the story to be told without the aid of false supports produced, in the end, an honest account which, because of its honesty, was more powerful, aye, and more romantic.

That attitude, and his singular striving to fulfil its demands, brought him no instant rewards. In an age when potential patrons seek always to offer their better side, Marzaroli's quest for truth, with its inherent promise to show all the features, good and bad, was regarded an unwanted risk.

When I first knew him, he had been commissioned by the Highlands and Islands Development Board – the agency set up by Harold Wilson's first government to promote the development of the Highlands in recompense, his Scottish Secretary, Willie Ross, had implied, for 200 years of neglect – to make a documentary film which would counter the prevailing misconceptions that then existed about life north of the Highland line. At that time, the second half of the Sixties, when such

bodies as the board, local authorities, new towns and, indeed, private companies decided that films might assist them in their task, they put the work in the hands of the Films of Scotland Committee.

A curious hybrid, which was supported but not funded by the Scottish Office, the committee was run by a former official of the Scottish Information Office, Forsyth Hardy. Raising funds for film-making was his forte and by exploiting his wide contacts and the establishment figures who served on his committee, he was able to nurture, as he saw it, the nascent Scottish film industry. In addition to Marzaroli, there were among its emerging talents Charles Gormley, Bill Forsyth, Murray Grigor, Paddy Higson, Lawrence Henson and Eddie McConnell. Their fate then was in Hardy's hands. He controlled the flow of money and allocated the work; there was no stricter master and he did not look kindly upon those who challenged his will.

A point of constant tension was that his view of Scottish films was not a width of tartan away from the Andy Stewart school of thought. It was guided by the principle that a film's value was measured by how well it was received by expatriate audiences in North America and Australia, not by how accurately it recorded Scottish life.

In that context the production of "Highlands" could hardly have presented more fertile ground for dispute. On the one hand was the HIDB, a fresh, untried agency striving to make its mark and believing that the lack of investment in its area owed a great deal to the misconceptions about, and ignorance of, the Highlands then harboured by the outside world. On the other was the Films of Scotland Committee, a close familiar of the Scottish establishment, undisturbed in its monopoly and determined to sustain not only that but also its propagandist view of Scotland. In between was Marzaroli.

He had the good fortune at this time to begin a long, close and productive friendship with the writer, Allan Campbell McLean, who had accepted the commission to write the treatment for the film. They shared the view that getting the truth on to the screen was the best way to fulfil their remit. As an inevitable consequence the production, from conception to final print, was punctuated by a series of bush fires ignited as their joint determination collided with Hardy's flinty, unyielding views.

In matching his filming to McLean's treatment, Marzaroli planned regular sorties from his Glasgow base. On several occasions as he, his partner, Martin Singleton and their crew prepared to set out, Hardy asked him to shoot some footage of the Commando Memorial at Spean Bridge; it would fit neatly, he claimed, into the "Highlands" sequence which followed a British Aluminium truck on a journey from Fort

William north through the Great Glen to the site of the new smelter at Invergordon. There was, of course, no reference in the treatment to the memorial. It had no part in the story as set out by McLean and approved by the board. Suitable though it might have been to an audience in, say, Vancouver, it was irrelevant to the purpose of the film's sponsors. Marzaroli decided to stick to that and resisted Hardy's pressure.

The result of that honesty was that "Highlands" broke out of the crippling mould which had restricted Scottish film-making to repeating the spent, false, tartan imagery that had stood in the way of a better understanding of Scotland and its people. Instead it focused on real characters living in a real landscape and broke down many of the myths that informed the majority urban view of life beyond the Highland line.

Marzaroli enjoyed making "Highlands". It brought McLean into his ken, of course, but it also widened his knowledge of, and deepened his affection for, the area. That relationship had been born in circumstances that had been much less happy.

Some fifteen years before, his studies at Glasgow School of Art had been brought to a premature end by tuberculosis. He was sent to recuperate at Kingussie, then considered to provide the peace and fresh air essential to convalescence. Later he frequently recalled, with considerable affection, his year under the friendly care of the Sisters of Charity who ran the Grampian Sanatorium. The regimen was strict but effective, and included having patients sleep in beds which protruded for about half their length into the open night air. Waking on winter mornings to find that, overnight, his bed had acquired an extra blanket of snow was an experience Marzaroli never forgot.

Nor did he forget the wisdom he found in the words of Camus and Dostoevsky, Shakespeare and Burns, Gorky, Tolstoy and Sartre, whose works he read as he recovered his health; or the power of the Highland landscape which, over the months he lay on his back, went through its kaleidoscope of change as if in a special performance for his eyes. From it all, he emerged wiser, a caring man who thought first of others, who kept, despite a belief that human beings could improve their own condition, a wary eye open for the blows that fate might have in store.

Born in northern Italy at Castiglione Vara in 1933, his warm, native Mediterranean blood had no trouble in merging with the Celt's respect for the unseen powers of natural, and supernatural, forces. Marzaroli himself was never reluctant to pass on his premonitions. Once he advised McLean and me to join him on the ferry trip to Tiree rather than take a hired aircraft from Dalcross Airport at Inverness. We didn't.

He could only nod sympathetically as we explained, over three of the stiffest drams ever served by the bar at the hotel in Scarinish, the grim details of our flight.

It contained almost every nightmare endured by the apprehensive flier: the starboard door of our tiny Piper Aztec burst open at 5,000 feet and again at 6,000 feet; ice formed on the propeller, forcing the pilot to lose height and us to cower in our seats behind him as the melting ice broke gradually into pieces which whanged against the fuselage like bullets; and the pilot, on his approach, lost radio contact with Tiree and required three passes away out to sea before, in low clouds and driving rain, he spotted the runway. Marzaroli, of course, was waiting comfortably in his old but heated Volvo to pick us up at the terminal.

But fate, in his book, need not always be malevolent. He had experienced its negative influence when filming "Highlands". His integrity permitted him no choice but to film a Sabbath morning congregation pouring out of a Stornoway kirk from an open position in the street rather than from what was suggested would be a more diplomatic and discreet upstairs window in a flat opposite. Out of the crowd strode an elderly woman, dressed, like all her sisters, entirely in black. She knocked over the blasphemous camera, sticks and all. Ever after Marzaroli declared that she had spooked the camera which developed a shake that no technician could trace or repair.

The other, western coast of Lewis was kinder to him. Here was the site of the Callanish Stones, those awesome reminders of early man's efforts to set some design on the world around him. Amid their gaunt shapes and giant shadows, both Marzaroli and McLean claimed to find renewal. Indeed, though he would not breach their brooding silence after midnight – that would be bad news, he said – Marzaroli swore that the stones' unseen force had repaired a long broken light meter.

Here, too, an old acquaintance, John MacGregor, worked on his loom. Like Marzaroli, a wise observer of the human scene, MacGregor was a port of call for people from all over the world, directed there by the local tourist office in Stornoway who knew that the visitors would get full value in any length of tweed they might purchase as well as in the conversation they would have with its maker. It was by that route that Nonie Nieswand, long after she and her husband, Peter, had been deported from Ian Smith's Rhodesia, came to MacGregor's croft with models and a photographer on an assignment for a fashion magazine. He guided her across the moor to the best location on the beach then, on the way back, surprised her by asking how her child was. At the time of her expulsion, of course, the world was told she was pregnant

but to be reminded of that knowledge in that remote spot years later was something she evidently had not expected

To Marzaroli this episode proved how wrong were those who thought the islanders parochial. Over the years he took many "snaps" of MacGregor, never disturbing the essential business of tweed-making but all the while the two conversed, the one pedalling the power into the loom, hands constantly running back and forth across the cloth, the other moving round the narrow confines of the weaving shed, seeking out another angle, another cast of light. The photographs capture the crofter's calm intensity and give a sense, too, that in some part of his mind, he is thinking about the world outside, beyond his croft, beyond Lewis.

On the west coast, too, stood Dun Carloway, the high curving remains of which still spoke to Marzaroli of primitive apprehension as well as of security. The tones of that message were no different from those he experienced at deserted Garenin, the silence of its empty, huddled black houses now disturbed only by the wind and the increasingly ubiquitous tourist.

Sensitive as he was to the past, Marzaroli's real interest was the future. Everywhere he went, children were never long absent from his lens. His studies of innocence abroad in Glasgow's streets are an eloquent and touching statement of his indestructible optimism. Sometimes, of course, he could go too far in his enthusiasm and thirst for understanding younger spirits. His film crews, more often than not, would return from expeditions to the islands limping and bruised from the challenge of football and cricket matches Marzaroli had waged against local bairns in the school playground or, as on the Out Skerries, on the nearest patch of reasonably flat ground. Fortunately, none of the injuries were ever serious, though the immediate reaction to them of Marzaroli himself, with visits to the local chemist to buy up what seemed almost the entire stock of bandages, creams and Elastoplast, spoke of his real concern for his crew's welfare – ensuring their comfort on location by booking them into well-appointed hotels with good kitchens and welcoming rooms was one of his tenets as a producer/director.

The same rules applied to his own sorties. He liked nothing better than a brisk start to the day. Work could not be contemplated before a hot, cooked breakfast and an extensive double check of his equipment. Then it would be off in the car, the key points in the itinerary already decided. As his occasional chauffeur, I soon learned that such trips were not merely a question of getting from one spot to another.

Sprawled in the back – for McLean usually satisfied a boyish glee by sitting with the driver – Marzaroli would fidget constantly with his camera, check his films, polish the lens and fiddle with the light meter. These processes would not be complete without a rummage through his pockets which bulged with tissues, packets of aspirin, bars of chocolate and other items that he thought essential to our well-being. All the while, the conversation fired back and forth, skipping from the quality of light to the fortunes of Celtic FC with an easy intensity. It was on such journeys that McLean and I were introduced to Marzaroli's "old Italian granny" who, according to her grandson at least, had had words of wisdom for every possible human dilemma – and which Marzaroli would repeat at appropriate moments. These came first in Italian before he offered his translation, prefixing that with the smiling phrase, "My old granny used to say . . .". What followed would run from ". . . happy is the mouse with two holes" (think about it, Marzaroli would advise) to "one hand always washes the other" and "as one door closes, another opens".

His Italian blood ran strong. His tall figure, elegant in its striking, dark appearance, his mannerisms – making affectionate physical contact with others, whether by rubbing their ear lobes between his thumb and forefinger or by easing their shoulder muscles with a soft massage, was a gentle, warm feature of his social behaviour – his extravagant gestures, his excitability, all declared his sunny, gregarious Italian origins. But he had lived in Scotland since he was two years old and that had given him a patience and determination more associated with these cooler northern climes; determination to get the shot right, to be faithful to its subject, and patience to wait until the external conditions made that possible.

This frequently meant waiting until the light changed, the sun travelled further through the sky, a cloud shifted or the tide turned. Then the magic occurred, brought about by a combination of his skill, the quality of his subject and the surrounding environment.

He was wise enough and experienced enough to appreciate that luck, too, played a large part in any photographer's professional life. That awareness had been born out of his time in photo-journalism, where a news event does not unfold in a strict series of predictable steps that allow the photographer the luxury of advance planning; it had been confirmed, too, by his study of the photographs of those fellow workers he admired, like Henri Cartier-Bresson and Paul Strand. The mid-50s New York photographic exhibition, "The Family of Man", organised by Edward Steichen – later published as a book, a copy of which Bill Forsyth, years later, brought back from the USA to grace

Marzaroli's bookshelves – also proved to be an enduring inspiration. But to "capture the moment" was often a matter of fortune; the impact of his Golden Haired Lass, or of his salmon netters off Skye, owes a great deal to the simple fact that he had been in the right place at the right time. But having found himself there, he strained every sinew, employed every skill to squeeze the opportunity dry.

In few of his human studies do his subjects even seem to be aware of being photographed. They, their expressions and the work they are doing are caught, it seems to the viewer, on the wing; they are intent on what they are doing oblivious to the obvious intrusion. I never knew Marzaroli to set up a shot formally, deploying the tripods and other paraphernalia so deliberately used by other contemporary practitioners of the craft. His camera was always in his hand, so much an extension of his being that most of his subjects, as they appear in the prints, seem as if they must have been blind to its presence.

That naturalness, that ease of the moment of recording, came from Marzaroli's technique. This was essentially informal, photographer engaging his subject in chat, exchanging pleasantries, discussing the present state of the world. As this went on, ever more animatedly, the camera would flick up to the penetrating, calculating eye and, click, the job was done. Then click again, and once more. The shutter became a punctuation mark in the conversation, never stopping the flow of the talk but signalling the completion of one snap and the beginning of the preliminaries of the next. People, in short, all sorts of people, in all sorts of situations, were always at ease with this tall, ambling, talkative, apparently relaxed figure who, bursting into their lives, was, all the while, inside, taut, coiled tensely like a spring.

His inner tension was most evident on public occasions, when presenting his work or arguing the case for financial support. Understandably he compared the first to putting a piece of himself on display. In that, he was more accurate than perhaps he knew. His photographs and films are, indeed, extensions of himself and exhibiting or publishing them put him in a situation in which he was vulnerable.

Preparing for an exhibition or a first screening was an agonising affair. This may seem oddly contradictory but it is a pattern of behaviour with which any creative artist would sympathise. He did his work in public yet when that same public, in another guise, was about to see it, and perhaps judge it, he, who enjoyed few things more than companionship, seemed to want to retire into a private, protective shell. Public reaction, he knew, could be hurtful.

To help himself through the process of seeking sponsorship, which meant dealing personally with businessmen and bankers, accountants

and bureaucrats of every kind, he had several suits, one, as it were, for each type of audience. But it was a part of his business that he did not like. "I'm no hustler," he often said by way of explanation.

Nor did he claim to have the administrative skills thought essential to the smooth running of any enterprise, large or small. Even writing letters was a task that had to be approached hesitantly, circuitously, with much deliberation and changing of minds. Securing a print from him, as Paddy Higson once noted, was a journey that required several adjournments to the coffee bar and much discussion before the particular negative could be tracked down.

As the 1980s opened, Marzaroli, his commissions from the Highland Board drying up and finding himself unattracted by the audio-visual bandwaggon on which so many were leaping, was looking for a new role. His friend and former co-worker, Charles Gormley, knowing his lack of enthusiasm for hustling and familiar with the gaps in his administrative ability, advised him to do what he did best – concentrate on his photography.

Like all good advice it was simple and obvious. By that time, of course, Marzaroli had built up a photographic archive of Scottish life that was unparalleled. For over twenty years he had scoured its landscape and observed its people; he had traced the changes in Glasgow through the desolation of the Gorbals to the Sixties optimism of the Red Road flats; portrayed the drama of the UCS work-in; recorded the Highlands and islands as they responded to the unexpected wealth new found off their shores; and, with all of that, had compiled a gallery in which the fishermen, artists, farmers, steel workers, road makers, writers, miners, actors, oil rig builders, politicians, crofters, teachers and sculptors who were engaged in the whole story, all found a place.

Gormley, of course, was right. And Marzaroli followed his advice. For those of us who had the privilege of sharing this small country with him, and, more importantly, for those who will come after, this was a blessing. For Marzaroli himself, as he continued his pursuit of Scotland's family, there was some reward. Recognition of his stature began to arrive with exhibitions of his work at Glasgow's Third Eye Centre, which also published a monograph about the man and his work. Publishers found his library an untapped source of material and, latterly, Deacon Blue chose his Glasgow studies as covers for their record sleeves. Nothing, however, pleased him more than the success which attended the publication in 1987 of *Glasgow: Shades of Grey*, a compendium of his record of the city as it emerged from its grim encounter with industrialisation to reclaim its Dear Green Place roots and moved to the threshold of its year as Europe's city of culture;

that it was prefaced by William McIlvanney, a writer he admired, was an extra, immeasurable bonus. The book put a valuable section of his work between hard covers, an ambition long sought and at last realised, and brought it to the attention of a new audience.

In 1980 Marzaroli said that he felt he had given a decade of his life (the 1960s) to working for the Films of Scotland Committee and another (the 1970s) to working for the Highland Board. The next (the 1980s) he had determined was going to be for himself. But fate, that constant companion on his journey, short-changed him. He did not get the full ten years, dying in 1988 after a long illness. Incalculable though that loss is, his photographs will be a source of admiration, excitement and, what he himself would have wished most of all, captured moments of truth for generations to come.

THE SEA

Seascape,
Lochs,
Working on the Sea,
Fishing,
Harbour

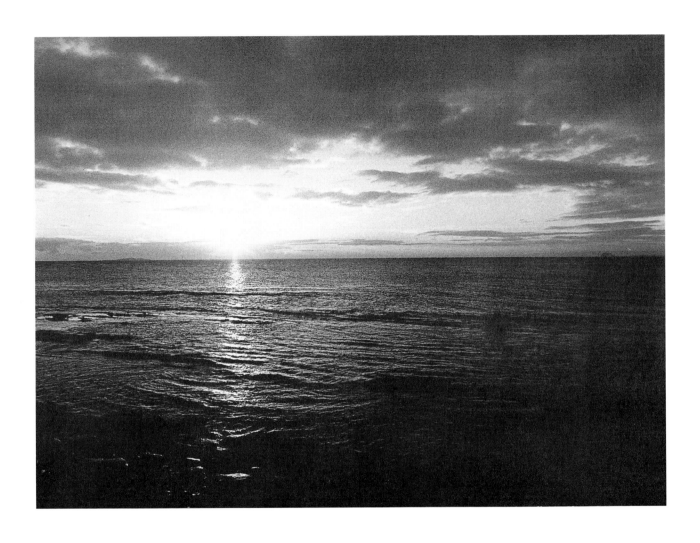

ST MONANS COASTLINE, EAST NEUK, FIFE, 1970

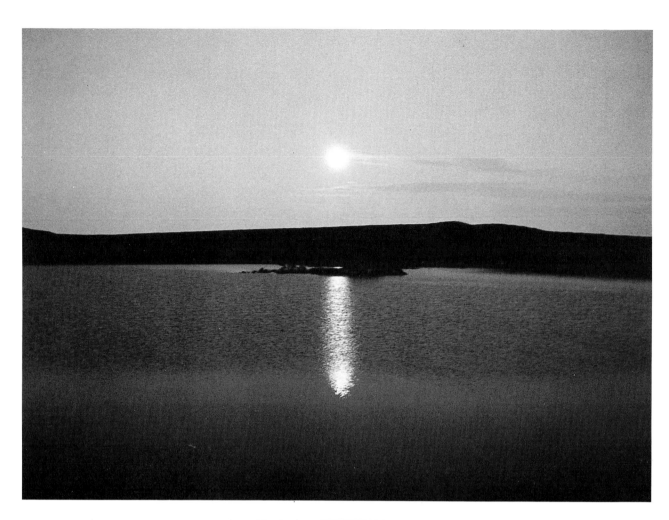

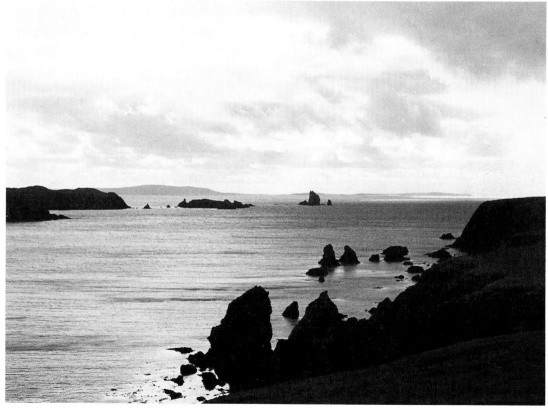

Upper
SUNSET, BUTT OF LEWIS, 1973
Lower
"THE DRONGS", "THE GRIND OF NAVIR", SHETLAND ISLES, 1971

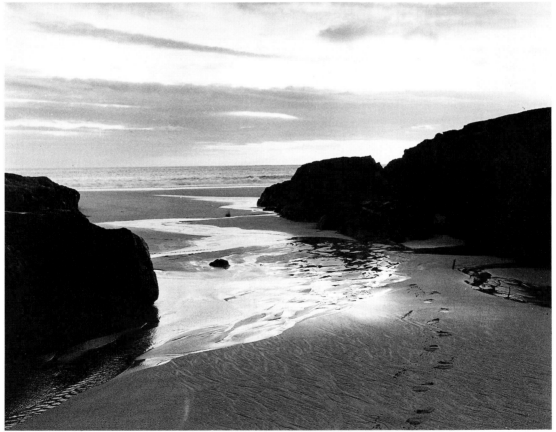

Upper
SUNSET OVER LINSADER, 1981
Lower
GIANT FOOTPRINTS, BARRA, 1973

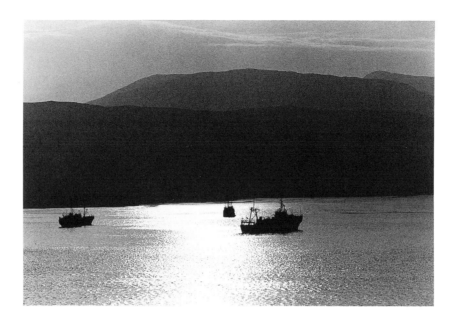

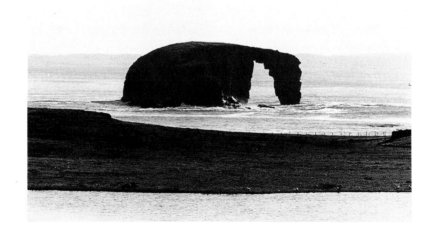

Upper
FISHING BOATS, ULLAPOOL, 1983
Middle
"TAKING A STROLL", AYR HARBOUR, 1972
Lower
"THE DRONGS", "THE GRIND OF NAVIR", SHETLAND ISLES, 1971

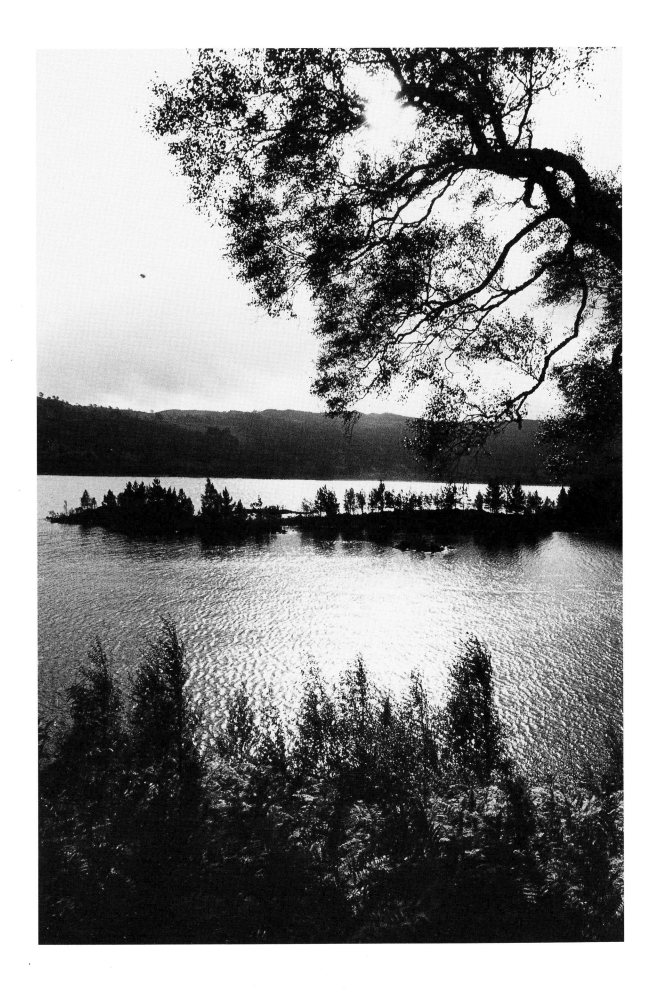

LOCH AFFRIC, 1983

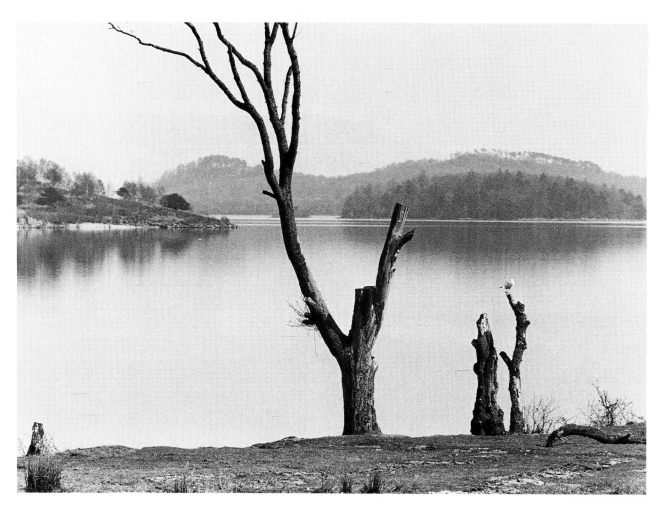

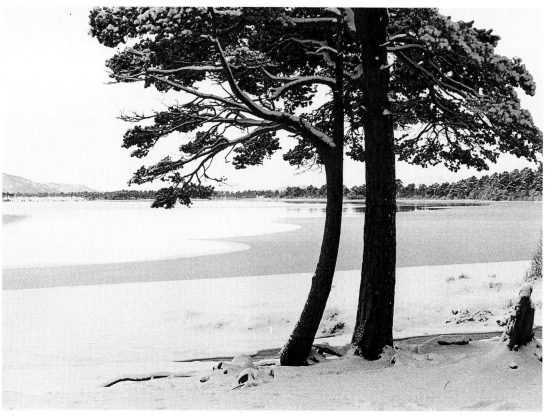

Upper
LOCH LOMOND SIDE, BALLOCH, April 1967
Lower
LOCH MORLICH, AVIEMORE, 1966

32

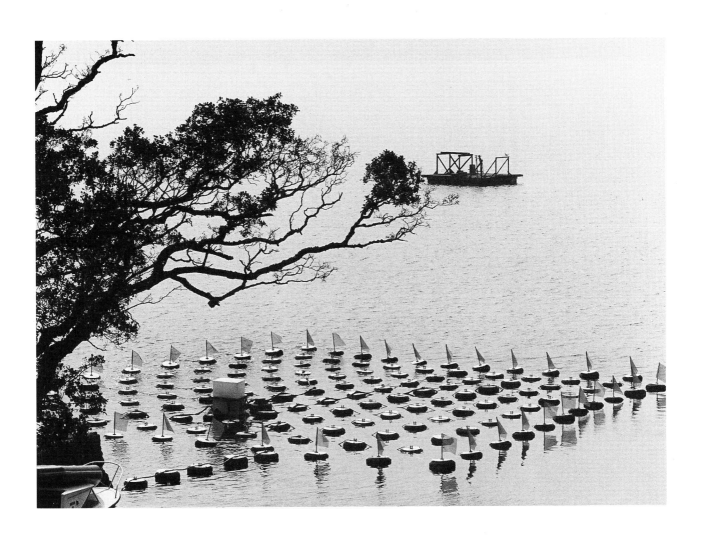

FISH FARMING, LOCH NESS, 1983

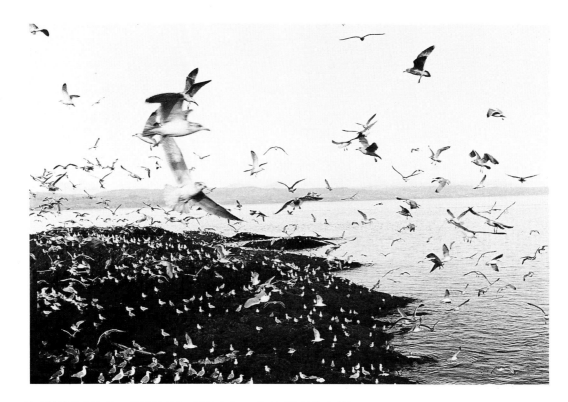

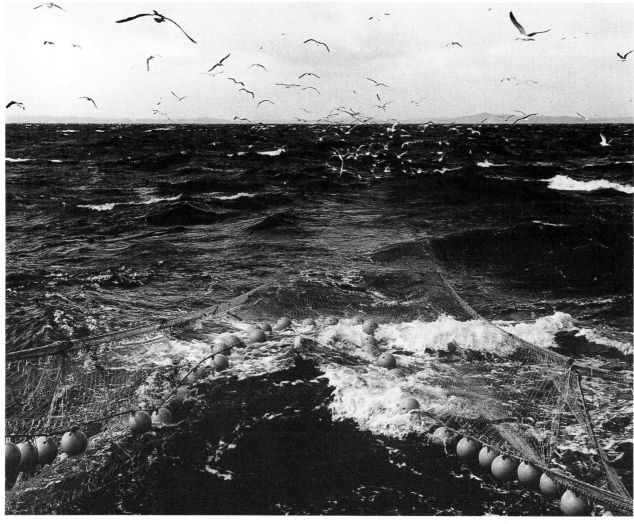

Upper
GULLS CATCH, HEBRIDES, 1967
Lower
FISHING OFF HARRIS, 1973

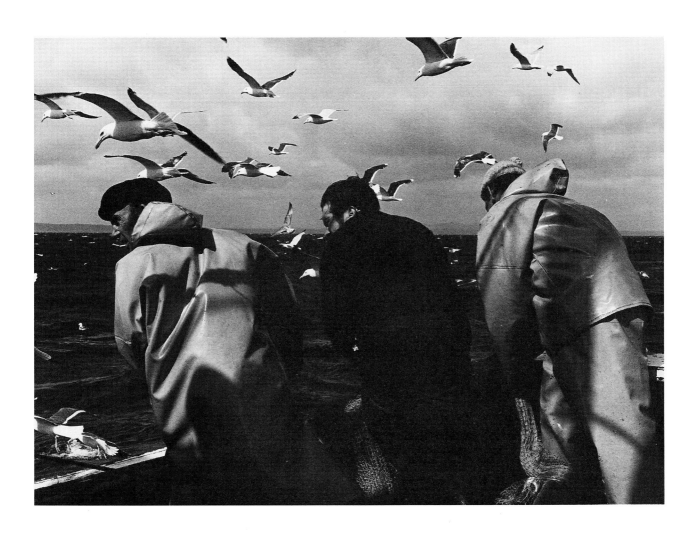

HAULING IN THE CATCH, OFF HARRIS, 1973

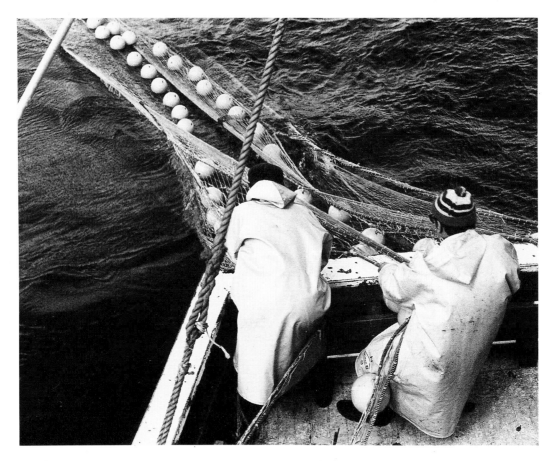

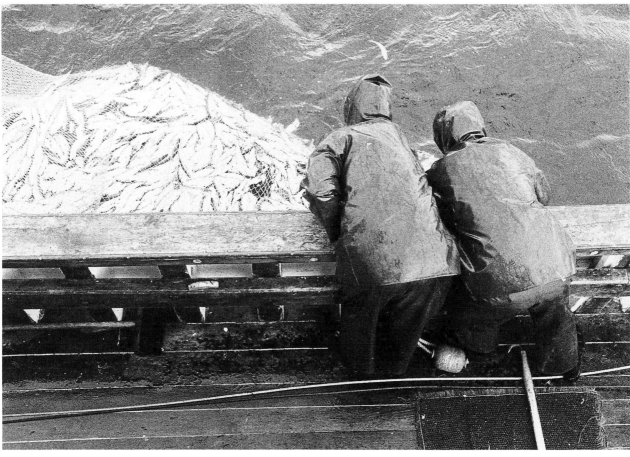

Upper
CASTING THE NETS, OFF HARRIS, 1973
Lower
COMET CREW, OUT SKERRIES, SHETLAND, 1976

36

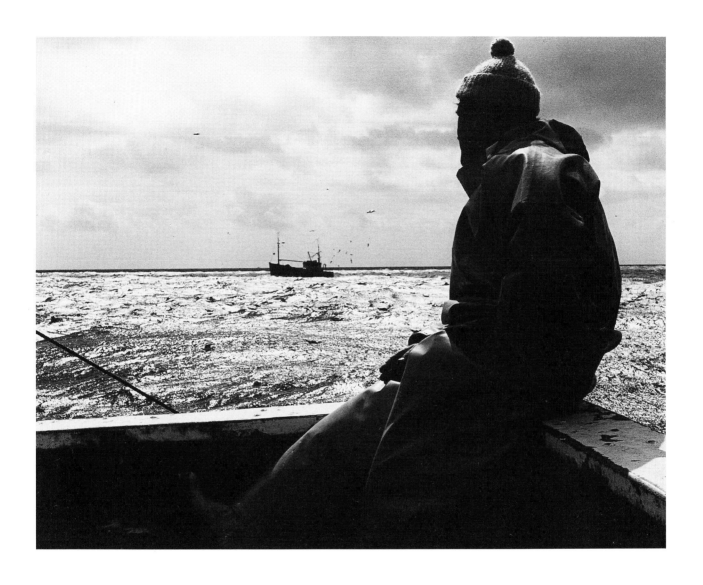

LOOKING OUT TO SEA, OFF HARRIS, 1973

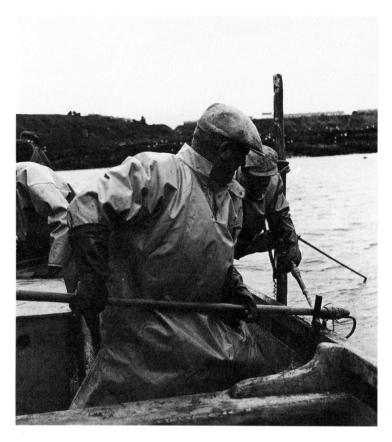

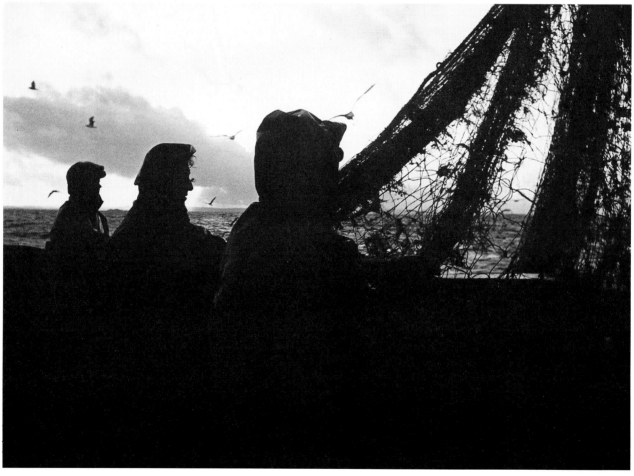

Upper
FISHERMEN, CATTERLINE, 1962
Lower
COMET CREW FISHING. OUT SKERRIES, SHETLAND, 1976

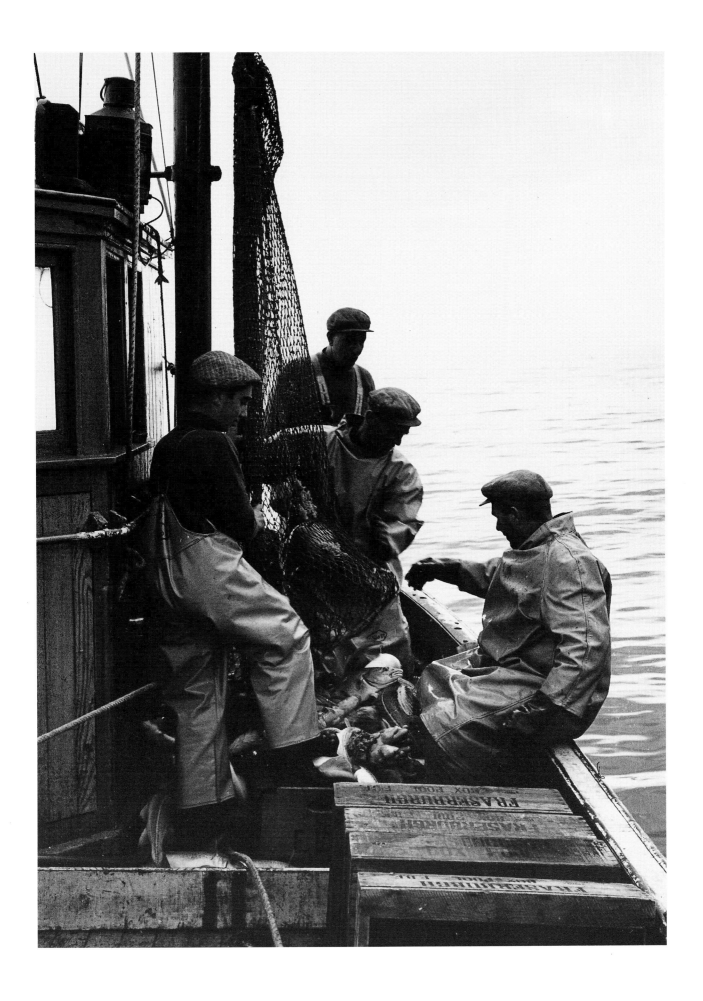

FRASERBURGH FISHERMEN, 1962

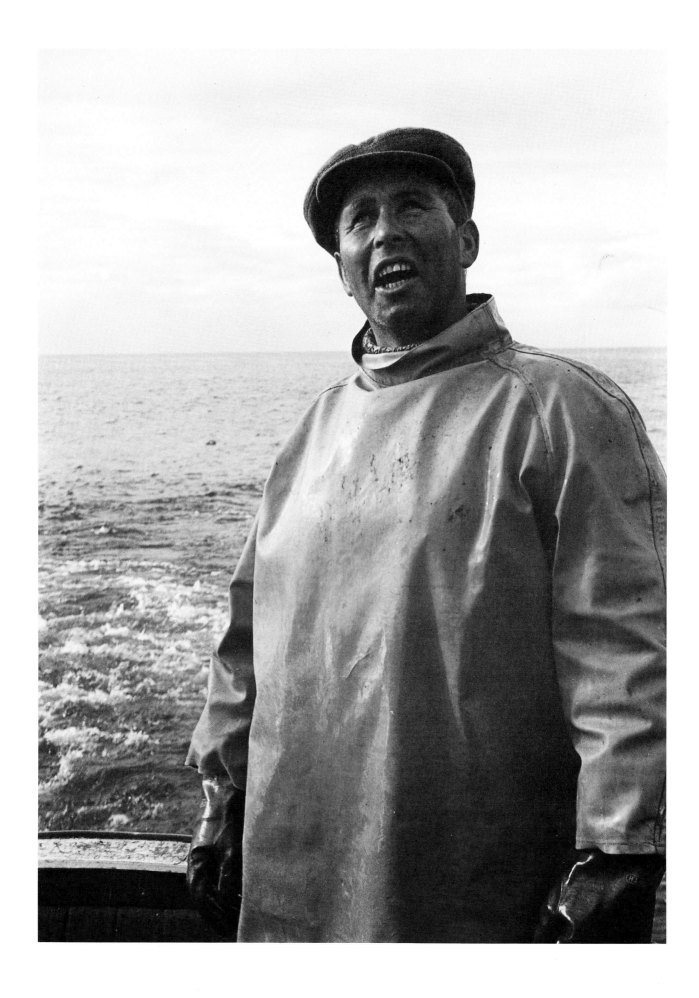

FRASERBURGH FISHERMAN, 1962

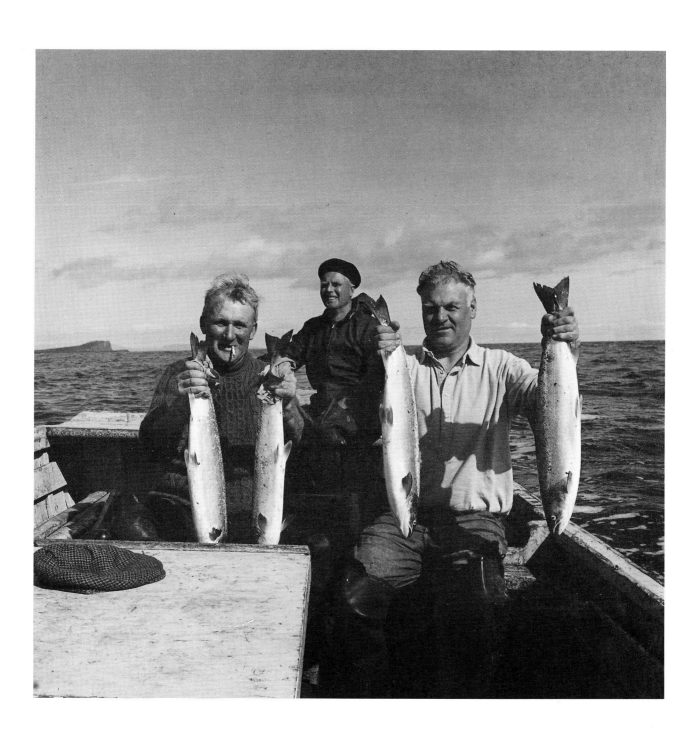

THE SALMON FISHERMEN, STAFFIN, ISLE OF SKYE, 1973

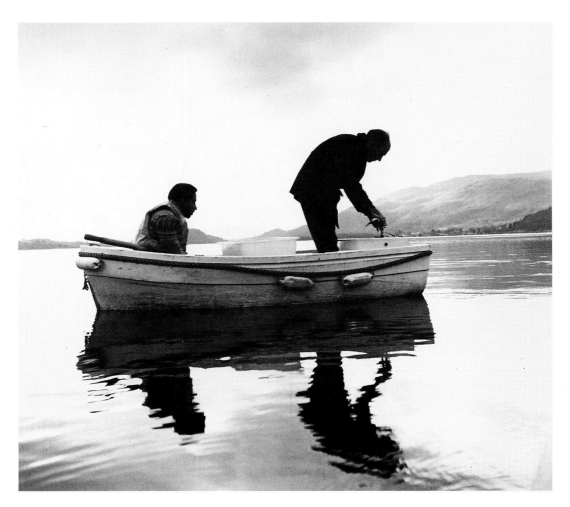

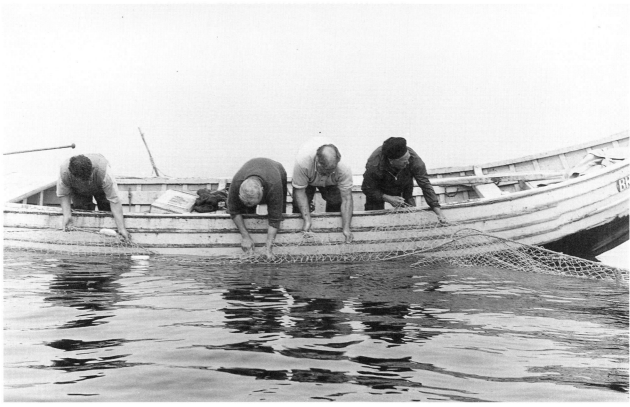

Upper
FISHING, DURING THE FILMING OF *FLASH THE SHEEPDOG*, LOCH LOMOND, 1967
Lower
SALMON FISHERMEN, STAFFIN, ISLE OF SKYE, 1973

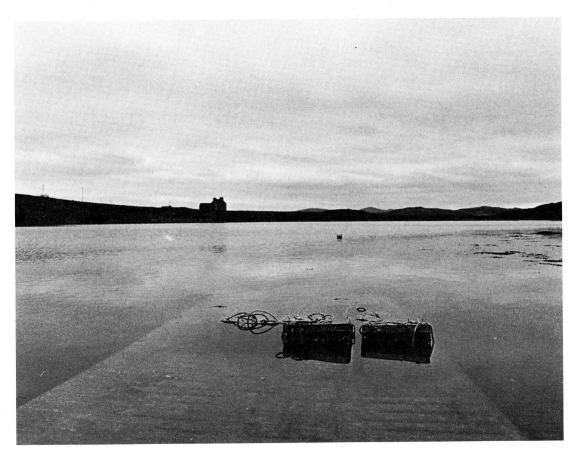

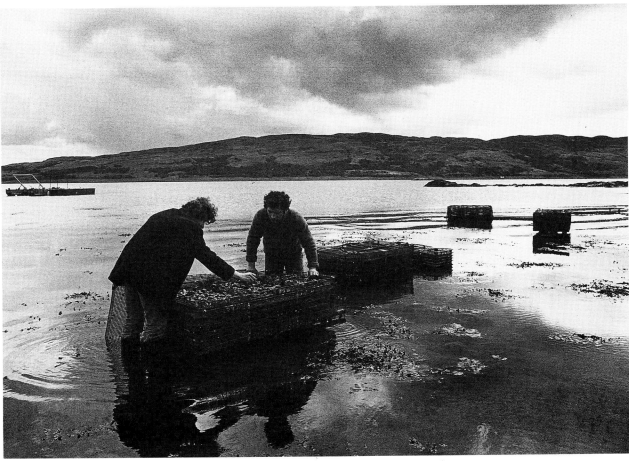

Upper
FISH FARM, MARICOLT FLOTATION, ISLE OF LEWIS, 1976
Lower
OYSTER CRATES ON LOCH SPELVE, CALEDONIAN
SHELLFISH COMPANY, ISLE OF MULL, 1980.

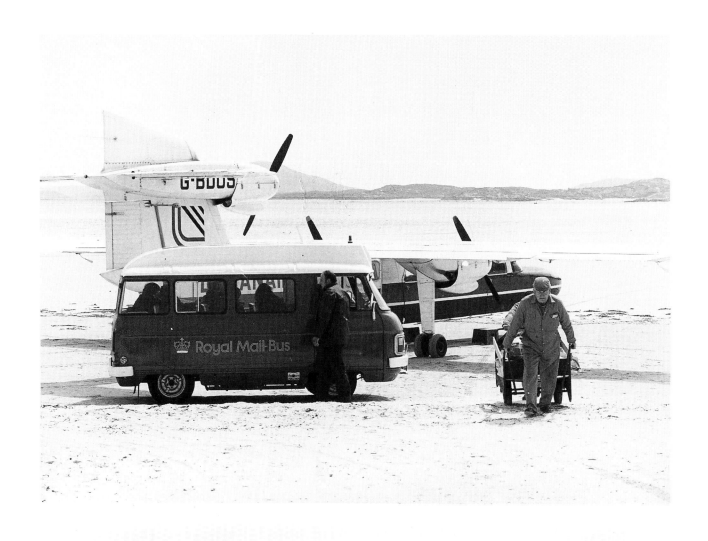

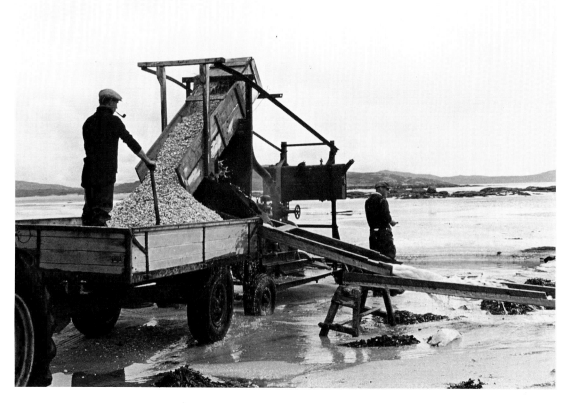

Upper
POSTAL DELIVERIES, LOGANAIR, ISLE OF BARRA, 1981
Lower
THE COCKLE STRAND, ISLE OF BARRA, 1981

44

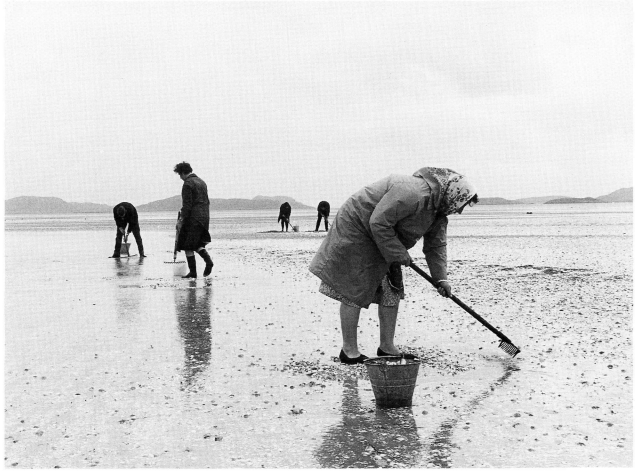

Upper
WASHING COCKLES, THE COCKLE STRAND, ISLE OF BARRA, 1964
Lower
WOMEN GATHERING COCKLES, THE COCKLE STRAND, ISLE OF BARRA, 1964

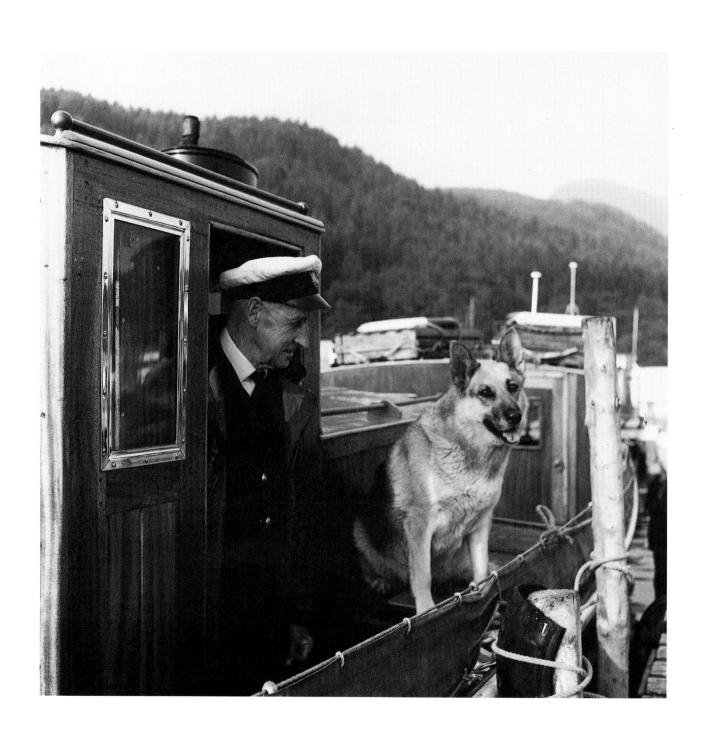

MR McFARLANE WITH HIS POST BOAT AT BALMAHA, LOCH LOMOND, 1967

Upper
FISHERMAN AT INVERLOSSIE, May 1968
Lower
FERRYMAN, GLENELG, KYLERHEA, July 1981

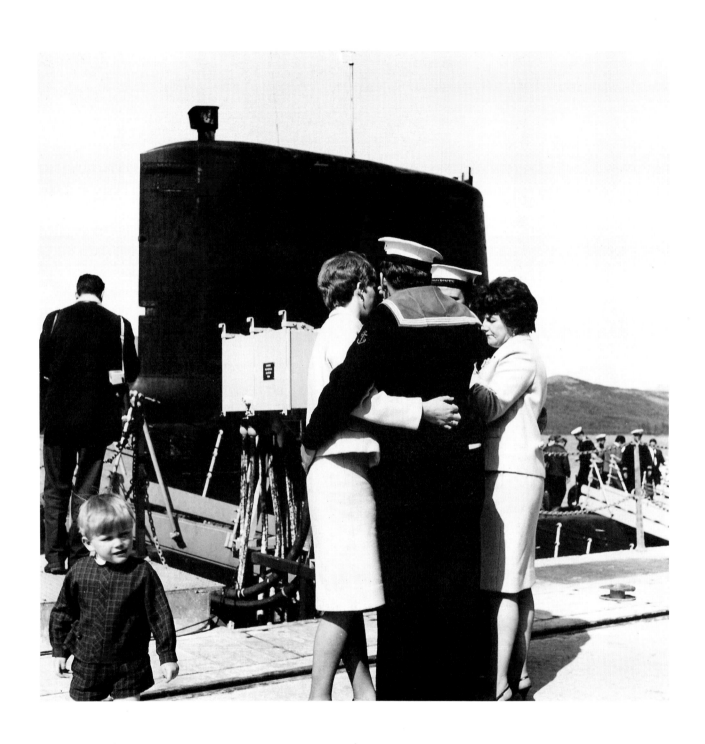

SUBMARINE CREW, H.M.S. *VALIANT* AT FASLANE, April 1967

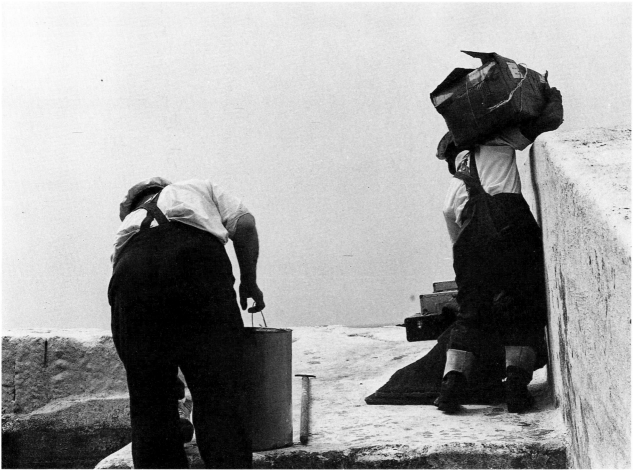

Upper
"JOHNNY LOVES RUTHIE", LOSSIEMOUTH HARBOUR, August 1968
Lower
UNLOADING LIGHTHOUSE SUPPLIES, EARLY 1970s

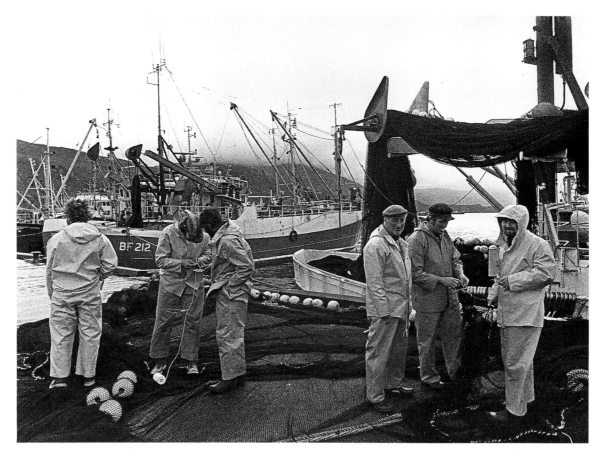

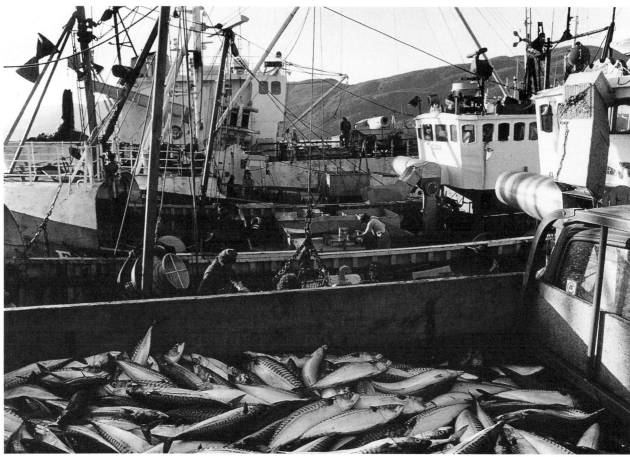

Upper
FISHERMEN REPAIRING NETS, ULLAPOOL HARBOUR, 1978
Lower
MACKEREL CATCH, ULLAPOOL HARBOUR, 1979

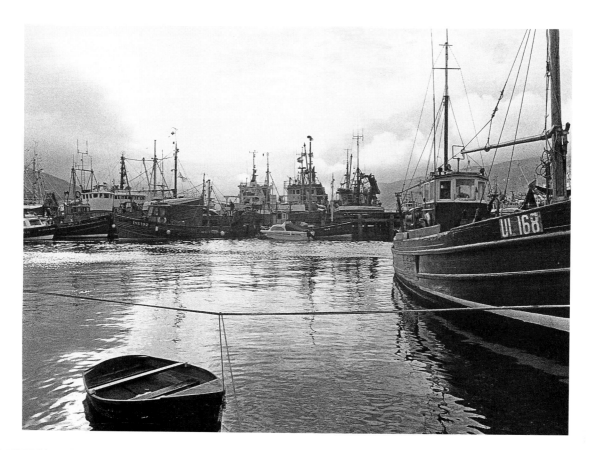

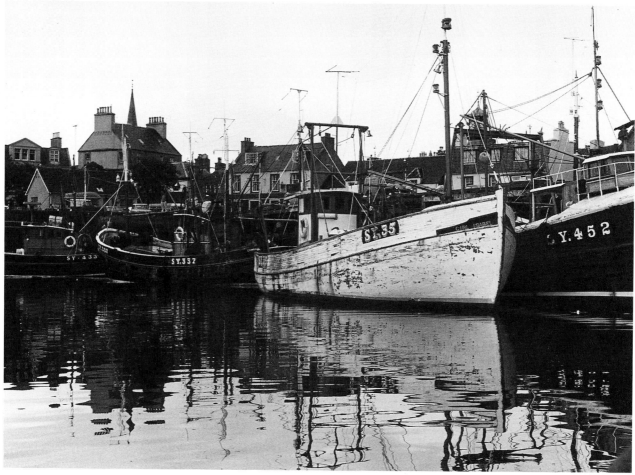

Upper
ULLAPOOL HARBOUR, 1978
Lower
STORNOWAY HARBOUR, ISLE OF LEWIS, 1973

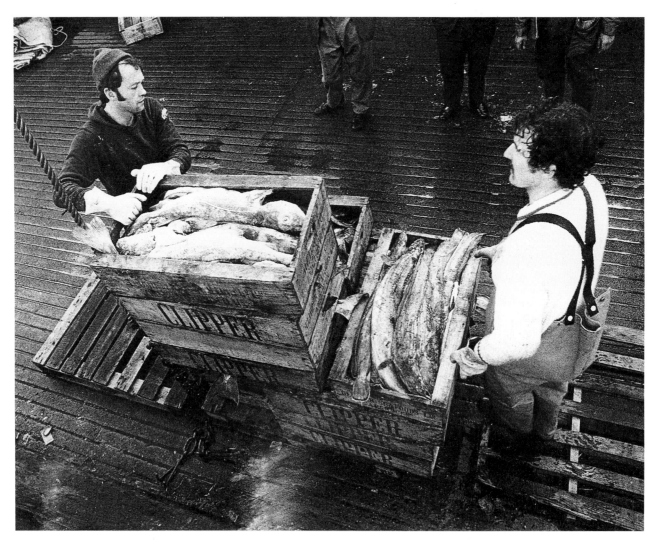

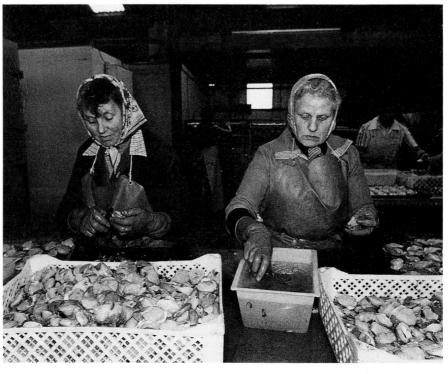

Upper
THE *ANNI ELIZABETH*, STORNOWAY, 1979
Lower
ARDVEENISH FISH FACTORY, ISLE OF BARRA, 1982

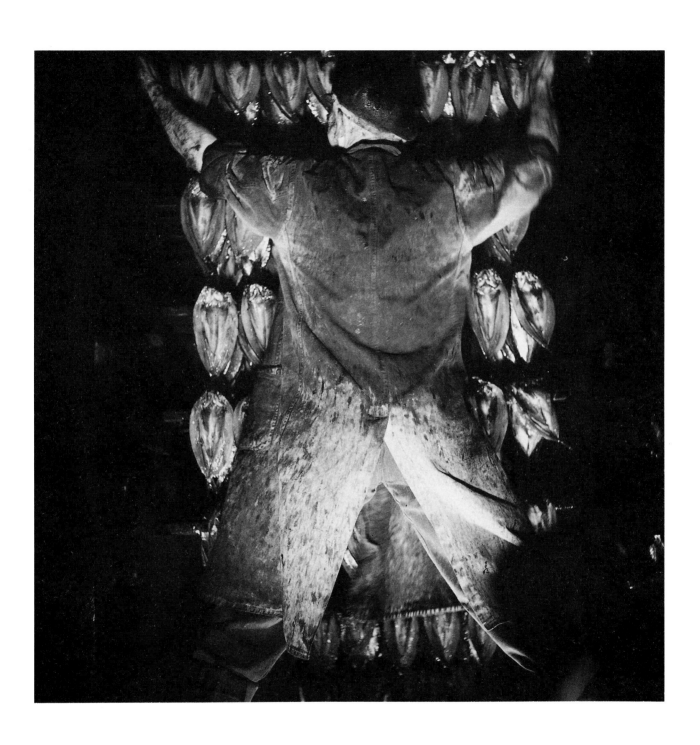

KIPPER SMOKING, FRASERBURGH, 1962

53

THE LAND
Landscape,
Farming,
Crofting

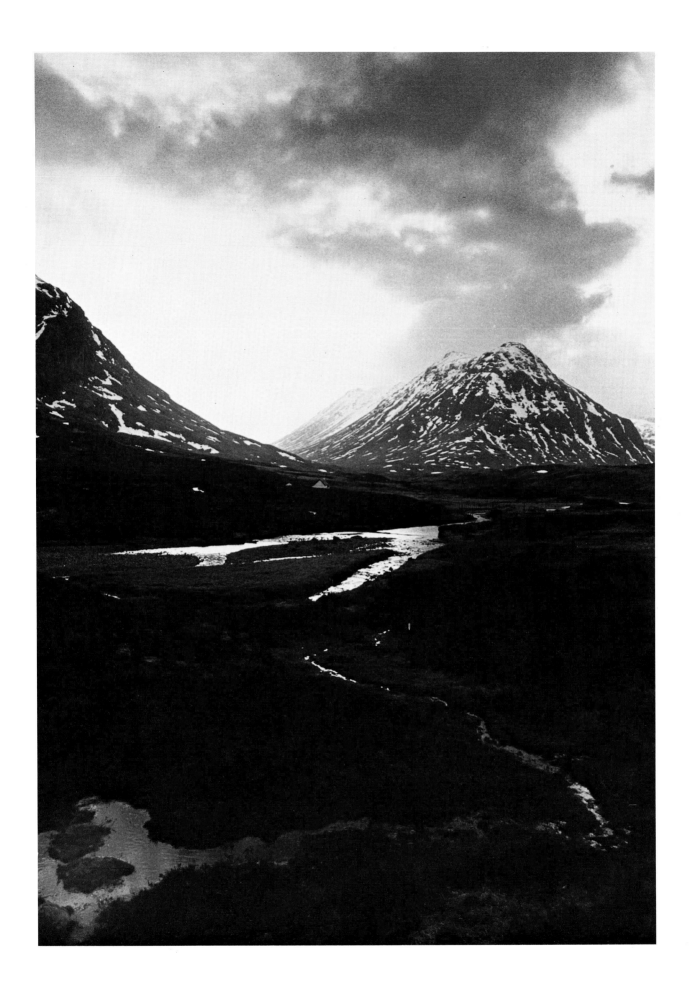

GLEN COE, April 1984

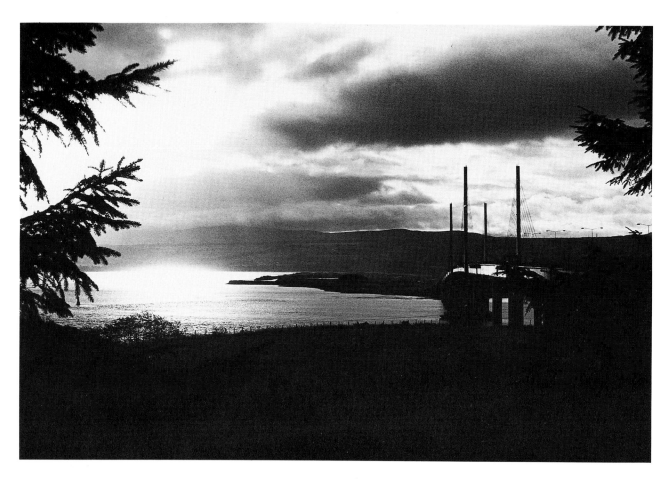

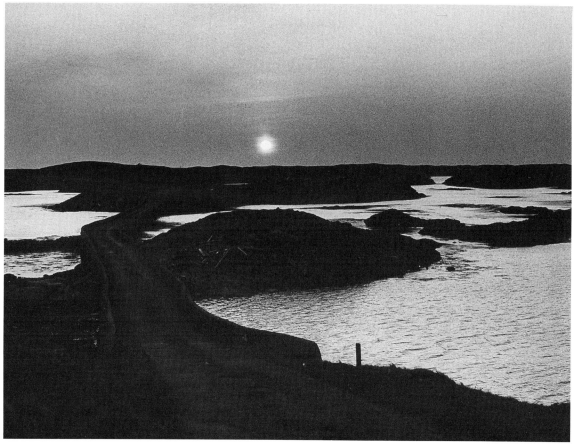

Upper
KESSOCK BRIDGE, 1983
Lower
PRIDE OF ISLANDS, 1980

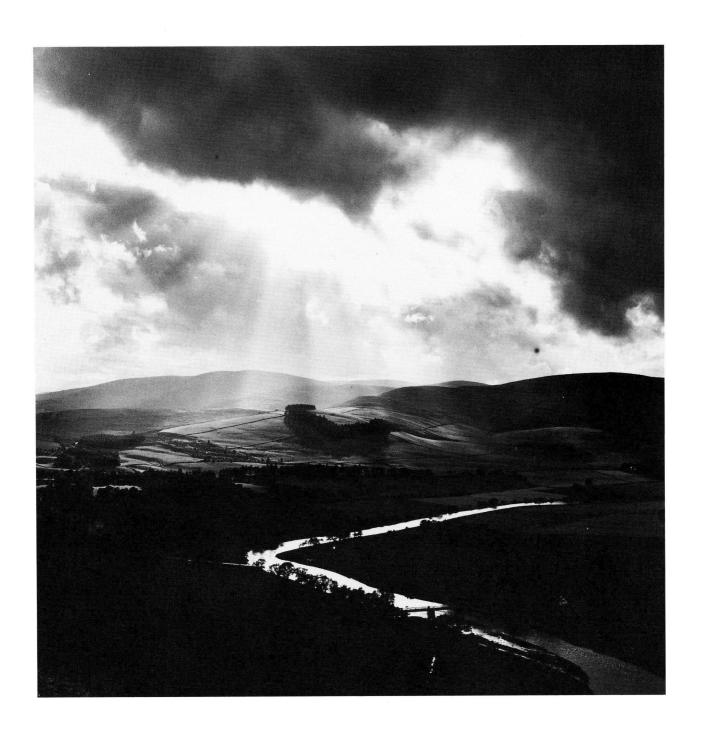

TWEED VALLEY, 1981

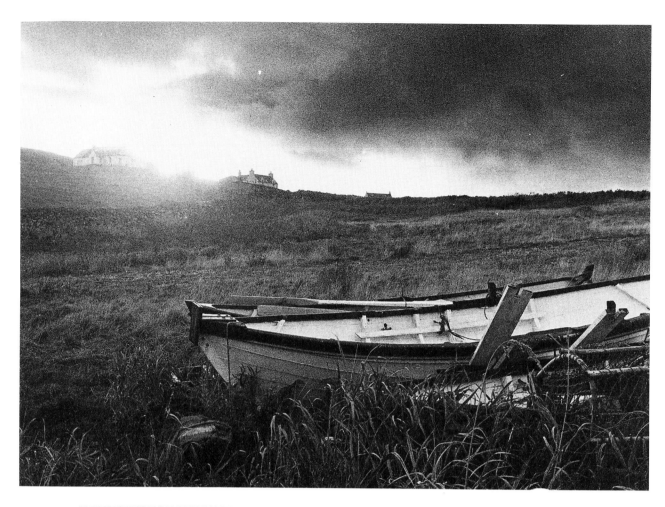

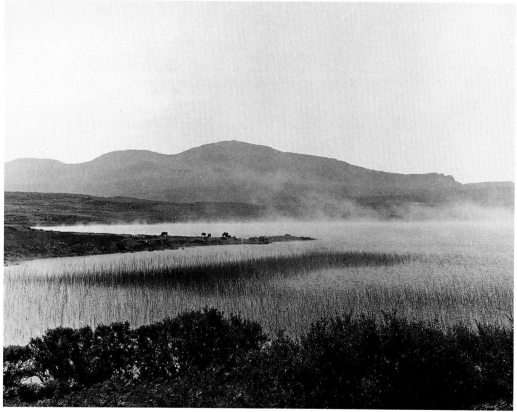

Upper
OUT SKERRIES, SHETLAND, 1976
Lower
LANDSCAPE, STAFFIN, ISLE OF SYKE, 1973

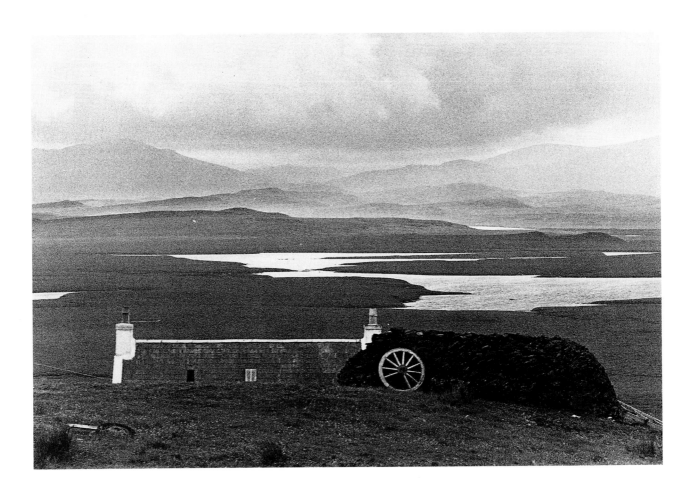

PEAT STACKS, LEWIS, 1979

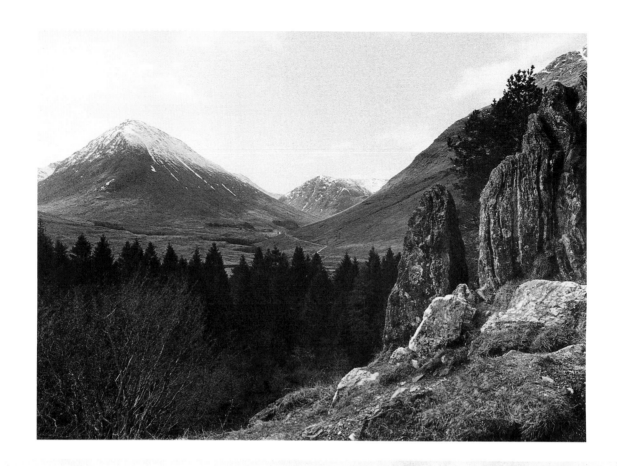

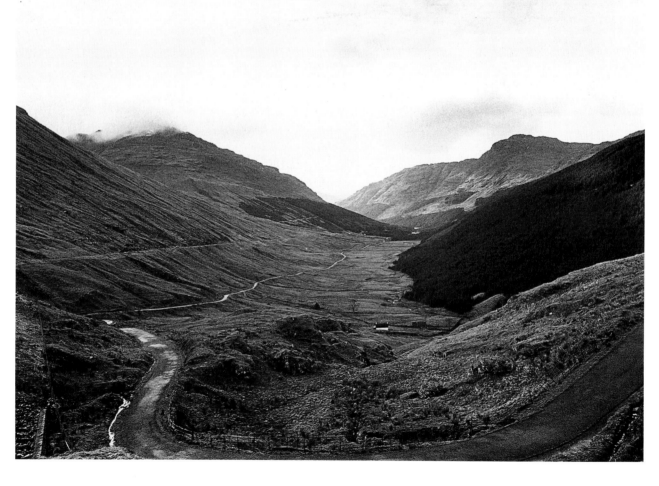

VIEW FROM THE SIGNAL ROCK, GLEN COE, April 1984
Lower
"REST AND BE THANKFUL", GLEN COE, April 1984

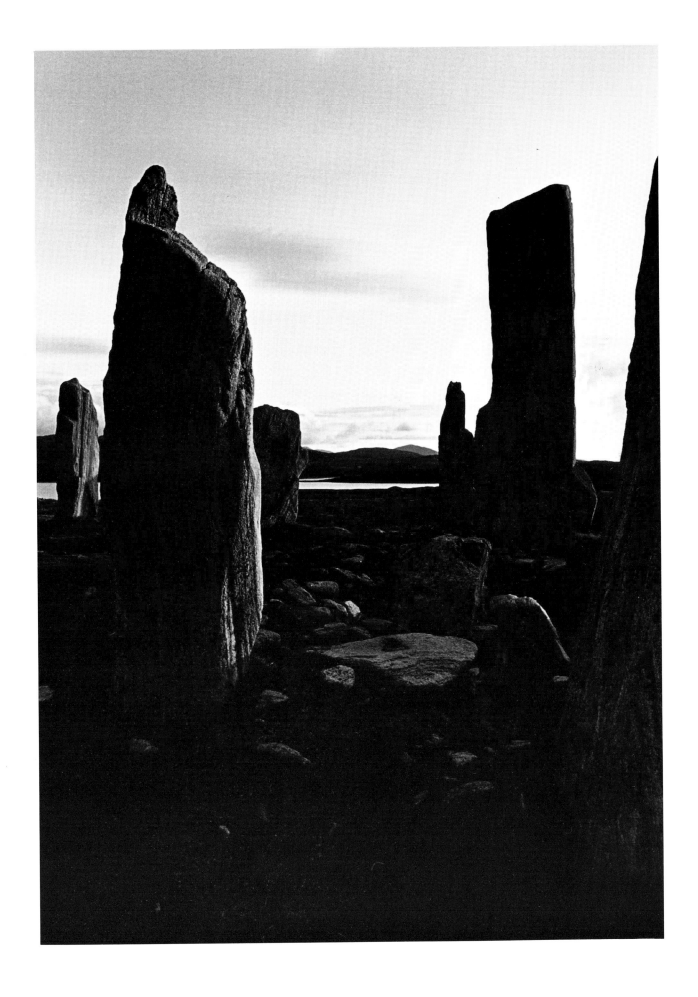

STANDING STONES, CALLANISH, WESTERN ISLES, 1979

Upper
THE OLD VILLAGE, GARENIN, April 1985
Lower
CROFTING LANDSCAPE, SHETLAND ISLANDS, 1971

SKARA BRAE, PREHISTORIC VILLAGE, ORKNEY, 1973

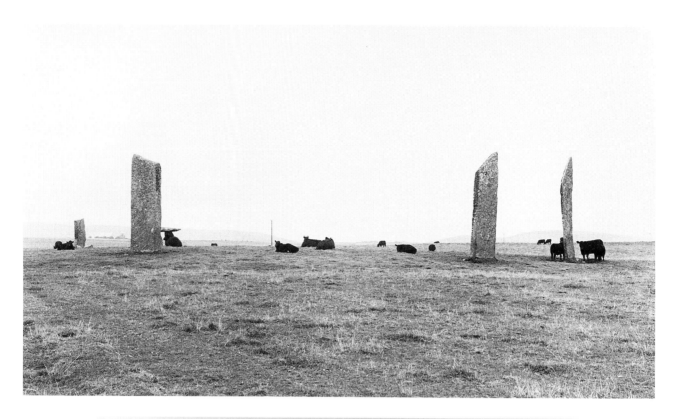

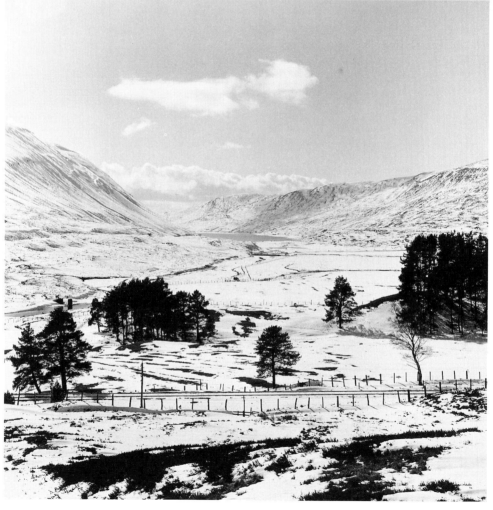

Upper
STANDING STONES OF STENNESS AND RING OF BRODGAR, ORKNEY, 1973
Lower
SNOW SCENE, NEAR TYNDRUM, GRAMPIAN MOUNTAINS, 1976

Upper
NORTHTON, ISLE OF HARRIS, 1979
Lower
BLACK MOUNT, RANNOCH MOOR, 1984

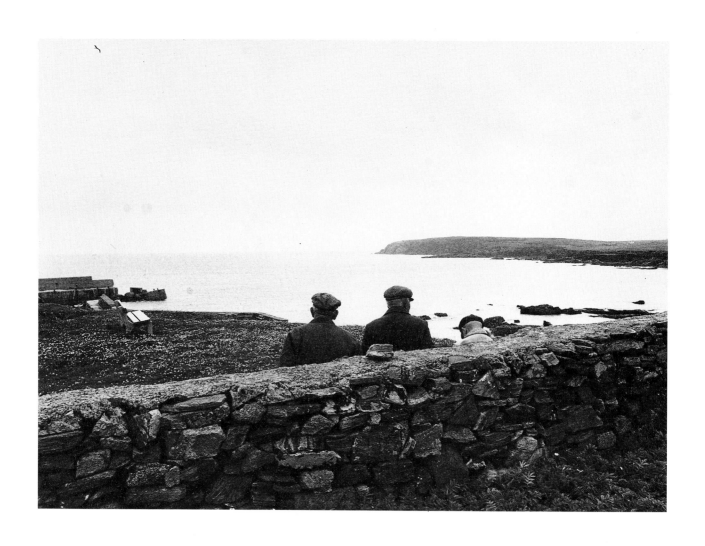

"LOCALS", ISLE OF LEWIS, 1979

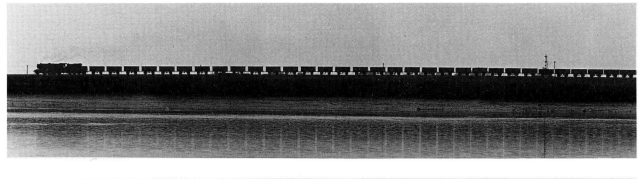

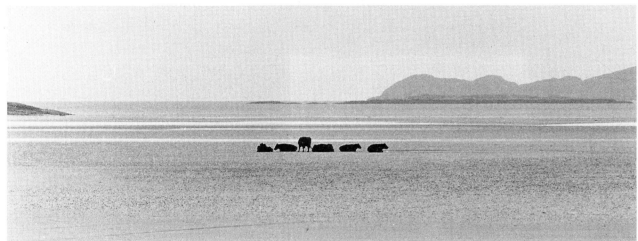

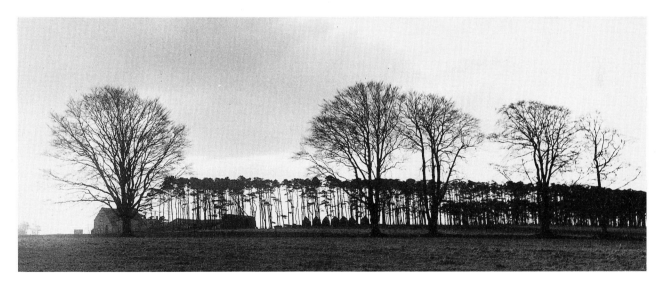

Upper
TRAIN ON EMBANKMENT, STIRLING, 1961
Middle
COWS ON THE BEACH, BARRA, 1968
Lower
TREESCAPE, PENICUIK, 1967

Upper
CLEARING THE LAND, ABERDEENSHIRE, 1962
Lower
CALUM MacLEOD, CALUMS ROAD, RAASAY, 1981

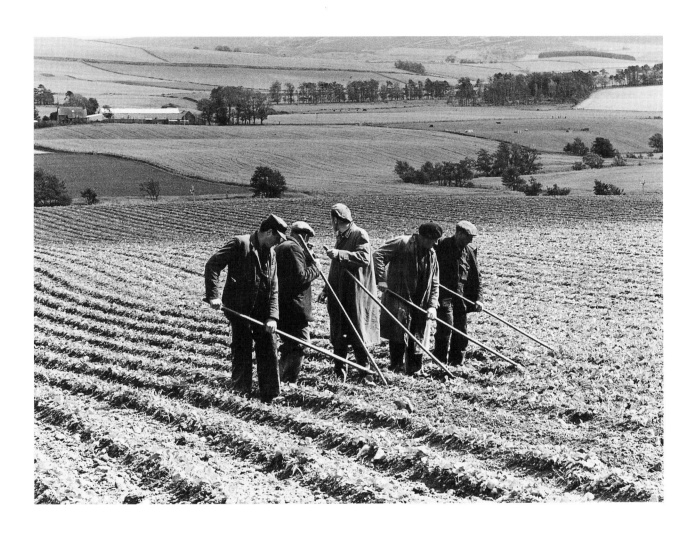

HOEING, ABERDEENSHIRE, 1962

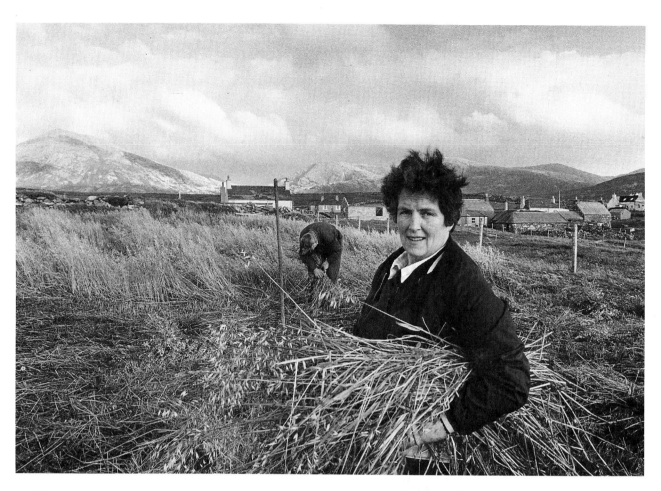

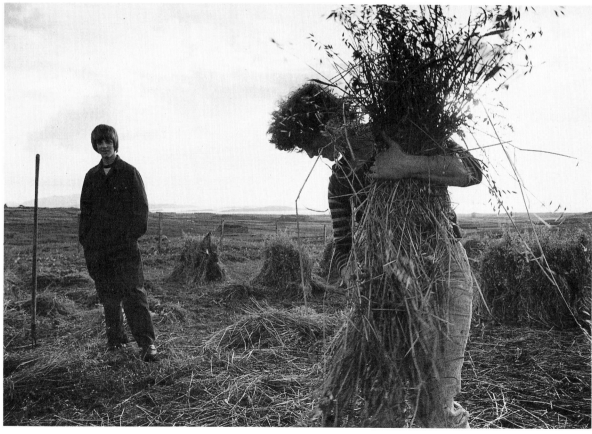

Upper
CORN GATHERING AT HARVEST, MANGISTER, LEWIS, 1973
Lower
CORN GATHERING AT HARVEST, MANGISTER, LEWIS, 1973

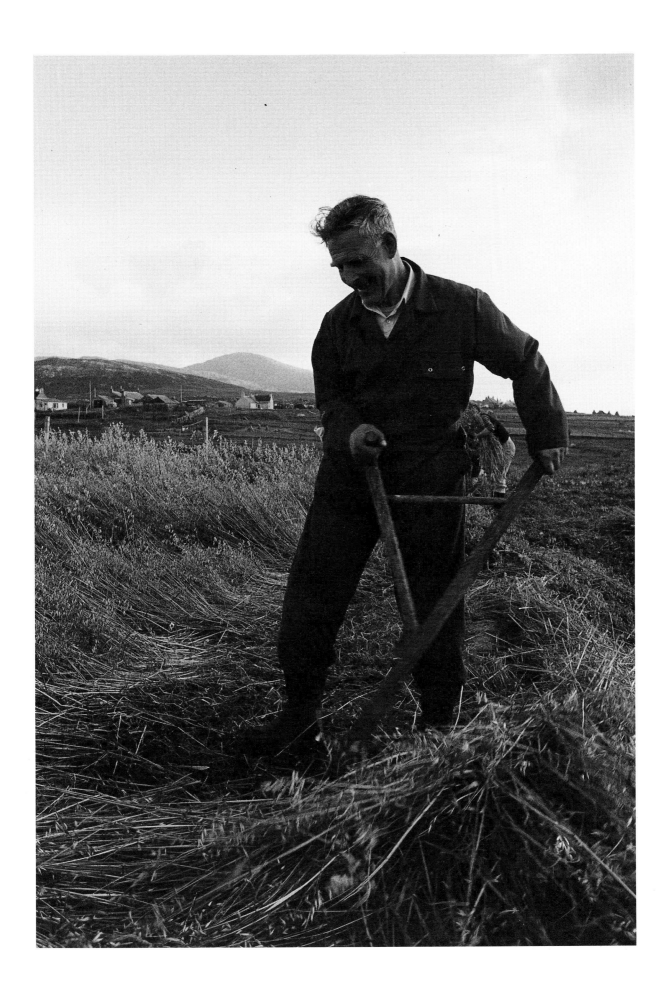

CORN GATHERING AT HARVEST, MANGISTER, LEWIS, 1973

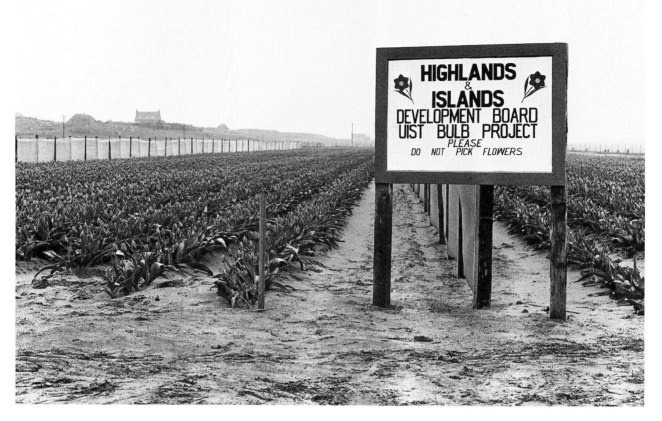

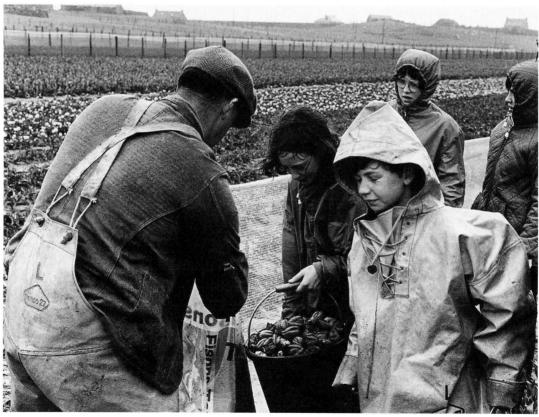

Upper
UIST BULB PROJECT AT THE TULIP FIELDS, VALLAY STRAND, NORTH UIST, 1970
Lower
BULB PLANTING AT THE TULIP FIELDS, VALLAY STRAND, NORTH UIST, 1970

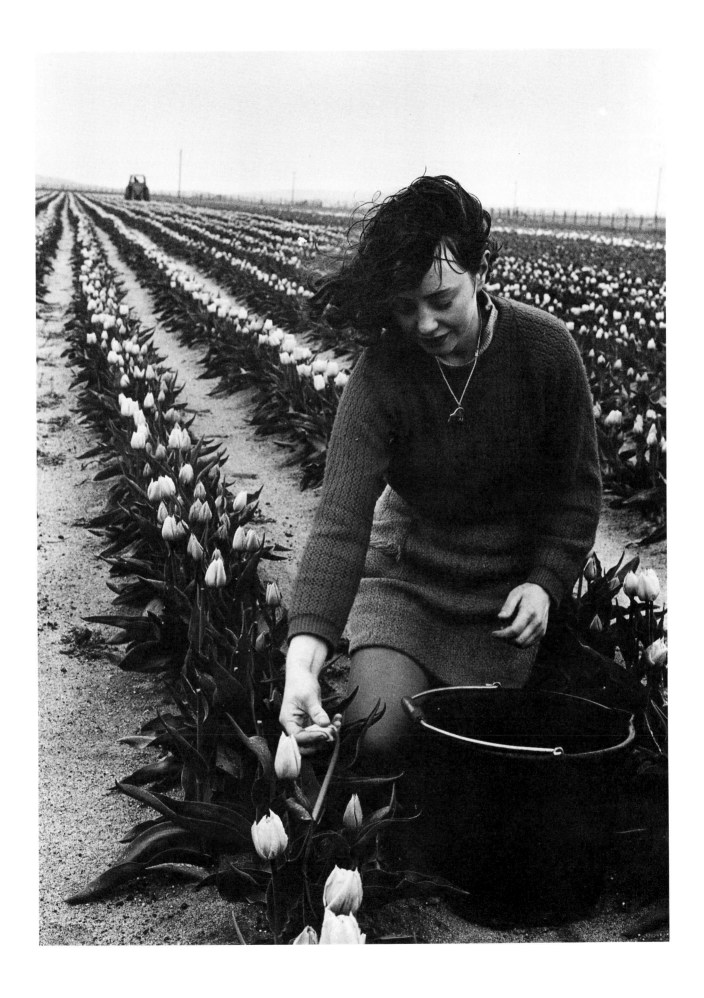

TULIP FIELDS, VALLAY STRAND, NORTH UIST, 1970

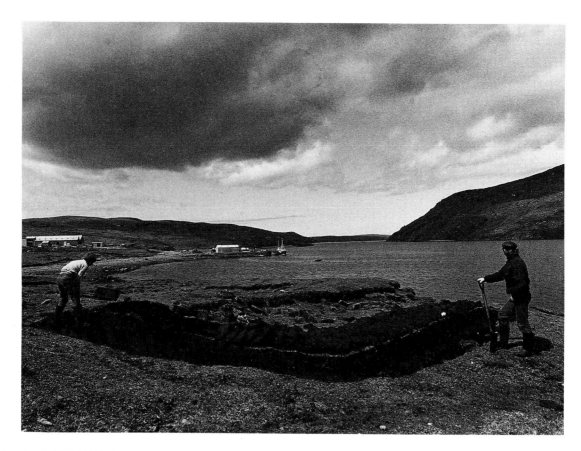

Upper
PEAT CUTTING, NORTH MAVINE, SHETLAND ISLES, 1983
Lower
LAZY BEDS, FINSBAY, HARRIS, June 1979

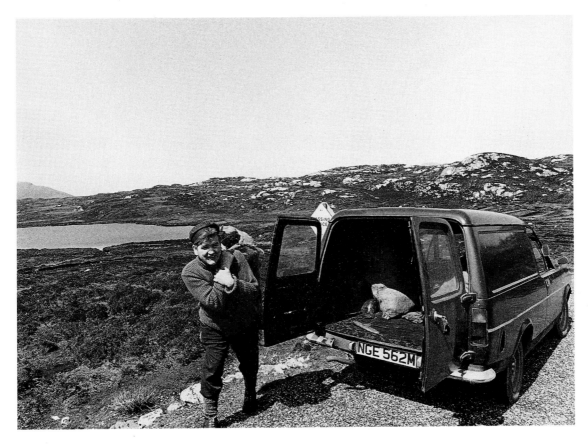

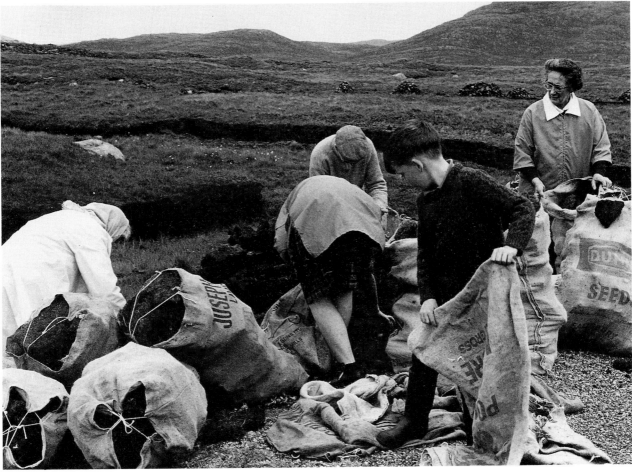

Upper
TRANSPORTING PEAT, ISLE OF HARRIS, 1979
Lower
BAGGING PEAT, ISLE OF HARRIS, 1973

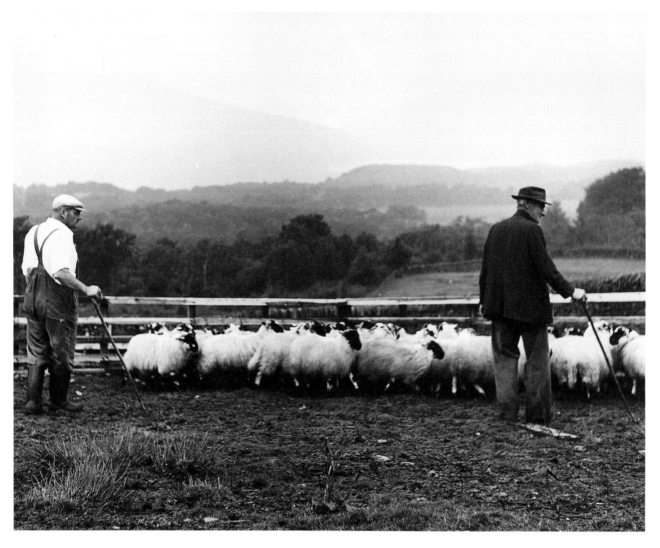

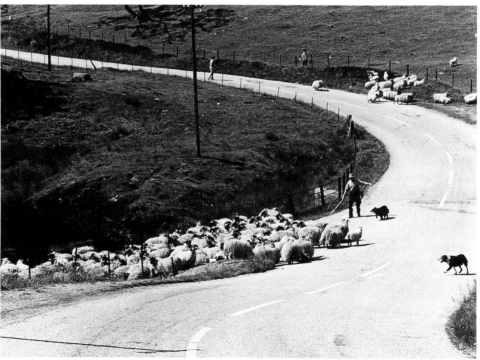

Upper
DONALD McLEAN, FARMER, LOCH LOMOND, 1967
Lower
HERDING SHEEP, UPPER TAYSIDE, 1962

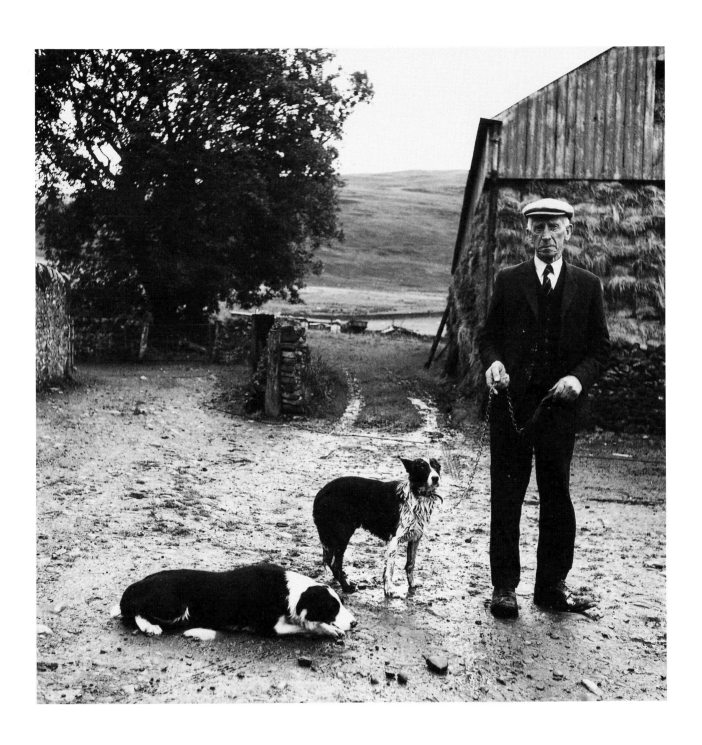

MR MURRAY AND HIS SHEEPDOGS, PEEBLES, 1967

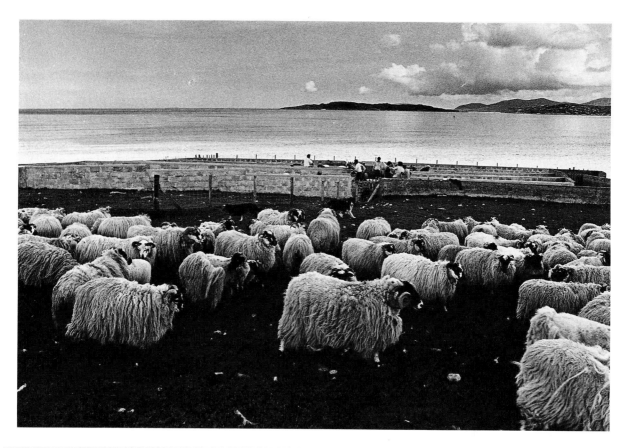

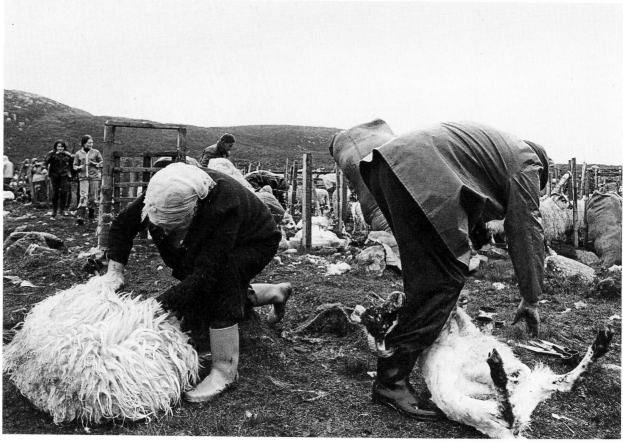

Upper
SHEEP SHEARING NEAR SEILEBOST, ISLE OF HARRIS, 1980
Lower
SHEEP SHEARING, ISLE OF LEWIS, 1979

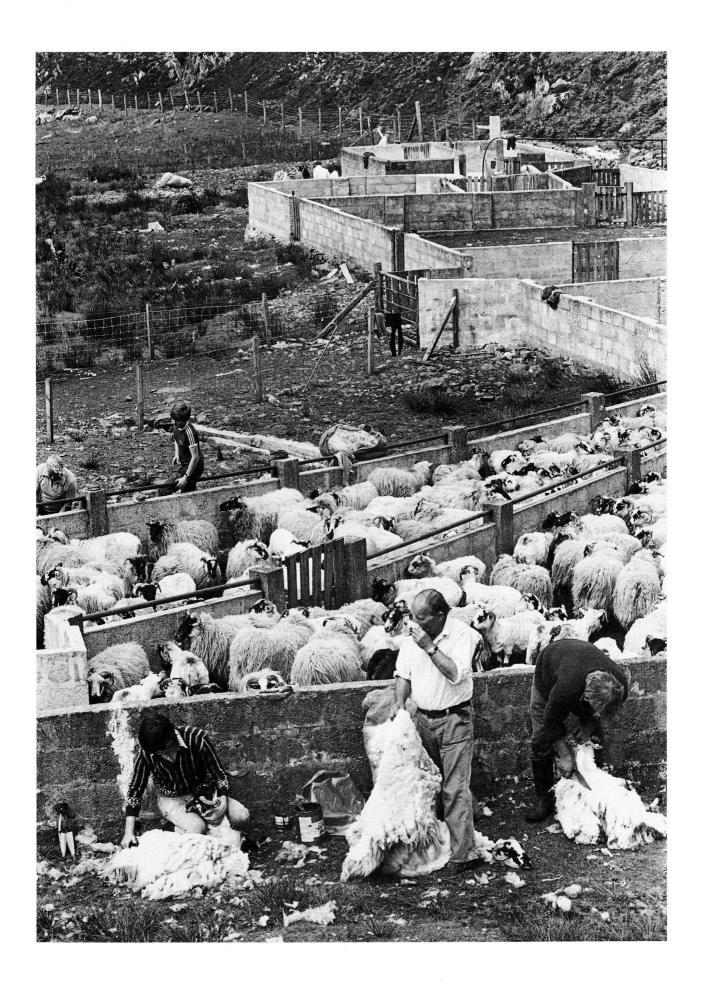

SHEEP SHEARING, LEVERBURGH, ISLE OF HARRIS, 1980

GIRL AT CROFT IN SKYE, early 1970s

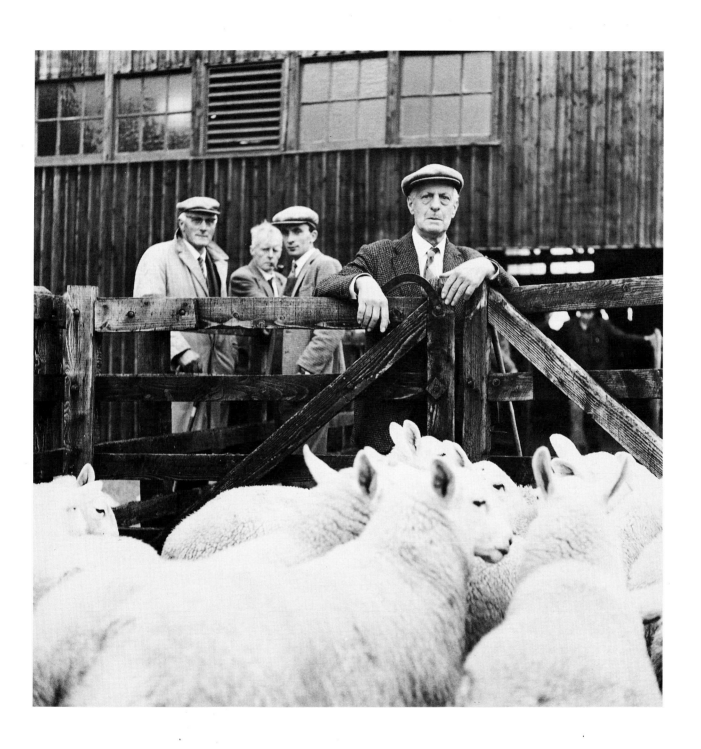

LAIRG LAMB SALES, SUTHERLAND, 1970

83

Upper
CATTLE FARMER, KIRKWALL MARKET, NORTHERN ISLES, 1973
Lower
FARMERS AT KIRKWALL MARKET, NORTHERN ISLES, 1973

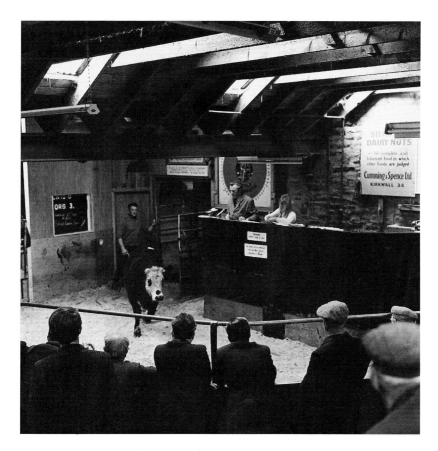

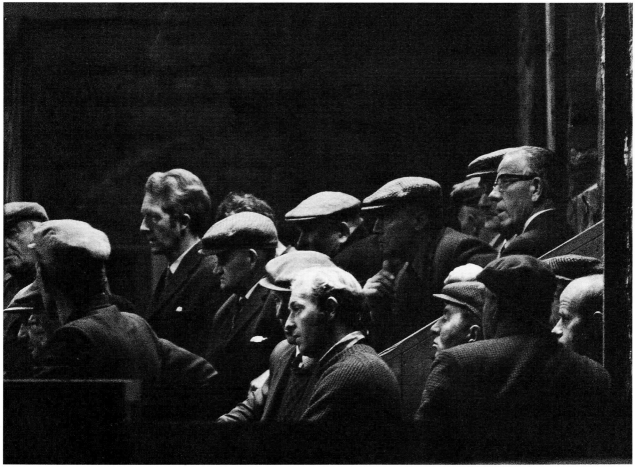

Upper
"FAIR DEAL", KIRKWALL MARKET, 1973
Lower
CATTLE FARMERS, KIRKWALL MARKET, NORTHERN ISLES, 1973

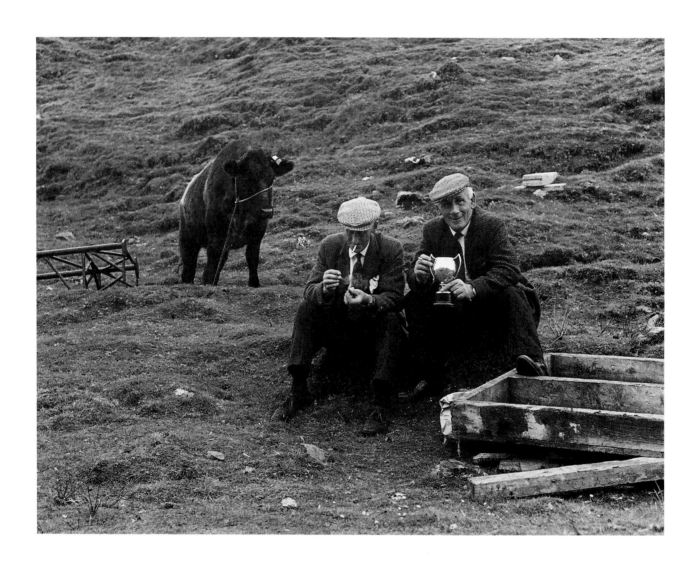

PRIZE-WINNING BULL, WEST LOCH TARBERT, HARRIS, 1973

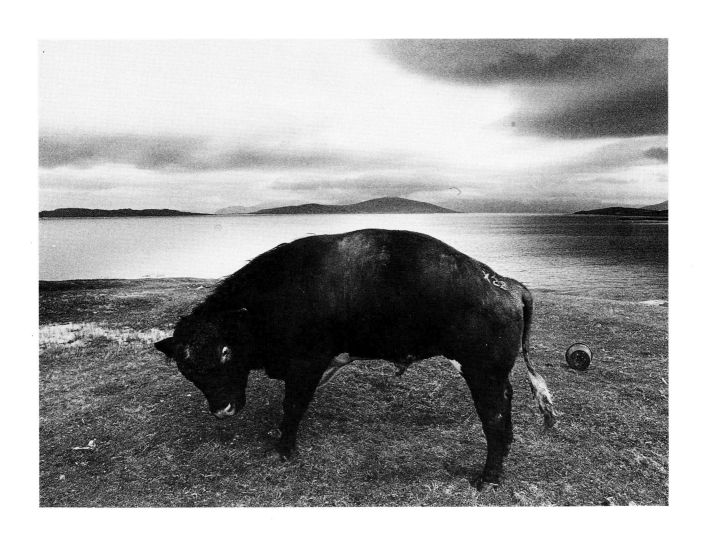

THE SCARISTA BULL, ISLE OF HARRIS, 1979

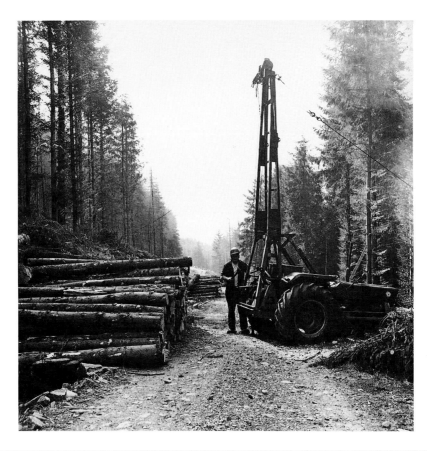

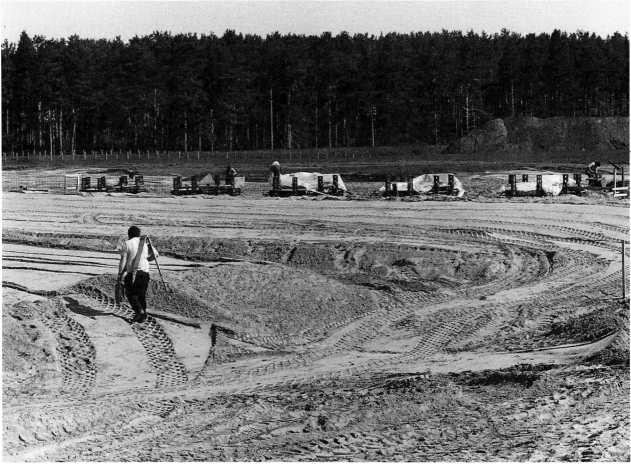

Upper
RATTAGAN FOREST, DURING THE FILMING OF *HIGHLANDS*, 1970
Lower
PREPARING THE SITE FOR THE TIMBER PROCESSING PLANT AT DALCROSS, 1970

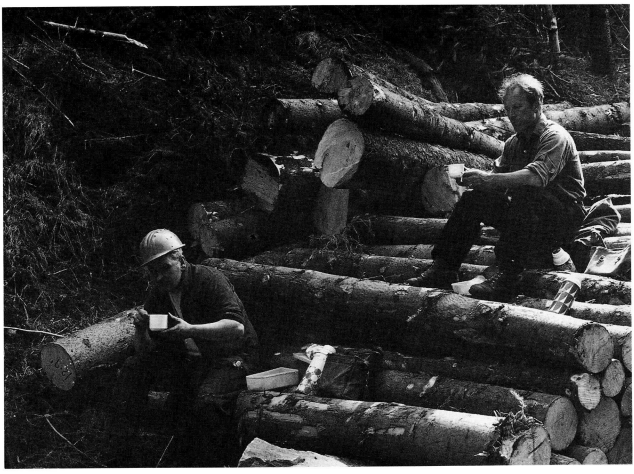

Upper
FORESTERS, RATTAGAN FOREST, 1970
Lower
FORESTERS TEA BREAK, RATTAGAN FOREST, 1970

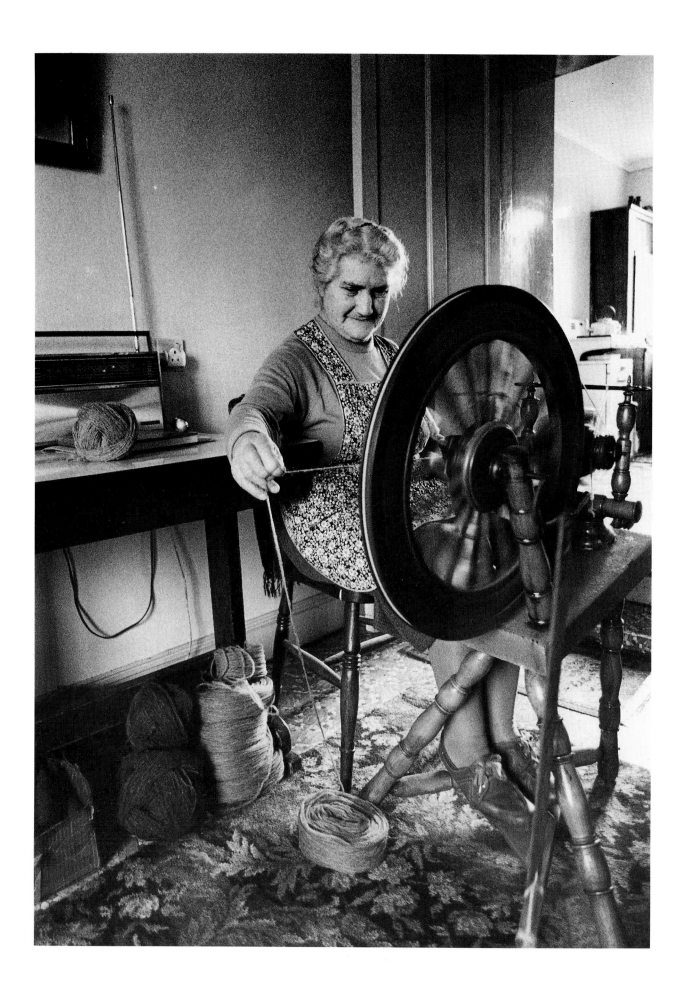

MARION CAMPBELL, "SPINNING ON THE LOOM",
PLOCKRAPOOL, ISLE OF HARRIS, 1985

90

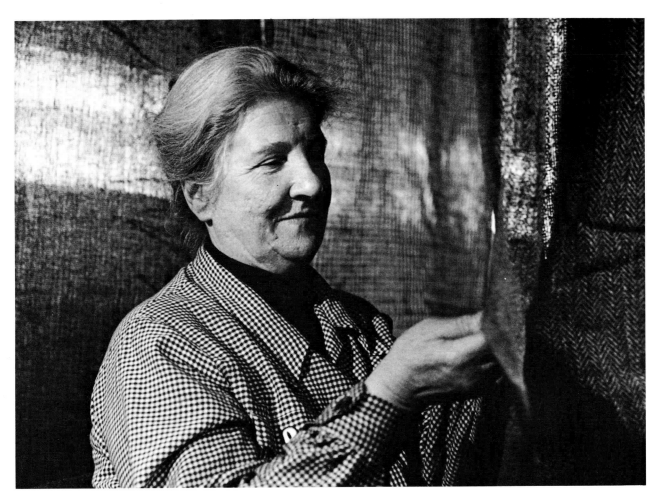

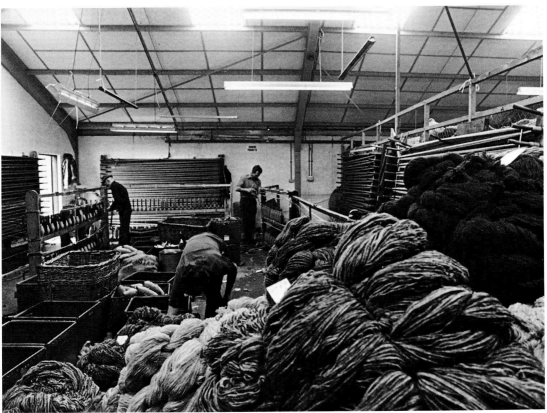

Upper
INSPECTING TWEEDS, MacKENZIES MILL, LEWIS, 1985
Lower
TWEED MILL, SHAWBOST, ISLE OF LEWIS, 1978

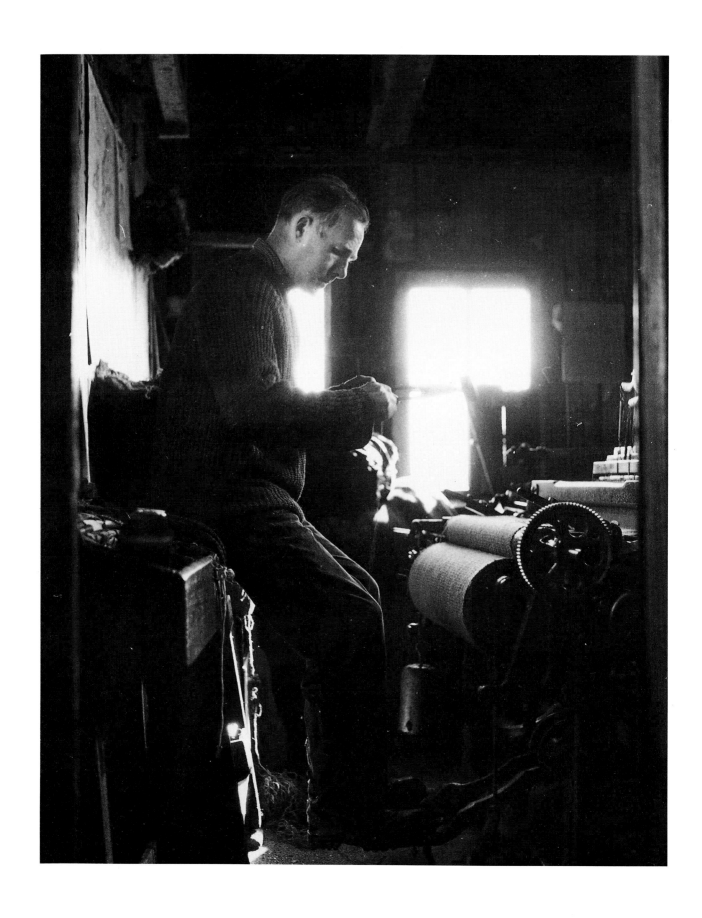

JOHN McGREGOR, LEWIS WEAVER, 1973

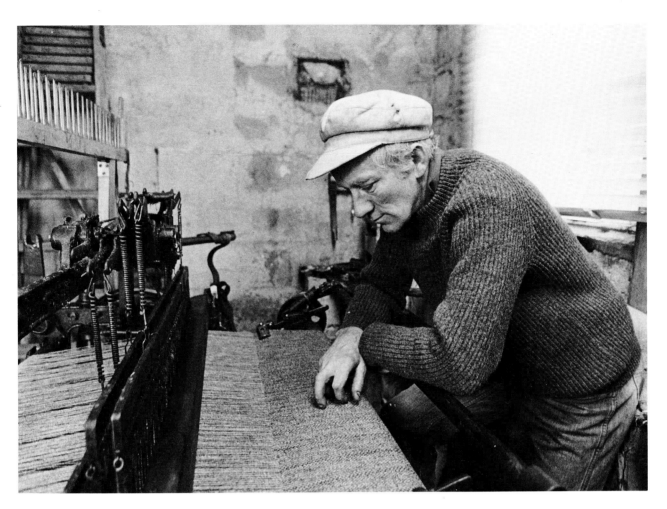

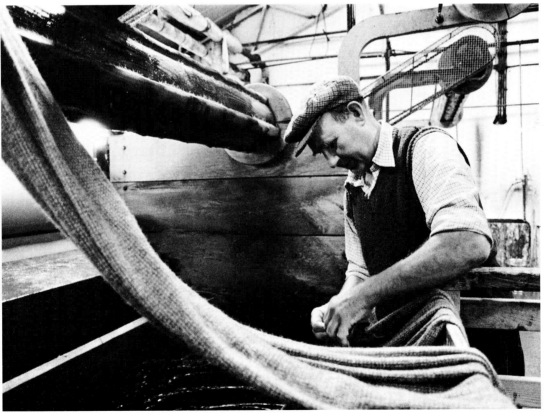

Upper
WILLIAM MacDONALD INSPECTING THE CLOTH, ISLE OF LEWIS, 1985
Lower
WASHING THE TWEED, BREASCLETE TWEED MILLS, ISLE OF LEWIS, 1979

INDUSTRY
Shipbuilding,
Boatbuilding,
Mining,
Ironworks,
Oil

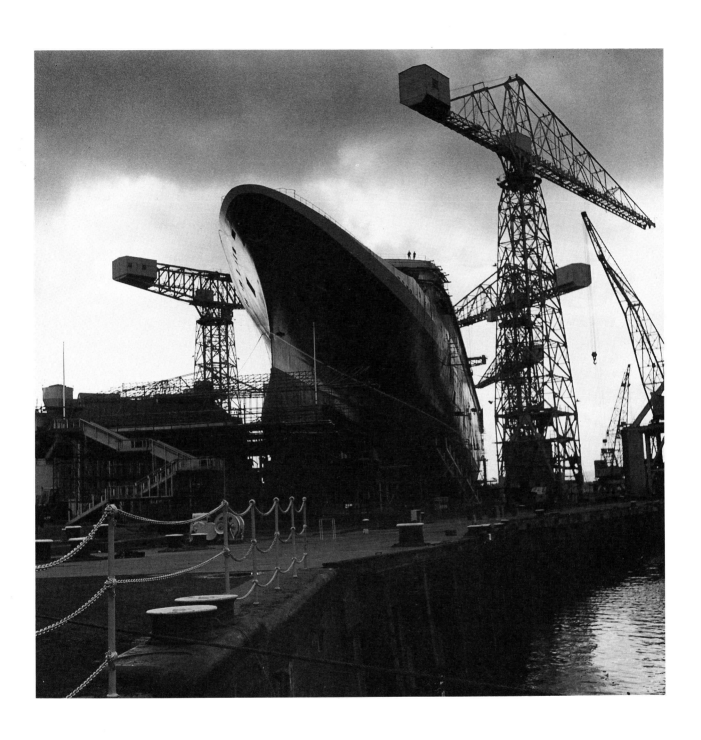

QE2 ON THE STOCKS, JOHN BROWNS YARD, 1966

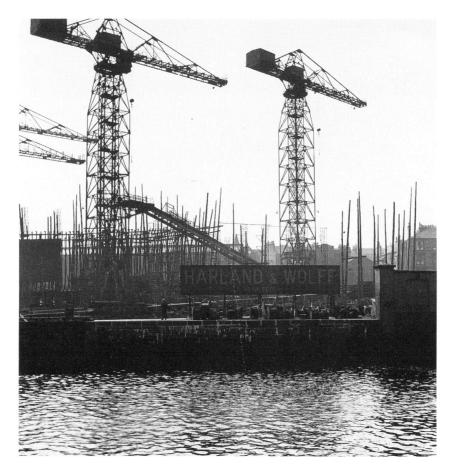

Upper
CRANES AT HARLAND AND WOLFF, GOVAN, 1964
Lower
QE2 ABOUT TO DOCK AT GREENOCK, 1985

98

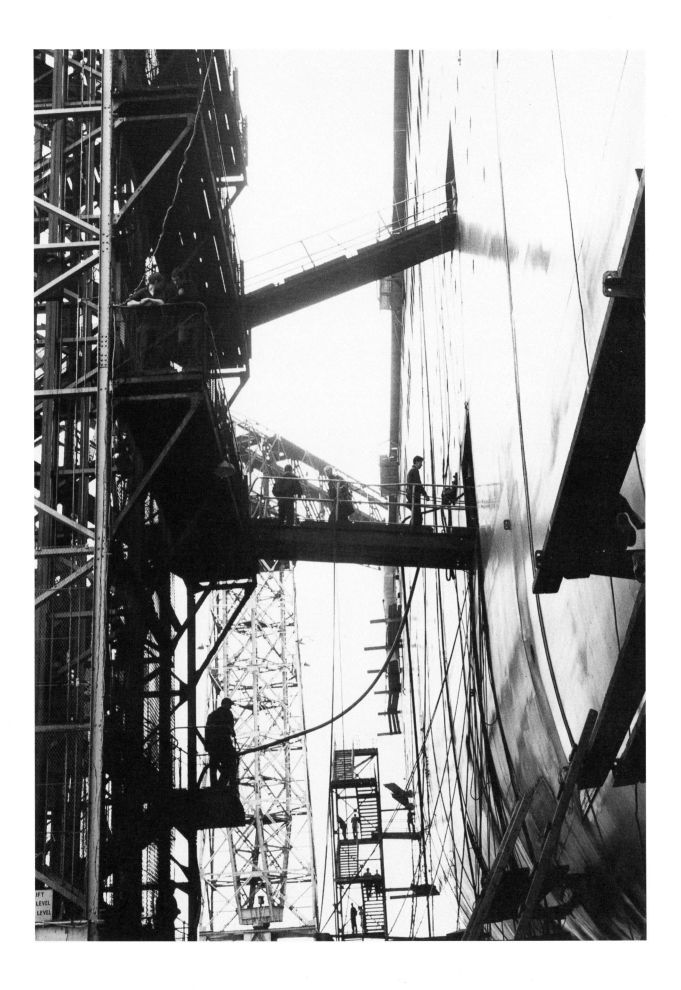

QE2 PRIOR TO LAUNCH AT JOHN BROWNS YARD, 1967

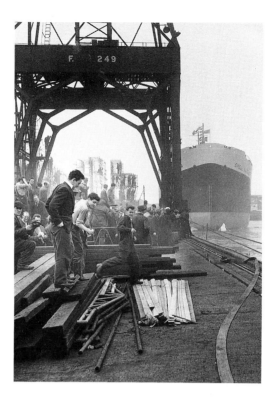

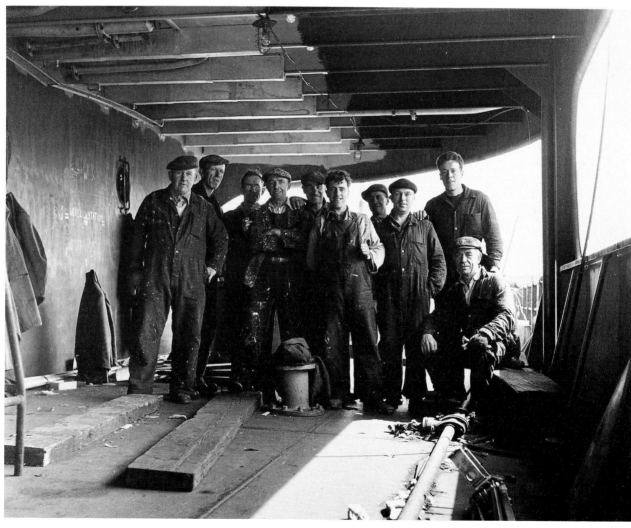

Upper
LAUNCHING OF THE *SHELL NAIGUATA*, FAIRFIELDS, 1960
Lower
SHIPBUILDERS, PRIOR TO THE LAUNCHING OF
THE *SHELL NAIGUATA*, FAIRFIELDS, 1960

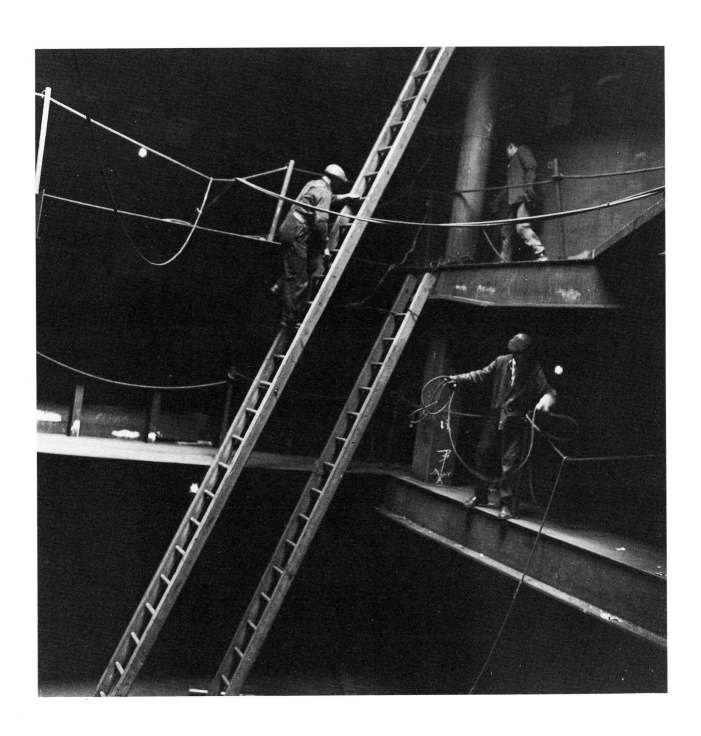

INTERIOR FITTINGS AT JOHN BROWNS YARD, 1960

101

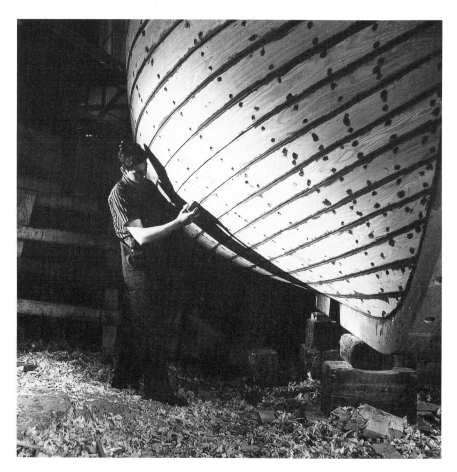

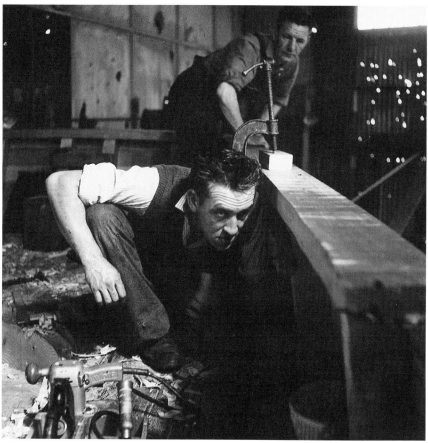

Upper
BUILDING THE *COMET* REPLICA, BUCKIE, 1962
Lower
BUILDING THE *COMET* REPLICA, BUCKIE, 1962

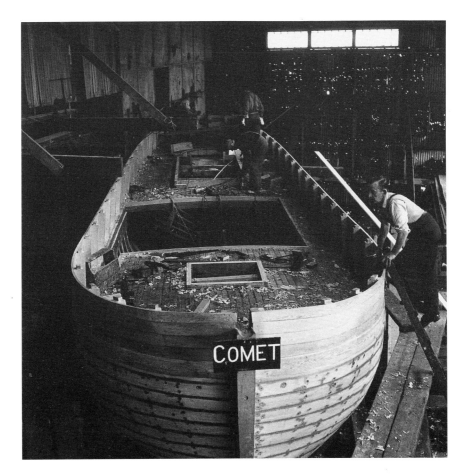

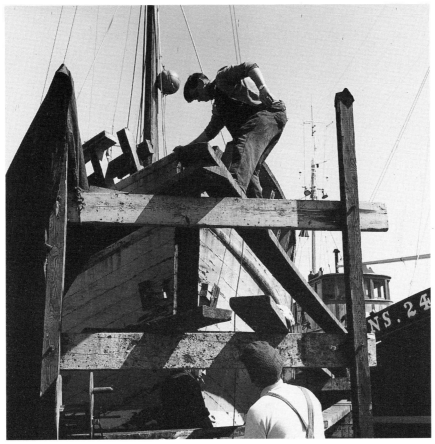

Upper
BUILDING THE *COMET* REPLICA, BUCKIE, 1962
Lower
BOATBUILDING, LOSSIEMOUTH, 1968

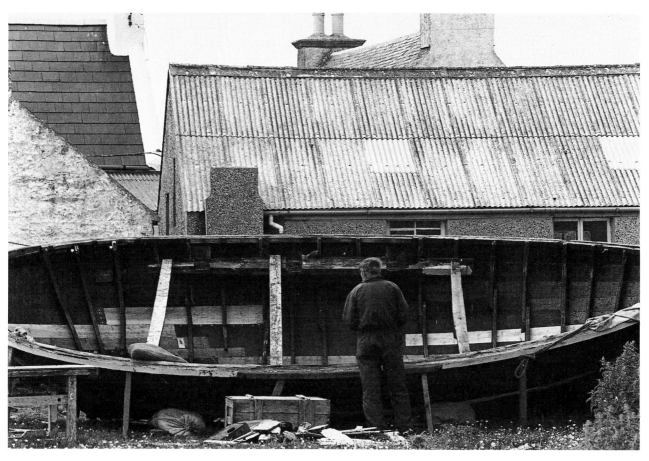

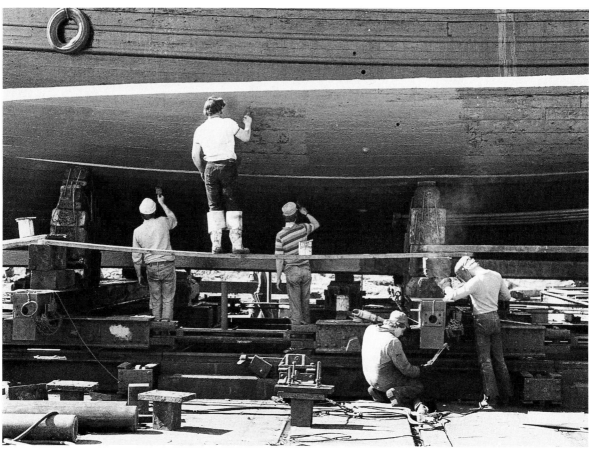

Upper
BOATBUILDER, SKIGERSTA, ISLE OF LEWIS, 1979
Lower
FISHING BOAT MAINTENANCE, STORNOWAY, ISLE OF LEWIS, 1982

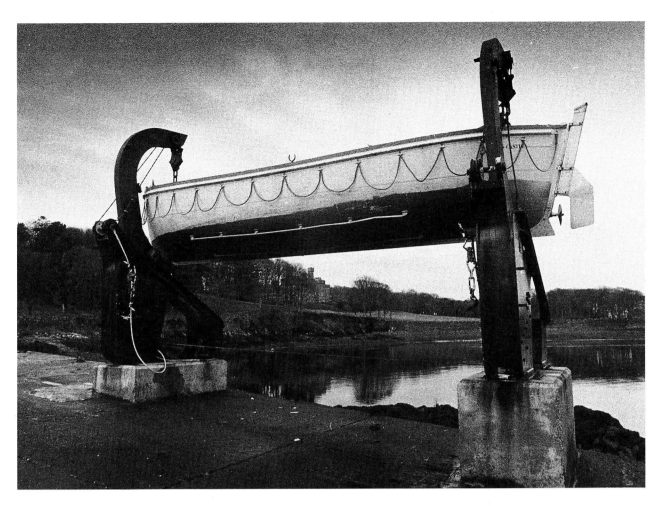

Upper
LIFEBOAT, STORNOWAY, ISLE OF LEWIS, 1977
Lower
SKIGERSTA, ISLE OF LEWIS, 1979

105

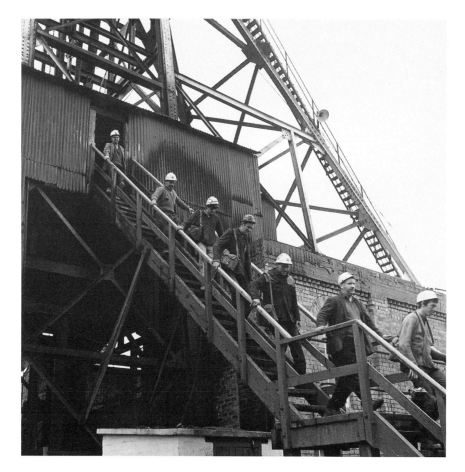

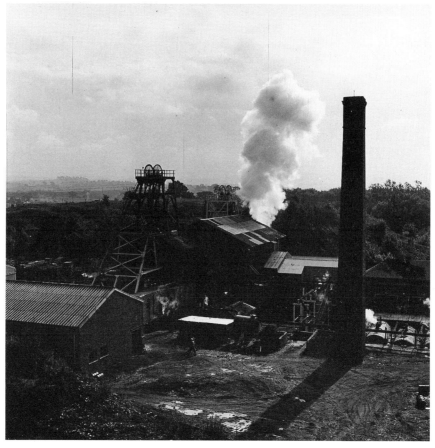

Upper
END OF SHIFT, PITHEAD, 1968
Lower
MINES, PITHEAD, 1968

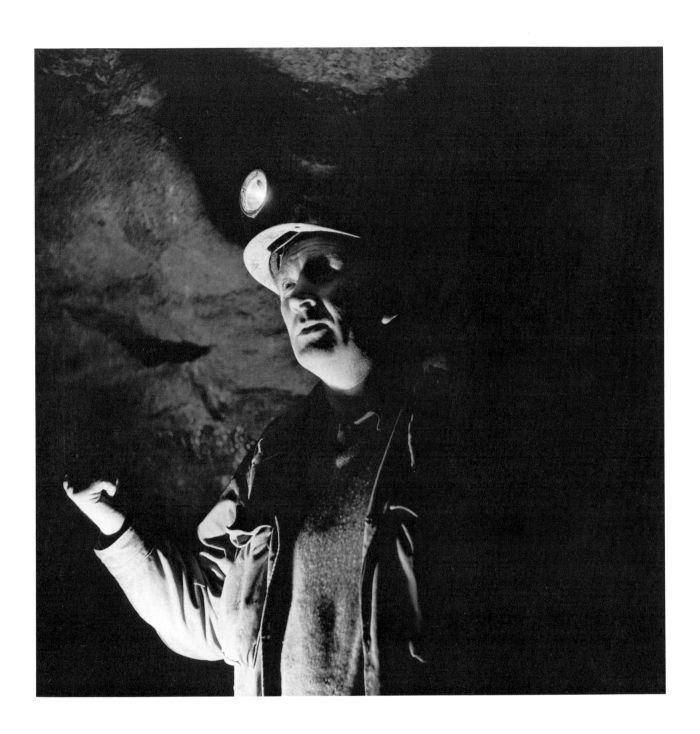

CLAY MINER, 1968

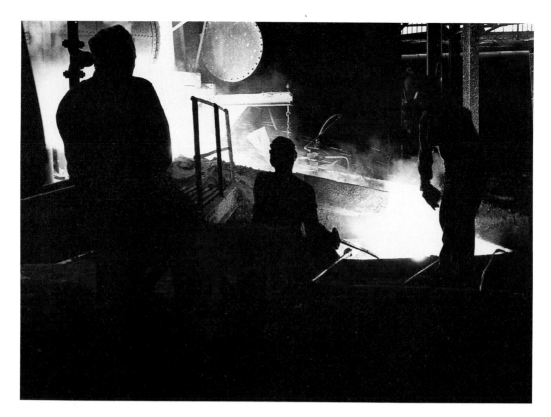

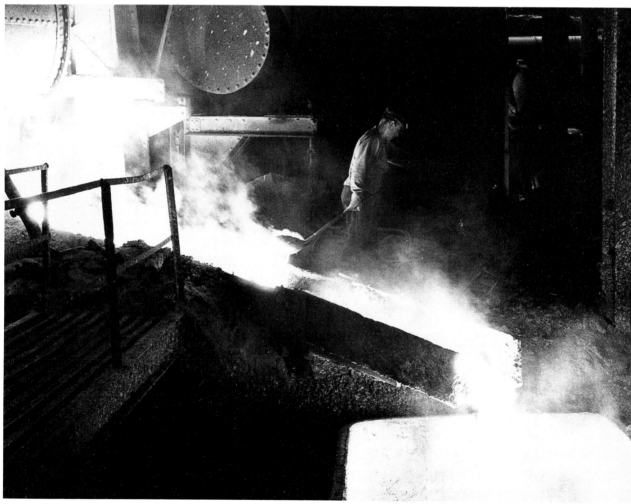

Upper
POURING MOLTEN METALS, CARRON IRONWORKS, 1961
Lower
POURING MOLTEN METALS, CARRON IRONWORKS, 1961

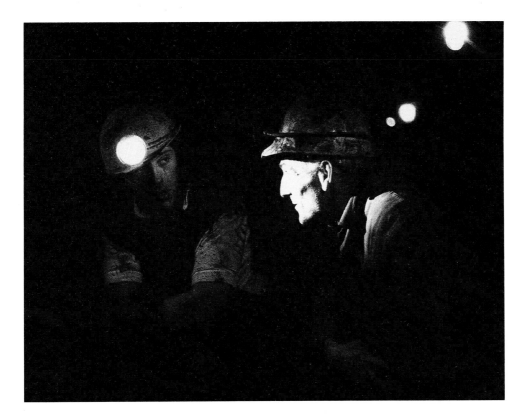

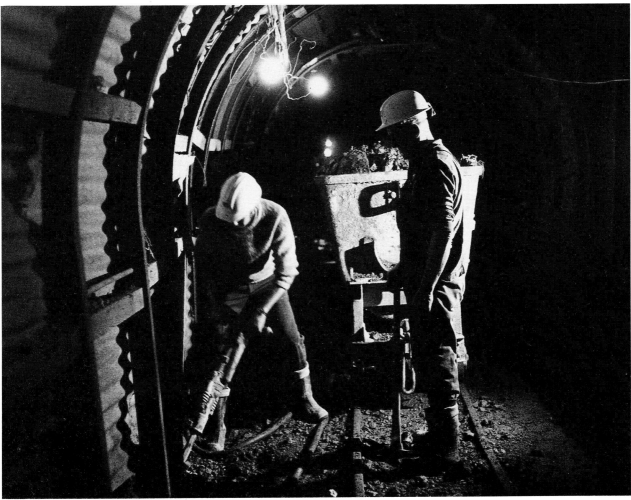

Upper
CLAY MINERS, 1968
Lower
CLAY MINERS, DRILLING, 1968

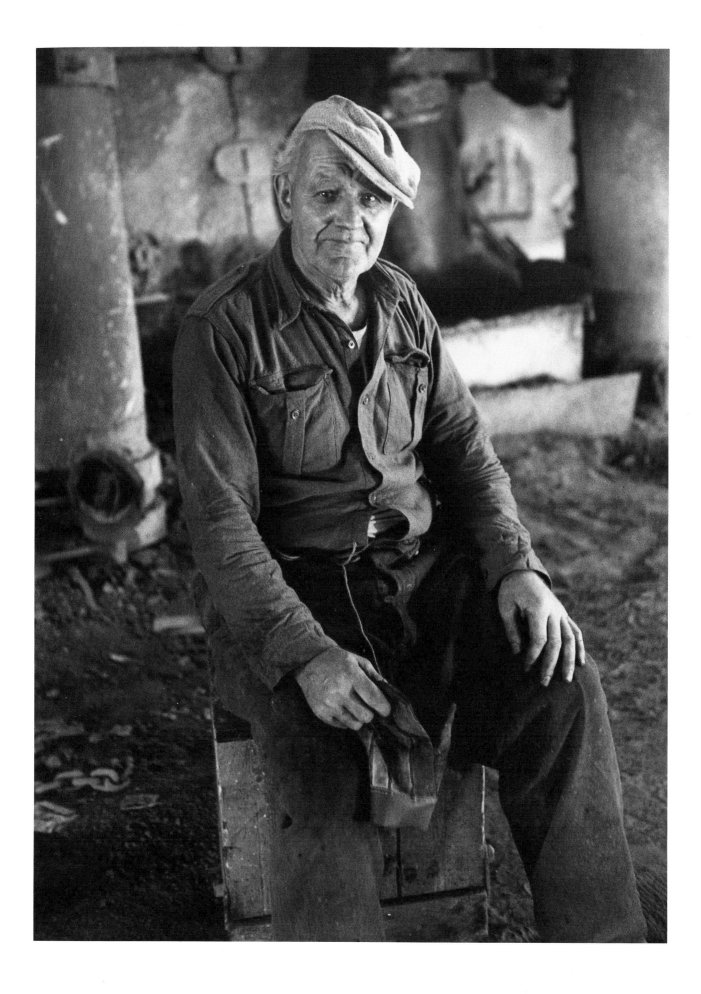

CARRON IRONWORKS, STIRLINGSHIRE, 1961

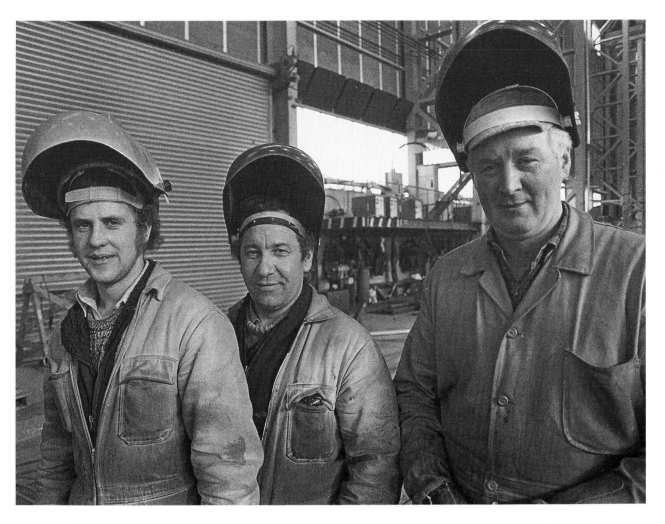

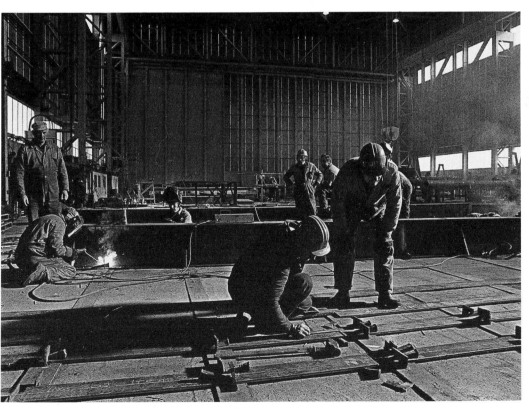

Upper
WELDERS, ARNISH POINT, STORNOWAY, LEWIS OFFSHORE, 1979
Lower
WELDERS, ARNISH POINT, STORNOWAY, LEWIS OFFSHORE, 1979

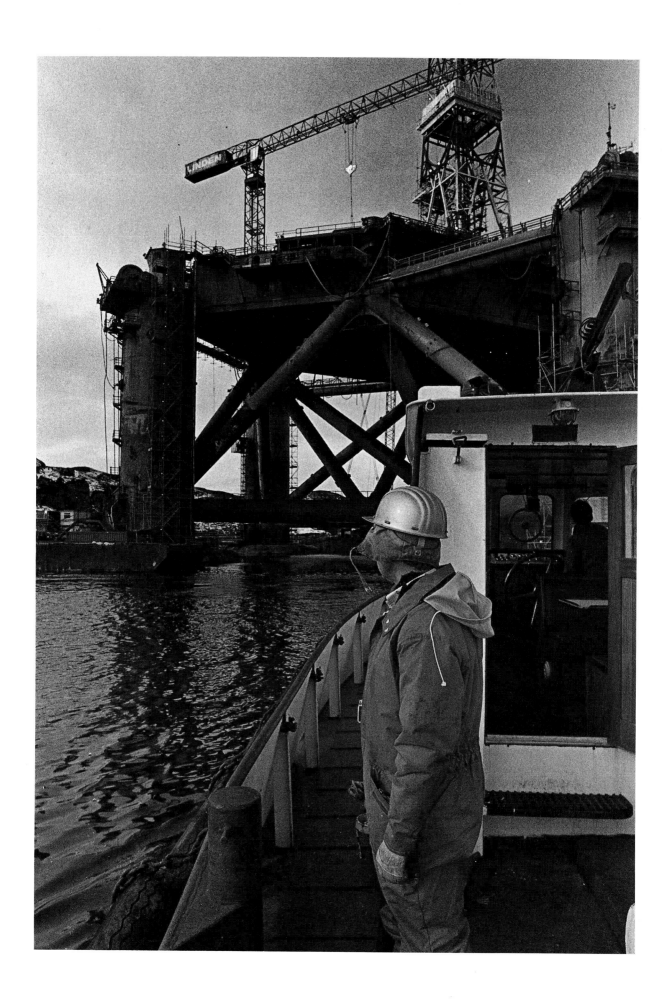

B.P. DRILLMASTER, ARNISH POINT, ISLE OF LEWIS, 1979

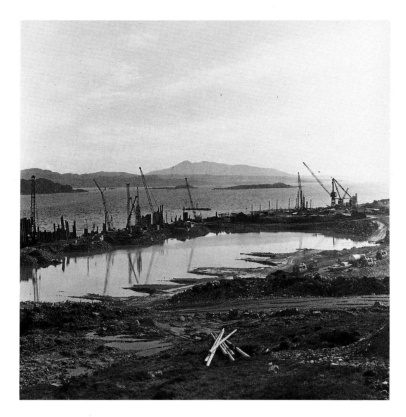

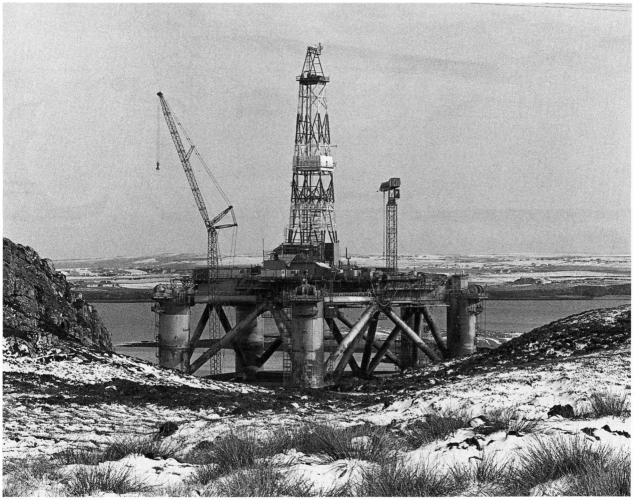

Upper
OIL RIG CONSTRUCTION YARD, LOCH KISHORN, 1975
Lower
B.P. OIL RIG, ARNISH POINT, STORNOWAY, LEWIS, 1979

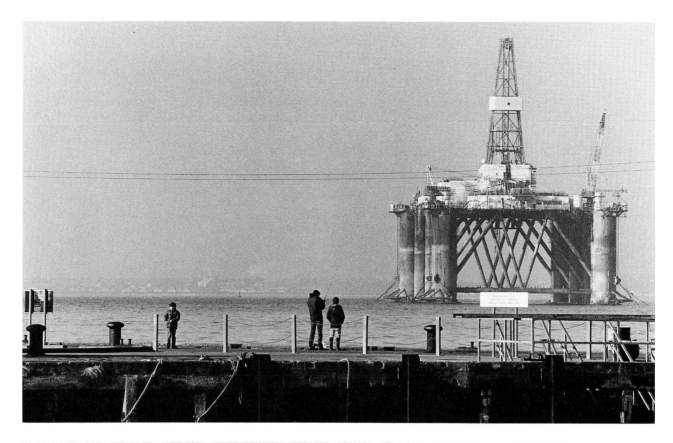

Upper
OIL RIG, NIGG BAY, 1985
Lower
NIGG HARBOUR, 1975

114

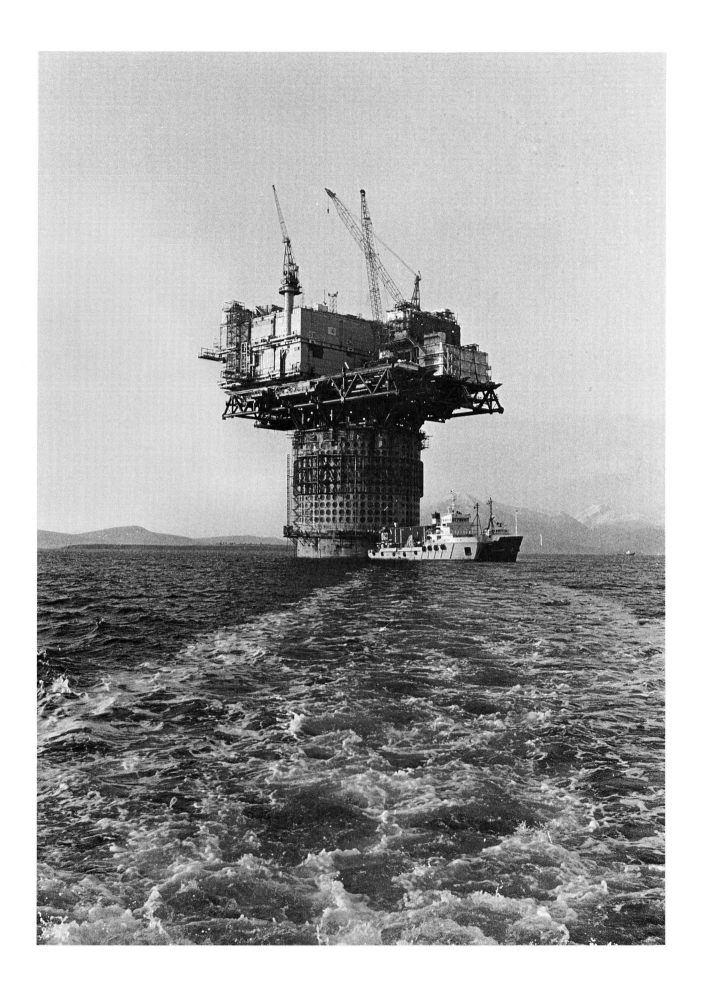

OIL PLATFORM, LOCH KISHORN, 1978

LEISURE

Common Riding,
The Highland Games

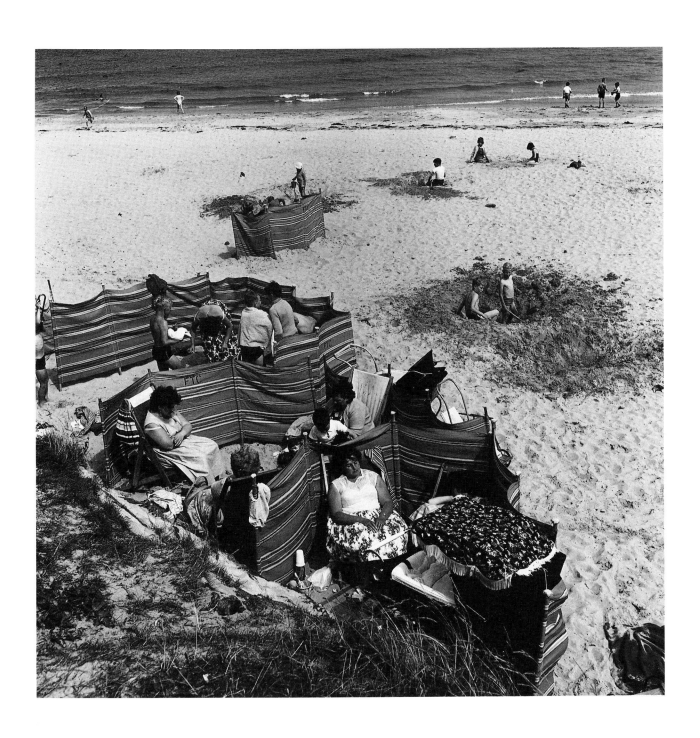

"SANDCASTLES", FRASERBURGH, 1962

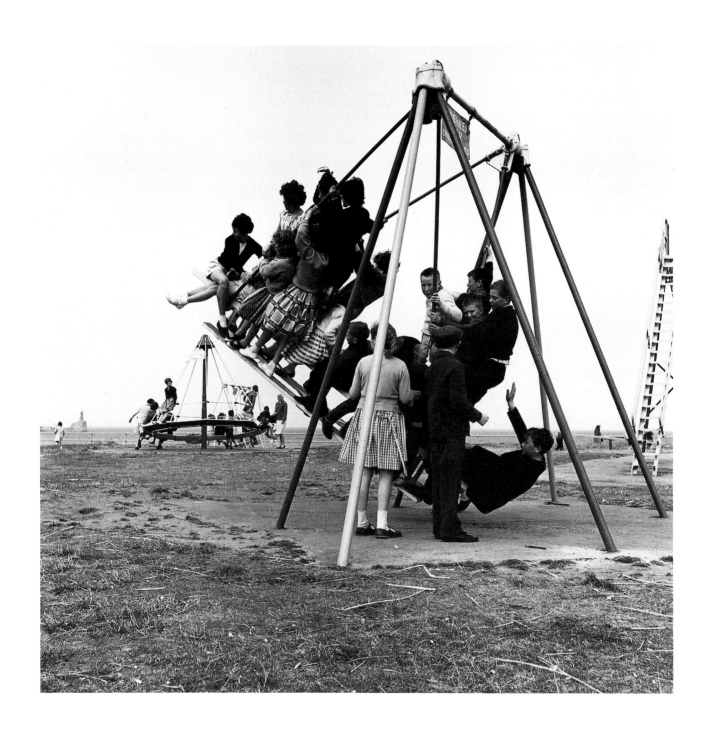

"SWINGS AND ROUNDABOUTS", FRASERBURGH, 1962

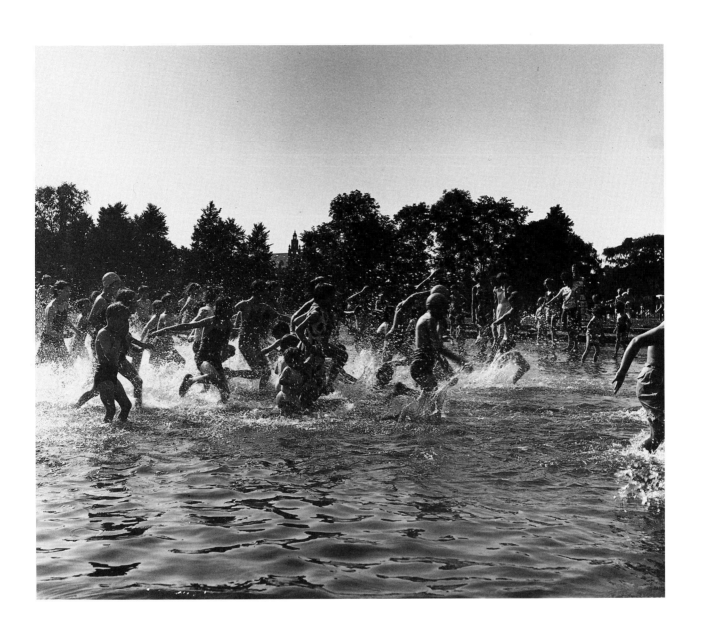

CHILDREN RACING AT KELVINGROVE PADDLING POND, 1963

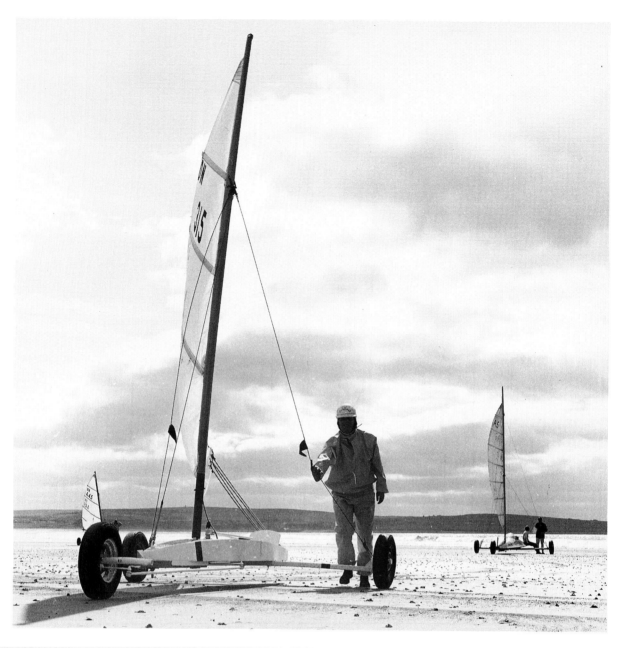

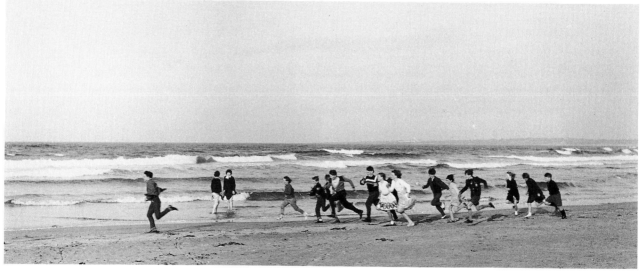

Upper
SAND YACHTING, CAITHNESS, 1972
Lower
CHILDREN RACING ON FRASERBURGH BEACH, 1962

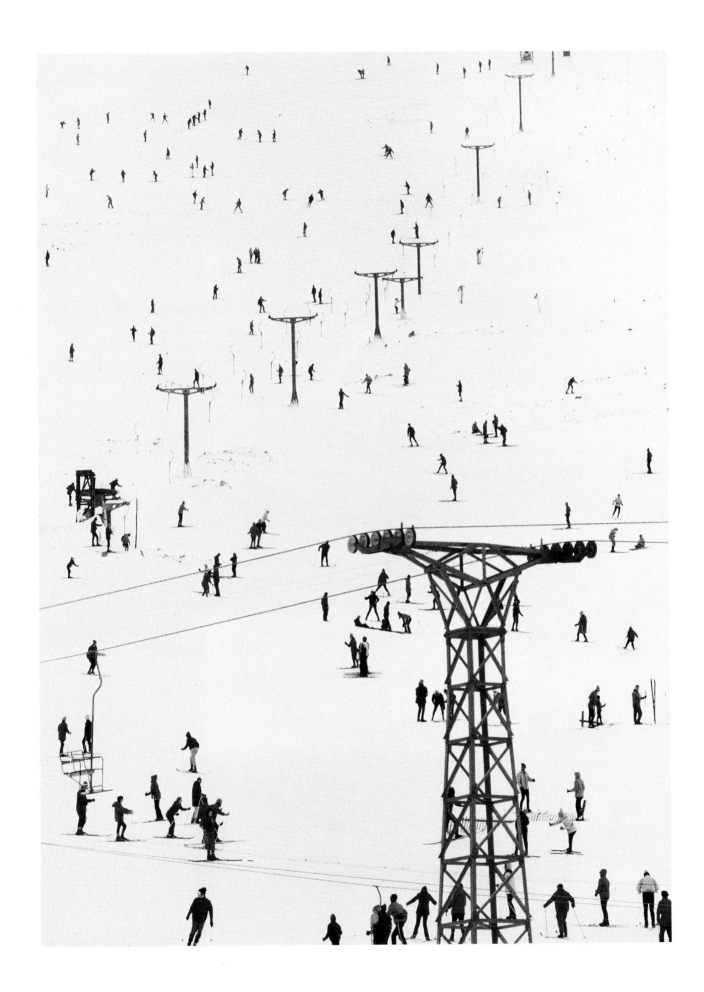

CAIRNGORM SKI SLOPES, AVIEMORE, 1970

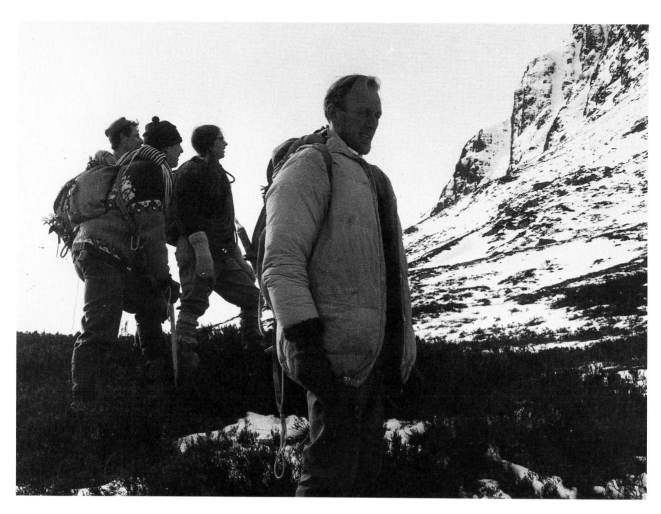

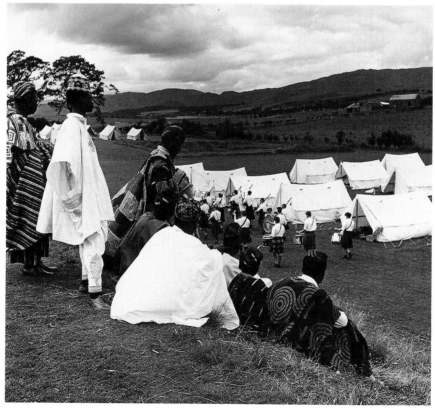

Upper
CLIMBERS ON THE CAIRNGORM, 1971
Lower
AFRICAN GUESTS AT B.B. CAMP, 1963

FINGAL'S CAVE, STAFFA, 1975

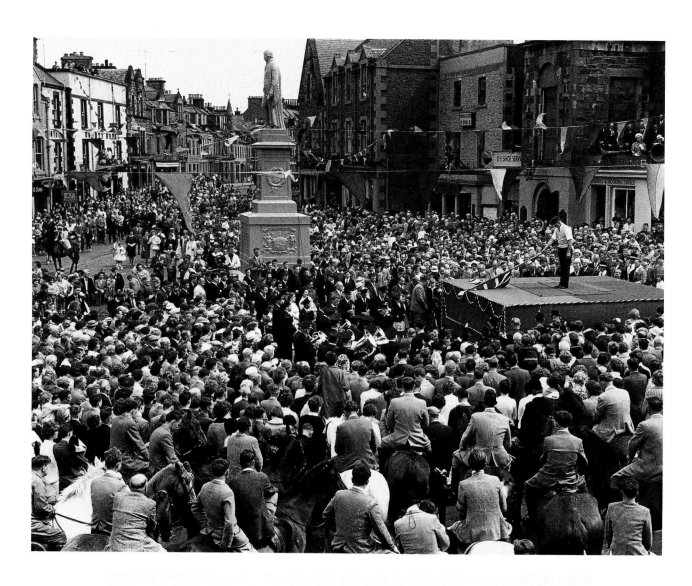

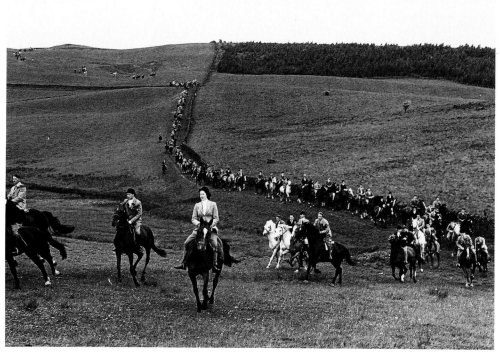

Upper
START OF THE SELKIRK COMMON RIDING, 1963
Lower
THE BRAW LADS AND LASSIES, SELKIRK, 1963

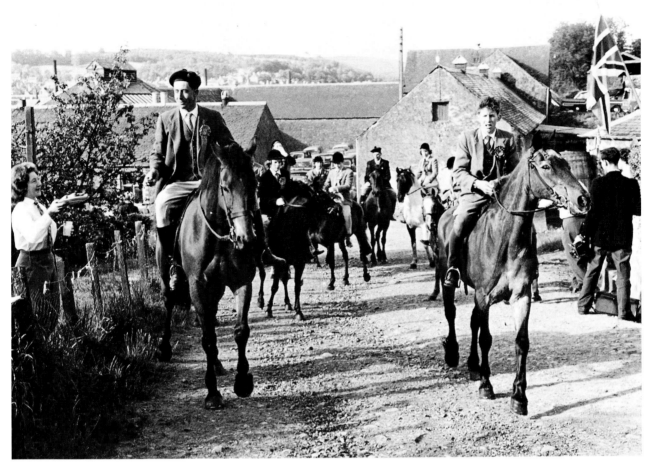

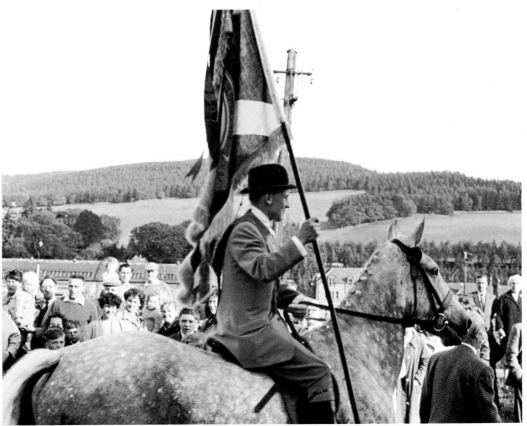

Upper
SHORTBREAD AND WHISKY, SELKIRK, 1963
Lower
STANDARD BEARER, SELKIRK COMMON RIDING, 1963

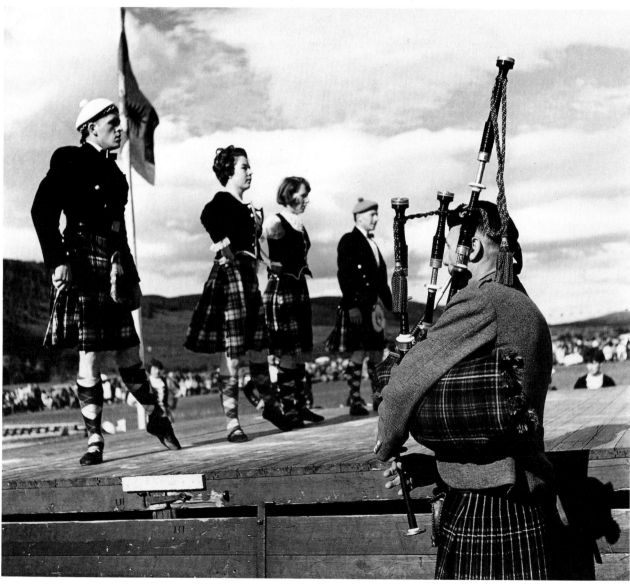

Upper
BRASS BAND, ROYAL HIGHLAND SHOW, INGLISTON, 1962
Lower
HIGHLAND DANCERS, BALLATER HIGHLAND GAMES, 1965

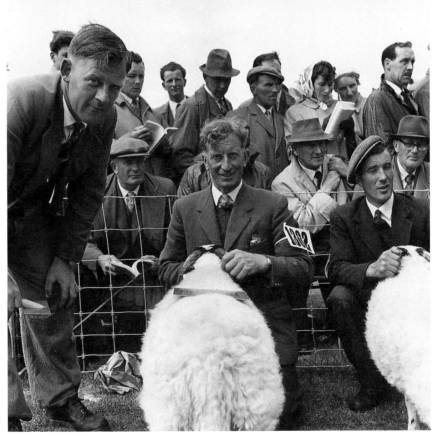

Upper
FARMERS AT THE ROYAL HIGHLAND SHOW, INGLISTON, 1962
Lower
JUDGING OF SHEEP, ROYAL HIGHLAND SHOW, INGLISTON, 1962

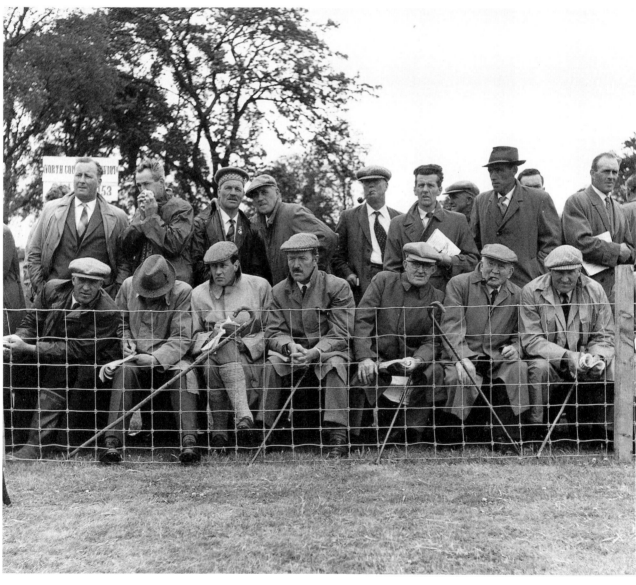

Upper
"TOSSING THE CABER", HIGHLAND GAMES, INVERNESS, 1965
Lower
SHEEP JUDGING, THE ROYAL HIGHLAND SHOW, INGLISTON, 1962

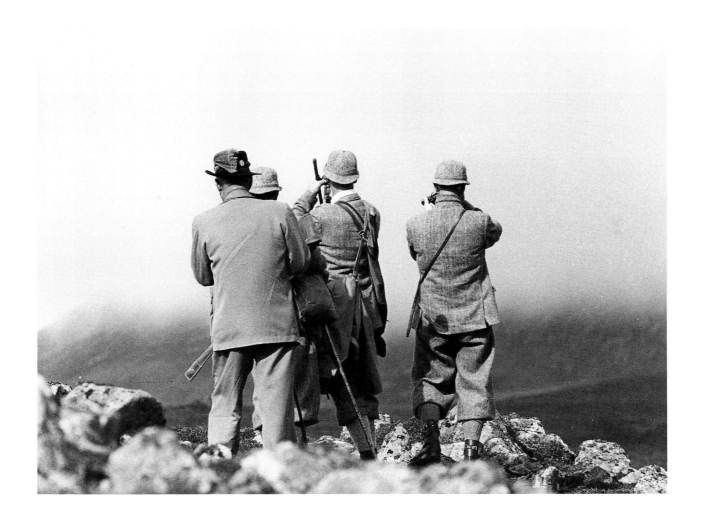

BEYOND THE GRAMPIANS, 1967

SCOTLAND'S
FAMILY

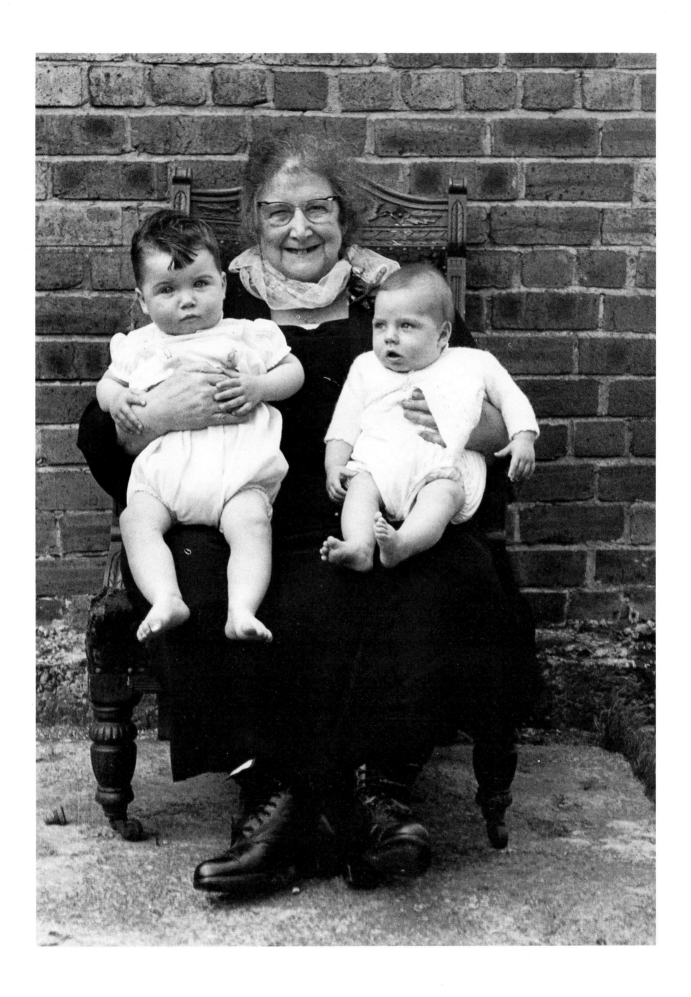

BELLA, GAVIN AND RICHARD, BAILLIESTON, 1961

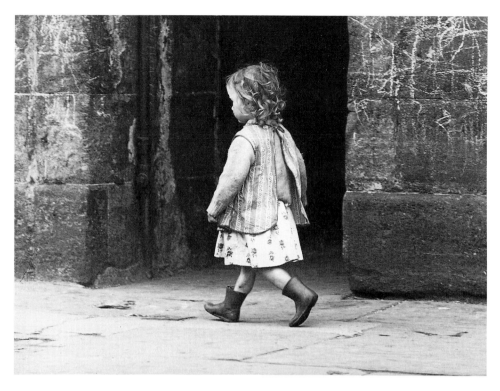

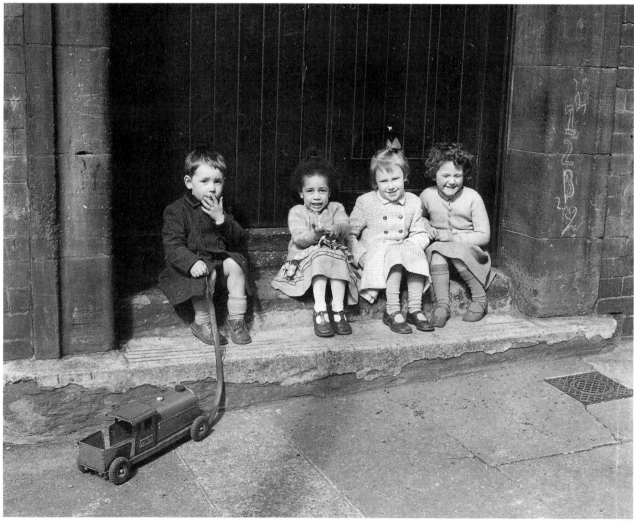

Upper
THE GOLDEN HAIRED LASS, GORBALS, 1964
Lower
CHILDREN, MARYHILL, GLASGOW, 1960

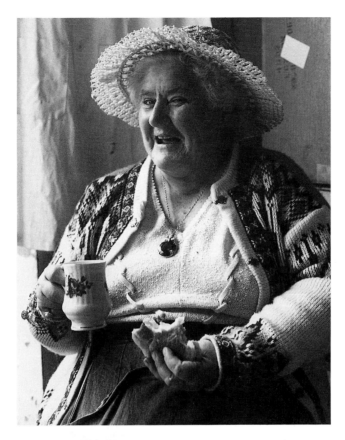

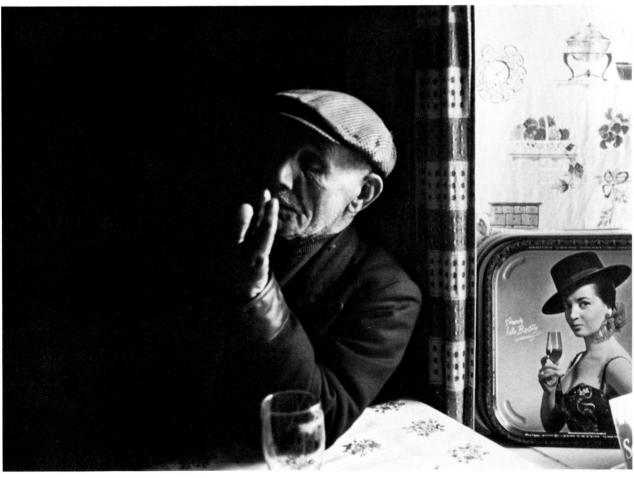

Upper
TEA BREAK, PADDY'S MARKET, GLASGOW, 1985
Lower
"ONE FOR THE ROAD", VATERNISH, SKYE, 1971

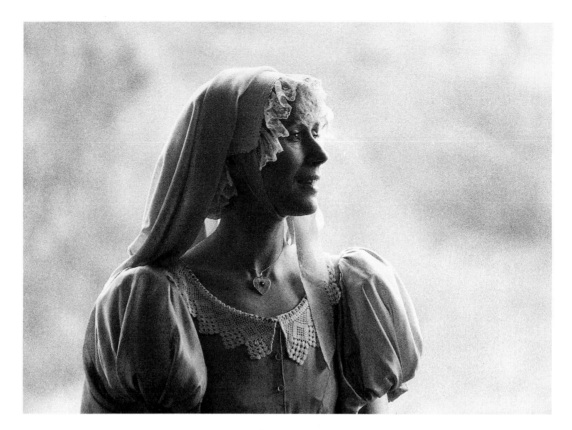

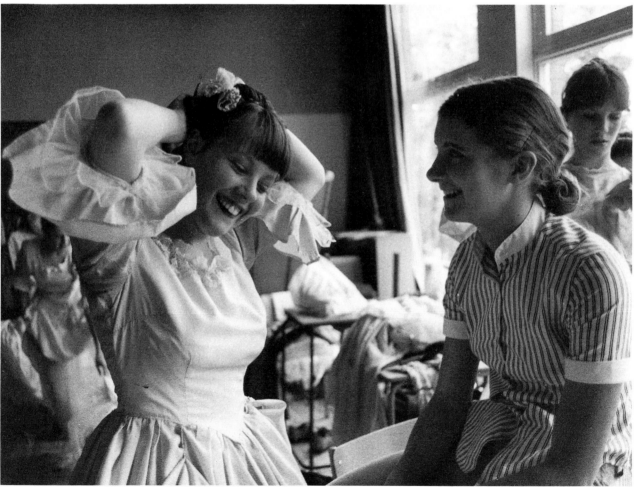

Upper
ANNE LORNE GILLIES SINGS, EDINBURGH FESTIVAL, 1985
Lower
REHEARSALS, SCOTTISH STUDIO BALLET PRODUCTION, 1975

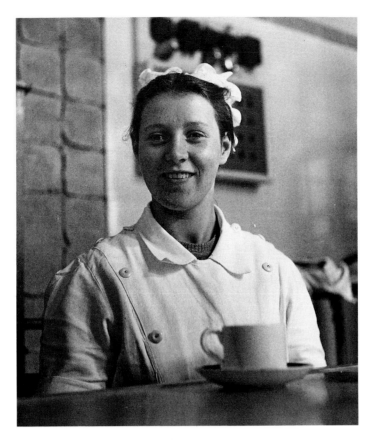

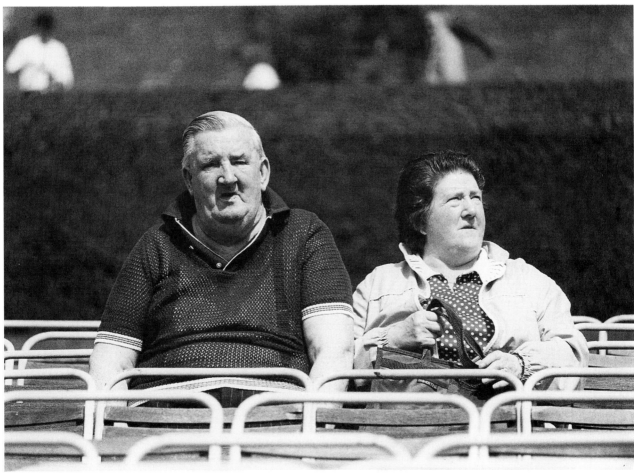

Upper
NURSE AT GRAMPIAN SANITARIUM, KINGUSSIE, 1955
Lower
PRINCES STREET GARDENS, EDINBURGH, 1985

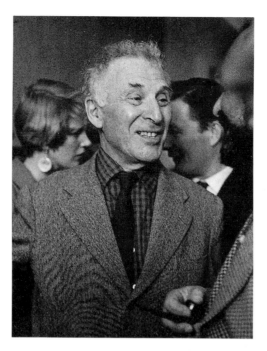

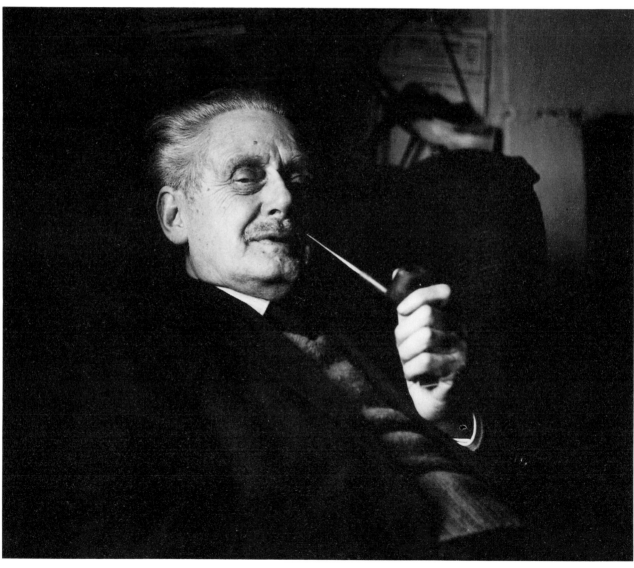

Upper
MARC CHAGAL, EDINBURGH, 1959
Lower
HUGH McDIARMID AT HOME, BIGGAR, 1966

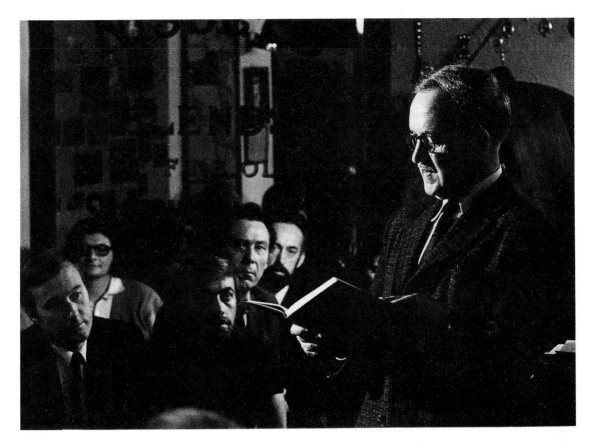

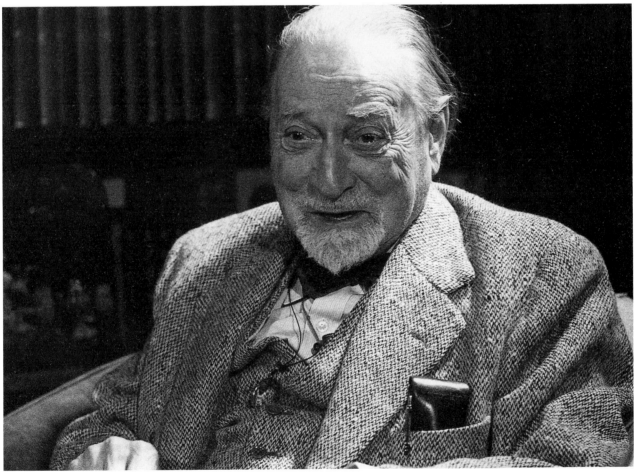

Upper
SORLEY MacLEAN THE POET IN EDINBURGH, 1974
Lower
SIR COMPTON MACKENZIE AT HOME, 85th BIRTHDAY, 1968

141

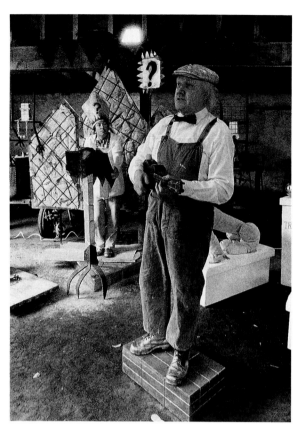

Upper
BILL PATTERSON AND GEORGE WYLIE, EDINBURGH FESTIVAL,
A DAY DOWN A GOLD MINE, 1985
Lower
BILL GIBB AND MODEL KAREN, EDINBURGH FESTIVAL, 1985

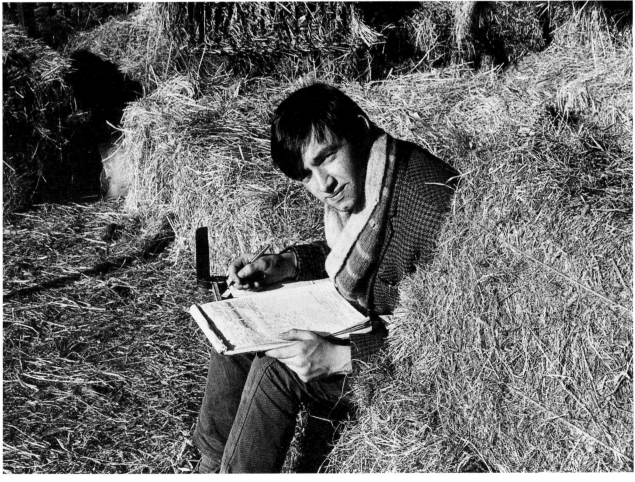

Upper
ANDREW CRUIKSHANK AS DR CAMERON, FILMING "DR FINDLAY'S CASEBOOK",
NEAR CALLANDER, 1969
Lower
BILL FORSYTH DURING FILMING *FLASH THE SHEEPDOG*, 1966

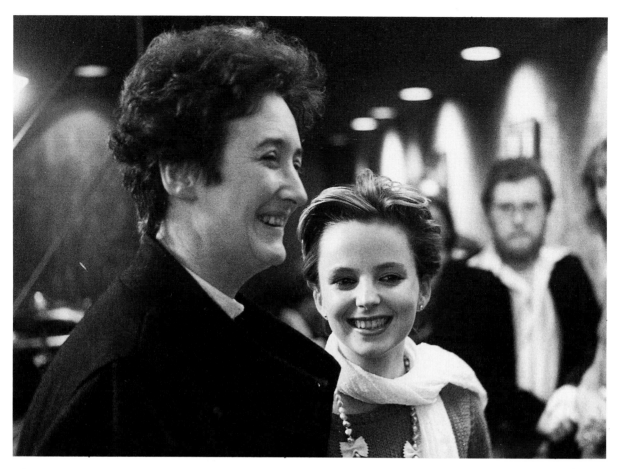

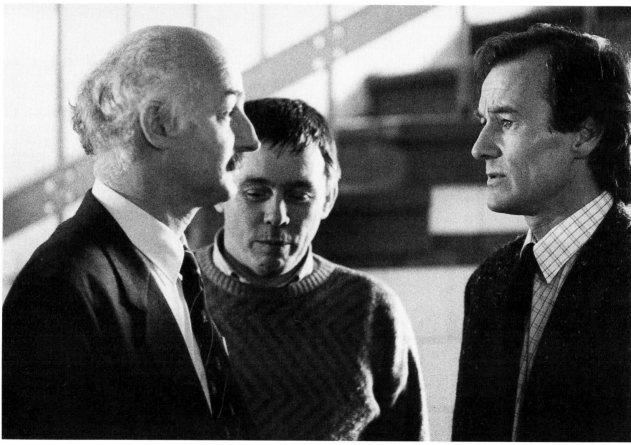

Upper
PADDY HIGSON, PRODUCER, AND CLARE GROGAN DURING
THE FILMING OF *LIVING APART TOGETHER*, 1982
Lower
DAVID ANDERSON, CHARLIE GORMLEY, DAVID HAYMAN,
DURING THE FILMING OF *HEAVENLY PURSUITS*, 1985

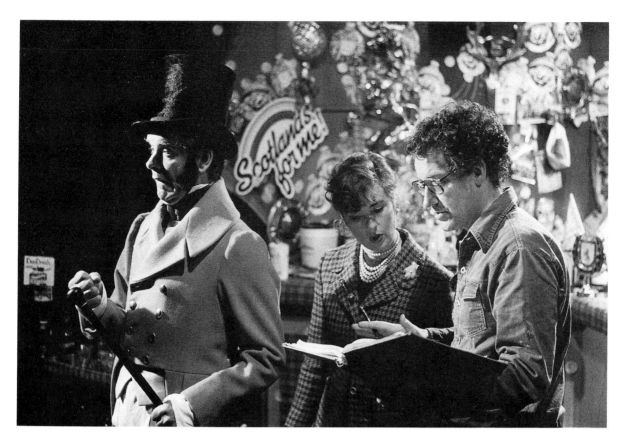

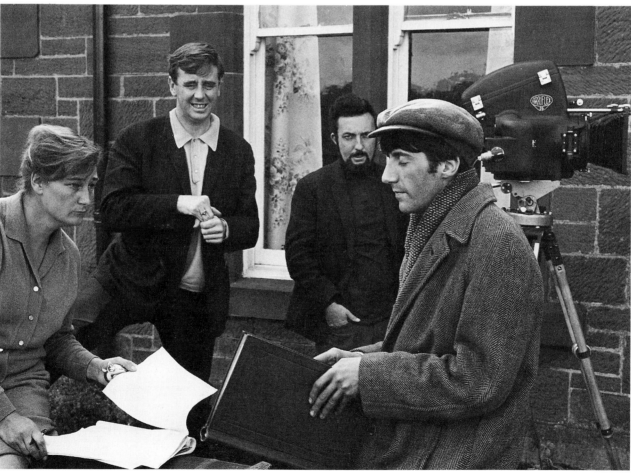

Upper
WALTER CARR IN *SCOTCH MISTS*, MURRAY GRIGOR DIRECTING, 1982
Lower
TOM CONTI AND FILM CREW NEAR DOUGLAS WEST, 1968

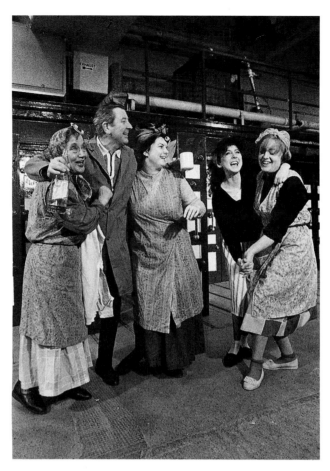

Upper
WILDCAT REHEARSALS OF *THE STEAMIE* AT GOVAN STEAMIE, 1984
Lower
ANE SATIRE OF THE THRIE ESTATES, ASSEMBLY HALLS,
EDINBURGH FESTIVAL, 1985

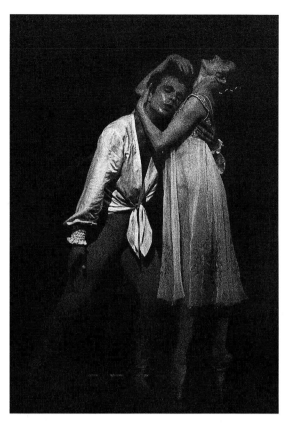

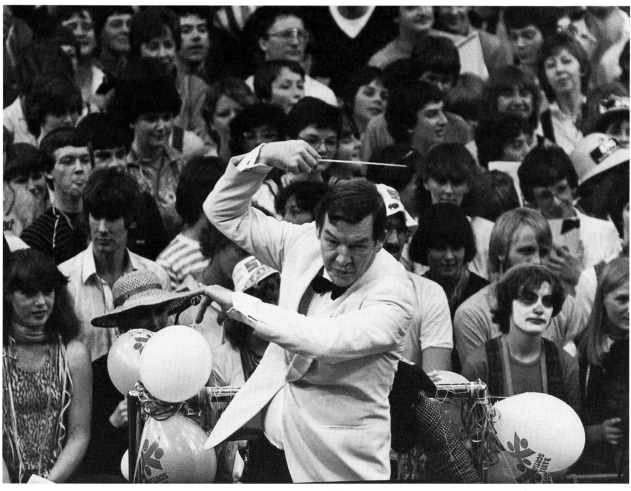

Upper
SCOTTISH BALLET, *ROMEO AND JULIET*, 1982
Lower
LAST NIGHT OF THE PROMS, SIR ALEC GIBSON, 1982

147

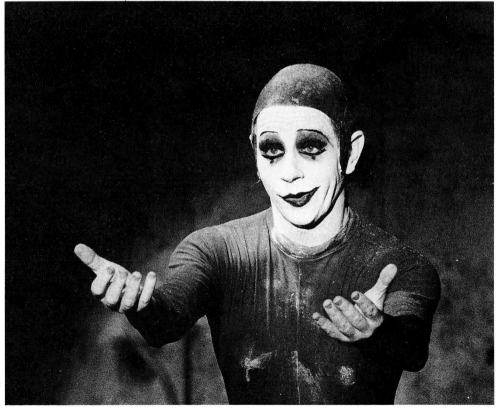

Upper
LINDSEY KEMP, MIME ARTIST, EDINBURGH FESTIVAL, 1972
Lower
"LINDSEY PLEADING", LINDSEY KEMP, EDINBURGH FESTIVAL, 1972

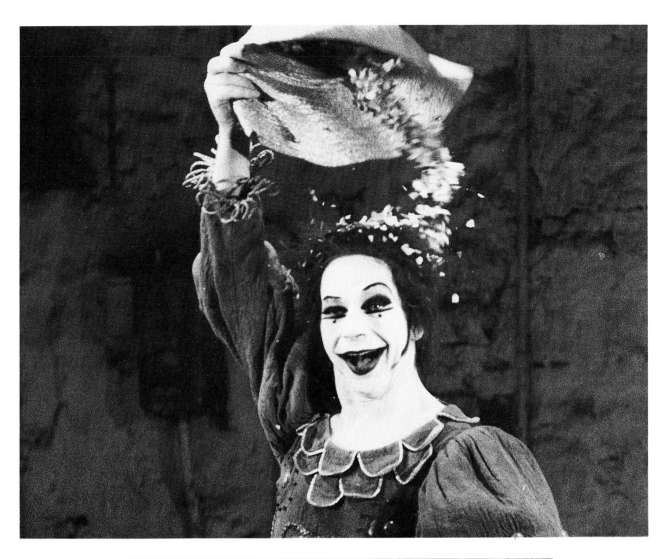

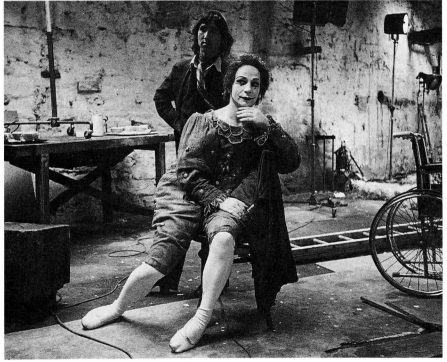

Upper
"LINDSEY WITH HAT", LINDSEY KEMP, EDINBURGH FESTIVAL, 1972
Lower
CELESTINO CORONADO AND LINDSEY KEMP, EDINBURGH, 1972

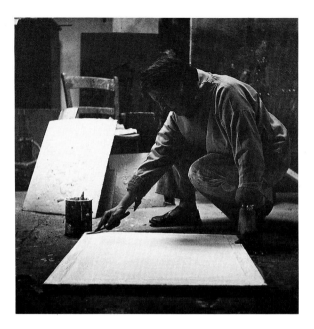

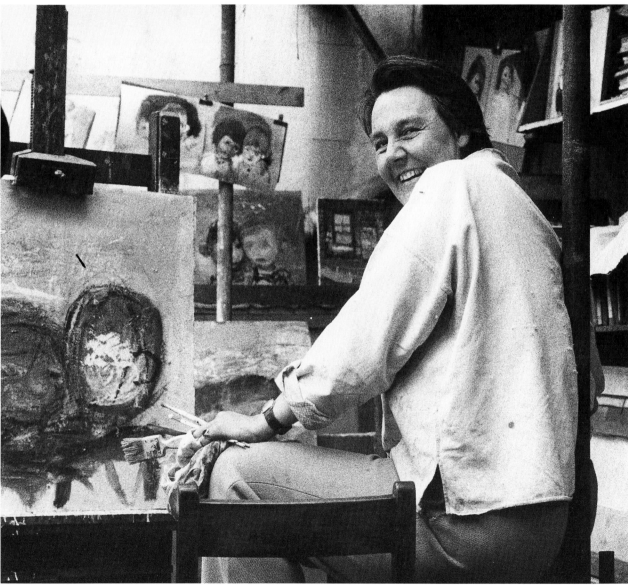

Upper
JOAN EARDLEY, INTERIOR TOWNHEAD STUDIO, 1962
Lower
JOAN IN HER TOWNHEAD STUDIO, 1962

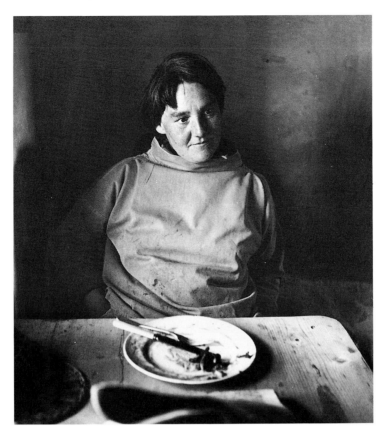

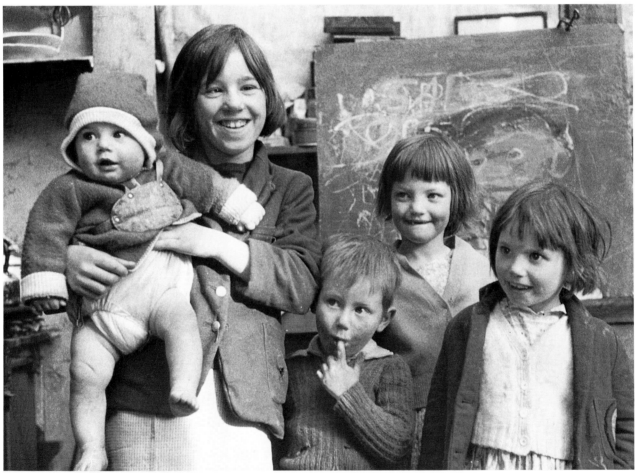

Upper
JOAN IN HER CATTERLINE STUDIO, May 1963
Lower
"THE SAMSON KIDS", IN JOAN EARDLEY'S TOWNHEAD STUDIO, 1962

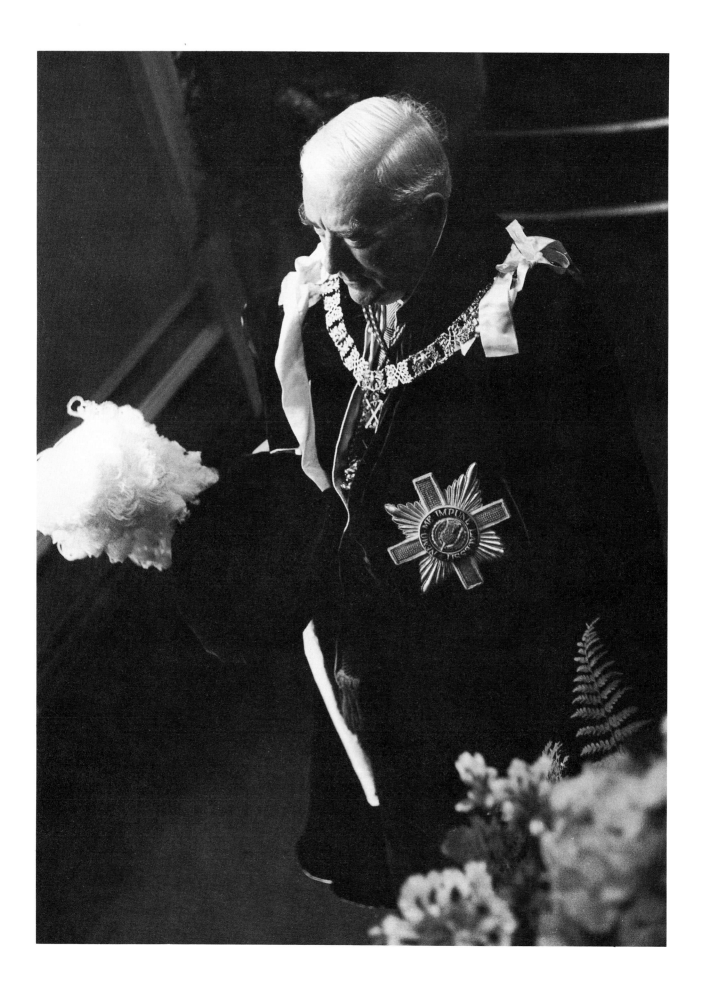

SIR ROBERT MENZIES, GRAND ORDER OF THE THISTLE, EDINBURGH, 1963

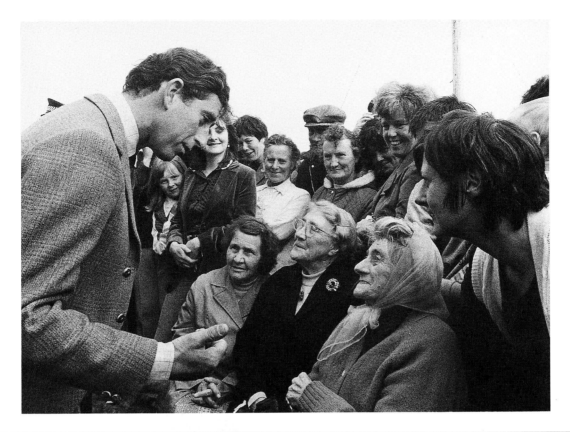

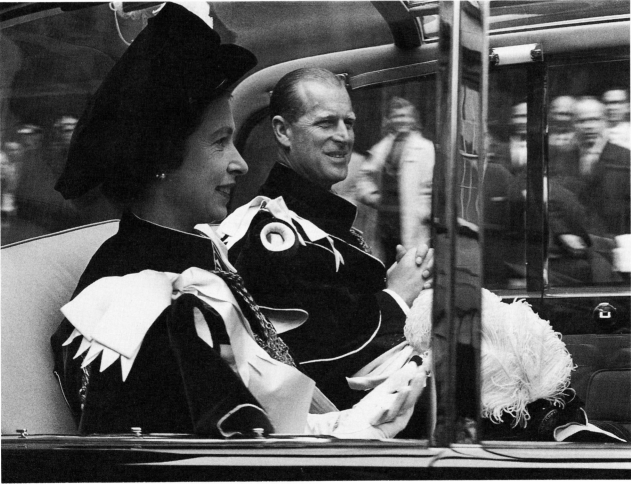

Upper
PRINCE CHARLES' VISIT TO SHAWBOST, LEWIS, July 1979
Lower
THE QUEEN AND PRINCE PHILIP, GRAND ORDER OF
THE THISTLE, EDINBURGH, 1967

ALL THE
WORLD'S A
VILLAGE

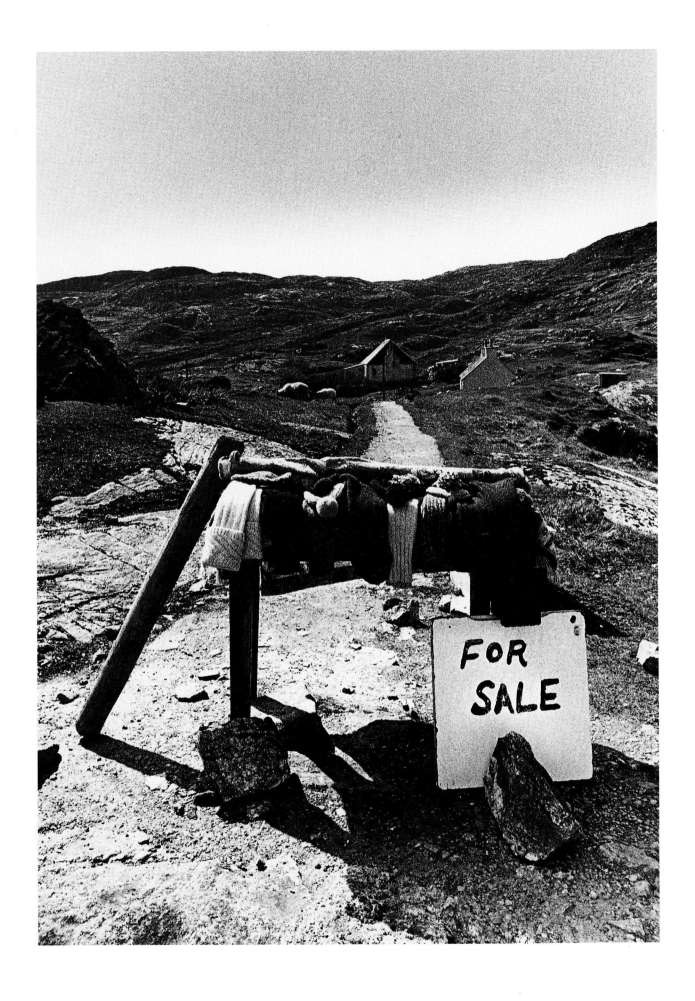

"THE GOLDEN ROAD", HARRIS, 1979

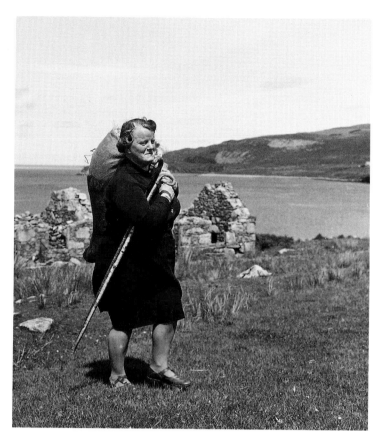

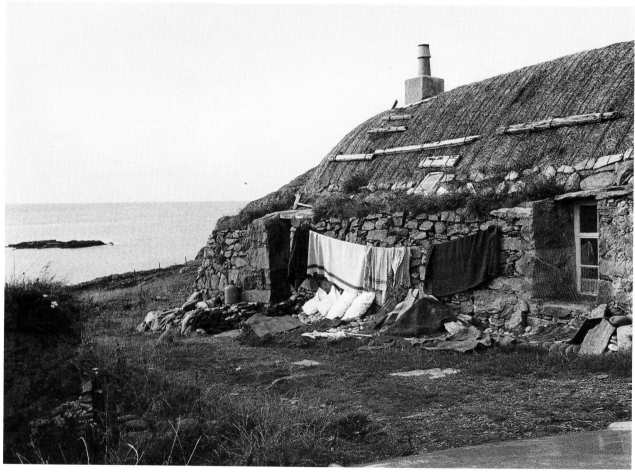

Upper
WOMAN GATHERING WOOL, ISLE OF SKYE, 1972
Lower
BLACK HOUSE, GARENIN, CARLOWAY, ISLE OF LEWIS, 1973

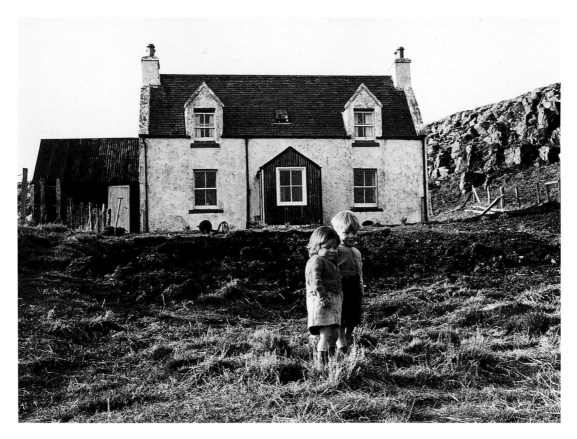

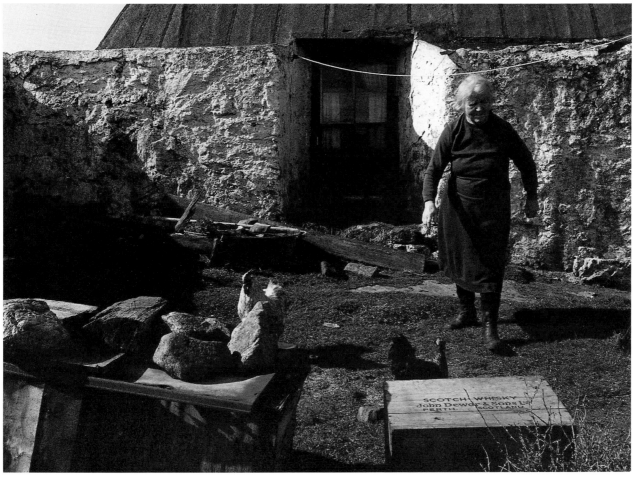

Upper
CHILDREN AT CROFT, VATERNISH, ISLE OF SKYE, 1967
Lower
WOMAN AT SCARINISH, 1970

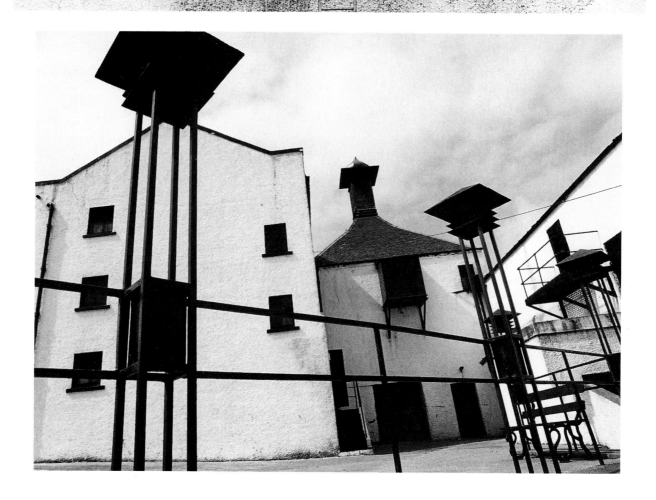

Upper
BOWMORE DISTILLERY, ISE OF ISLAY, 1984
Lower
BOWMORE DISTILLERY, ISLE OF ISLAY, 1984

HUGH MILLAR'S COTTAGE, CROMARTY, 1980

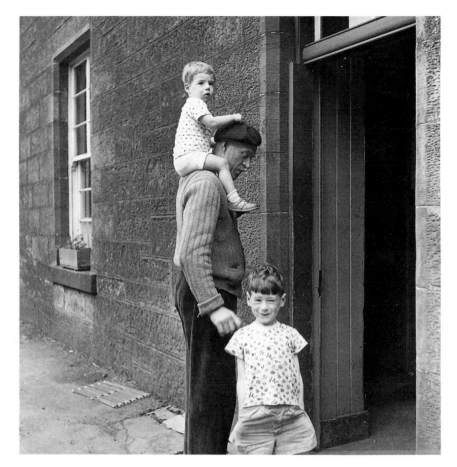

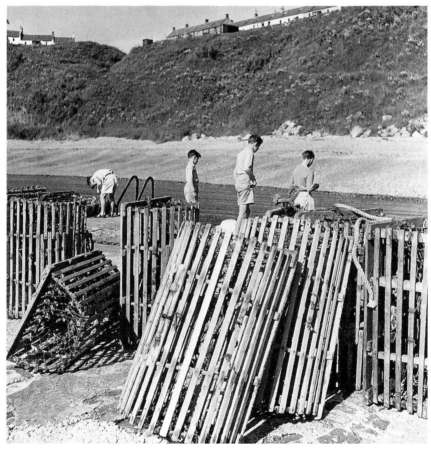

Upper
"GUVNOR" AND CHILDREN, BALFRON, 1958
Lower
"LOBSTER CREELS", CATTERLINE, 1958

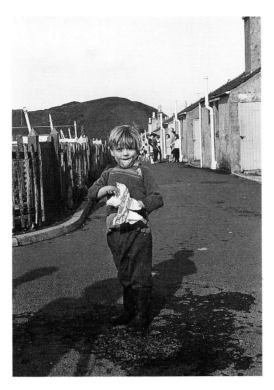

Upper
BOY AT DOUGLAS WEST, 1968
Lower
"LAMB", STAFFIN, SKYE, 1969

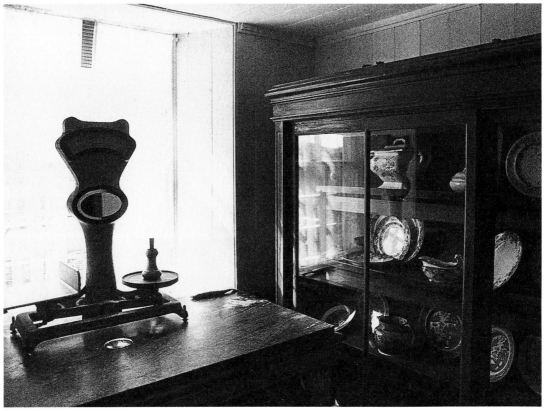

Upper
RODEL HOTEL INTERIOR, ISLE OF HARRIS, 1979
Lower
BULLOCK HOUSE, ISLE OF RHUM, 1971

Upper
DERELICT BLACK HOUSE, GARENIN, 1979
Lower
RODEL HOTEL INTERIOR, ISLE OF HARRIS, 1978

165

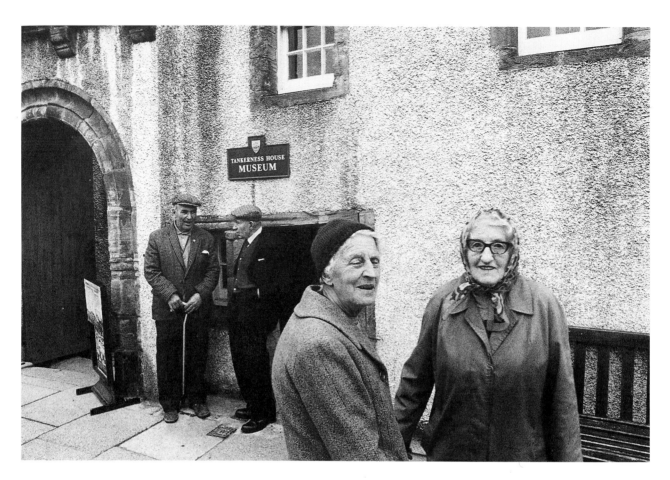

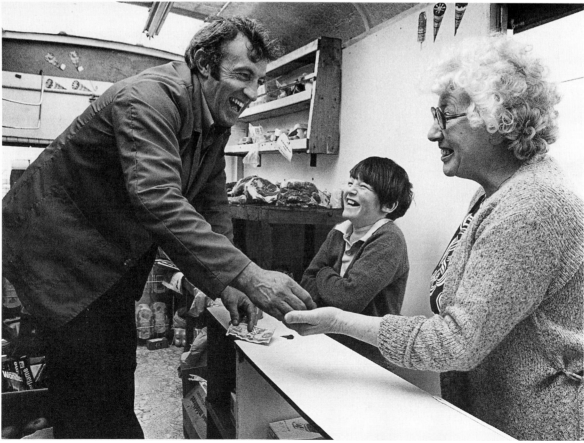

Upper
TANKERNESS HOUSE MUSEUM, ORKNEY, 1979
Lower
TRAVELLING SHOP NEAR KERSHADER PARK, ISLE OF LEWIS, 1980

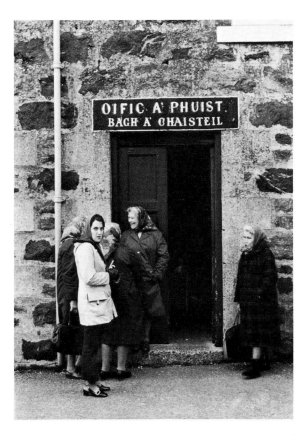

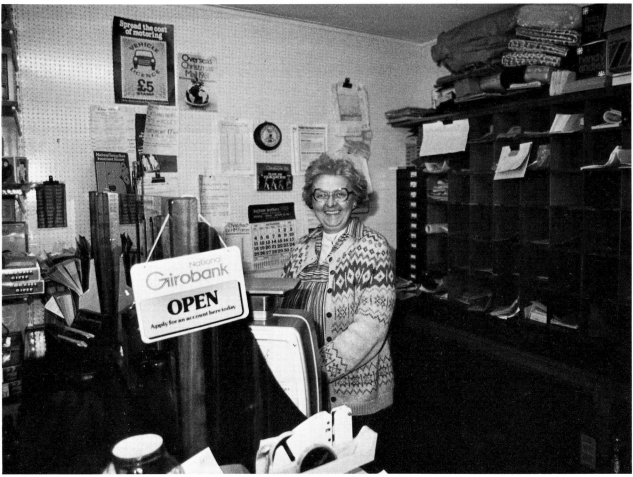

Upper
HEBRIDEAN POST OFFICE, 1971
Lower
MUIR'S MINI MARKET, HILLWICK, SHETLAND, 1981

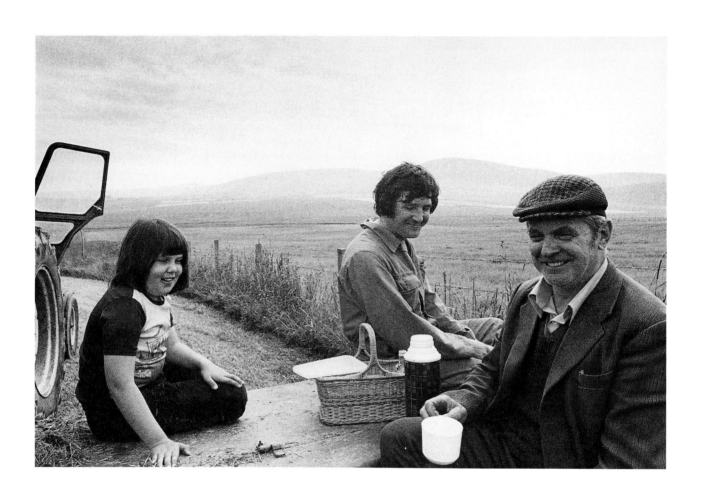

FARM WORKERS' TEA BREAK, ORKNEY, 1979

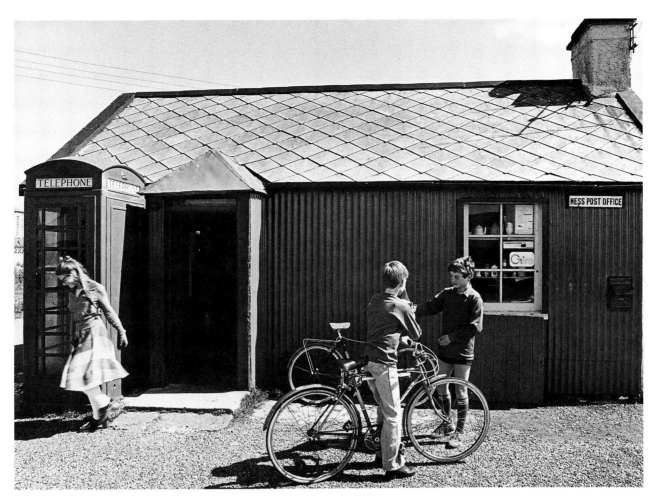

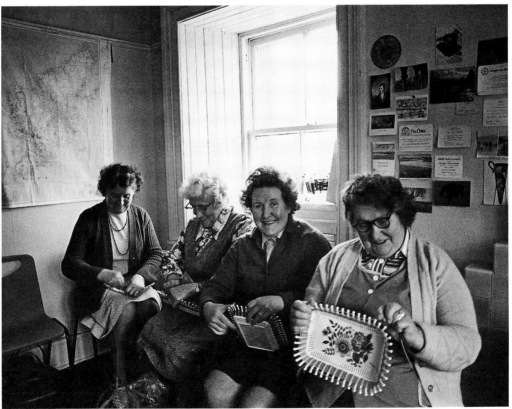

Upper
POST OFFICE, PORT OF NESS, 1980
Lower
COMMUNITY CO-OP, PORT OF NESS, LEWIS, 1980

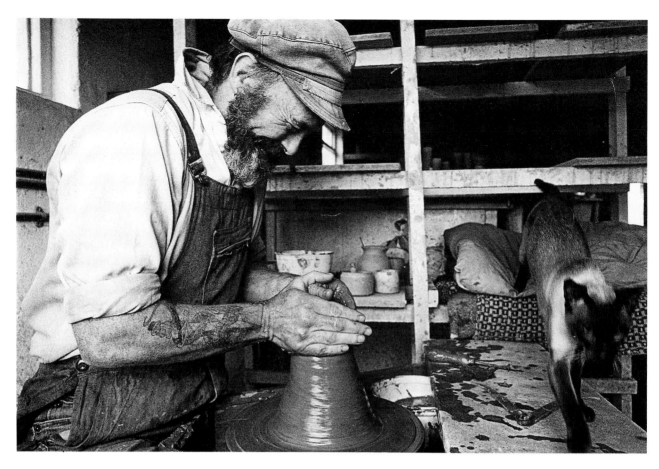

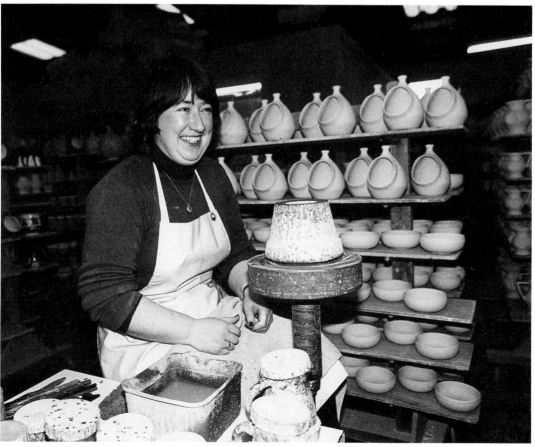

Upper
ED THOMSON, POTTER, RODEL, HARRIS, 1979
Lower
KINGUSSIE POTTER, 1982

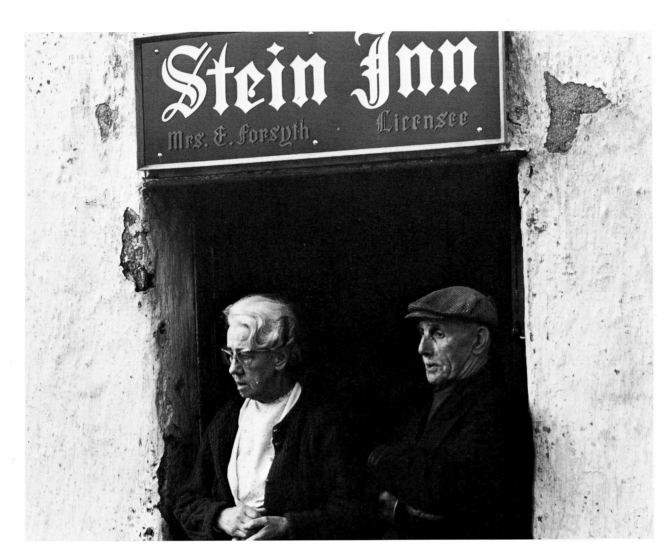

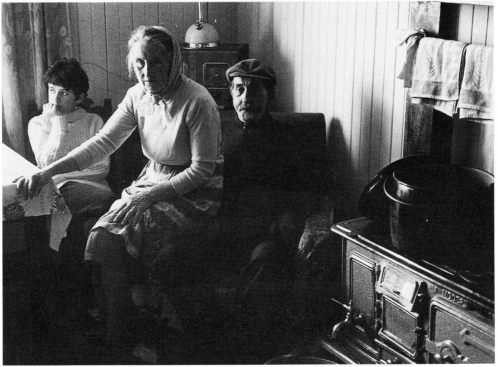

Upper
THE STEIN INN, VATERNISH, ISLE OF SKYE, 1971
Lower
FAMILY, BARRA, 1971

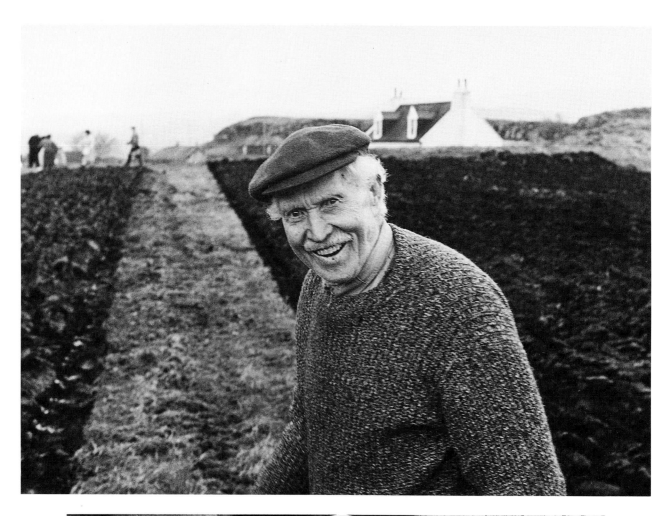

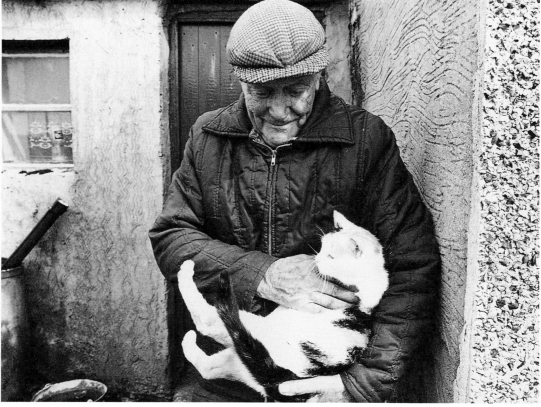

Upper
CROFTER AT THE POTATO DRILLS, VATERNISH, ISLE OF SKYE, 1967
Lower
SURVIVOR H.M. YACHT *IOLAIRE* WHICH SANK IN STORNOWAY HARBOUR ON
FIRST OF JANUARY 1919, NESS, ISLE OF LEWIS, 1979

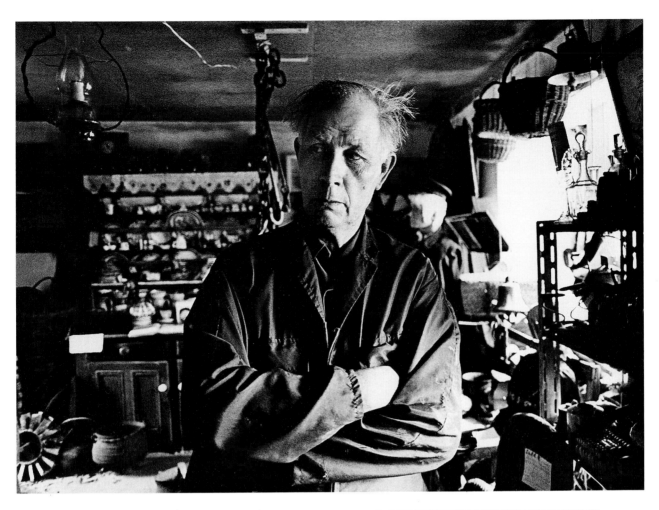

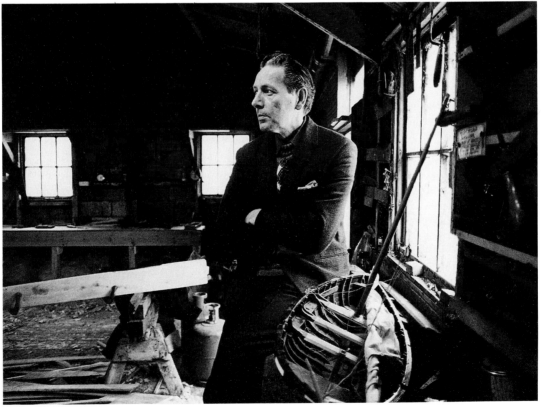

Upper
ANGUS MacLEOD, CALBOST MUSEUM, LEWIS, 1979
Lower
BOATBUILDER, PORT OF NESS, LEWIS, 1979

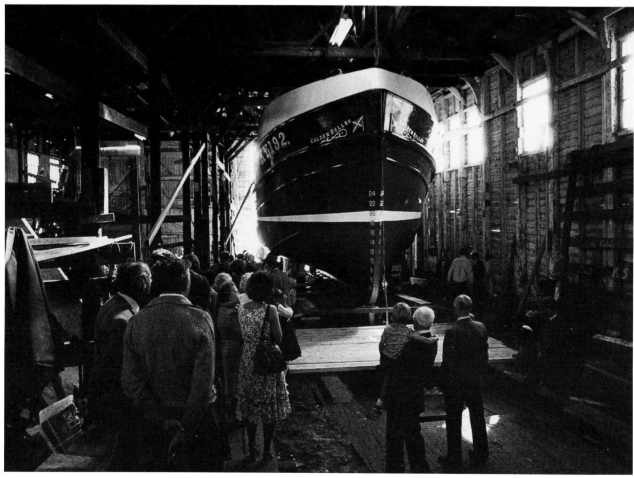

Upper
KAY MONTADOR, SEA QUEEN DAY, ST MONANS, FIFE, 1981
Lower
LAUNCHING OF FISHING VESSEL, MILLARS YARD, ST MONANS, 1981

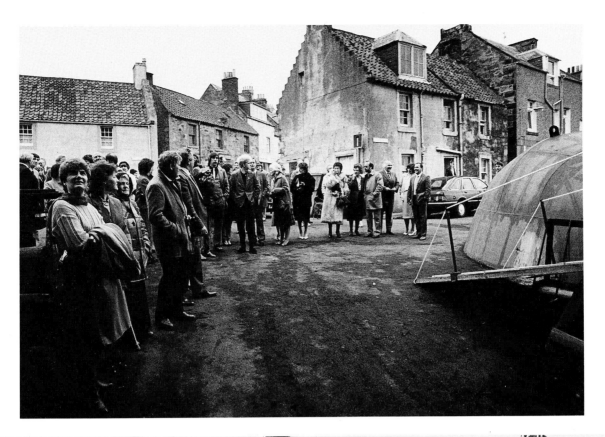

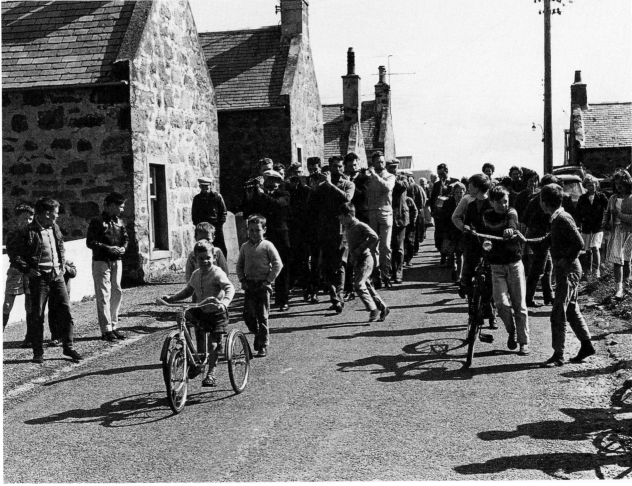

Upper
BOAT LAUNCH, MILLARS YARD, ST MONANS, FIFE, 1986
Lower
INVERLOCHY PIPE BAND, 1963

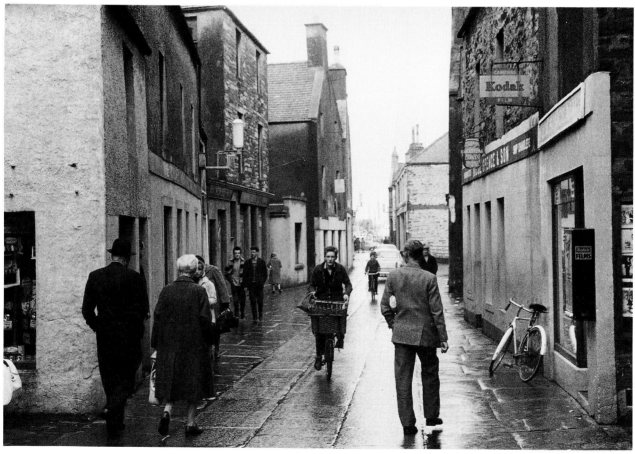

Upper
PITTENWEEM VILLAGE, 1980
Lower
KIRKWALL, ORKNEY, 1971

Upper
MAIN STREET, STORNOWAY, ISLE OF LEWIS, 1971
Lower
GEORGE MacKAY BROWN, ORKNEY, 1979

Upper
BANDSTAND IN THE NORTH
Lower
BANDSTAND, DUNDEE, 1959

178

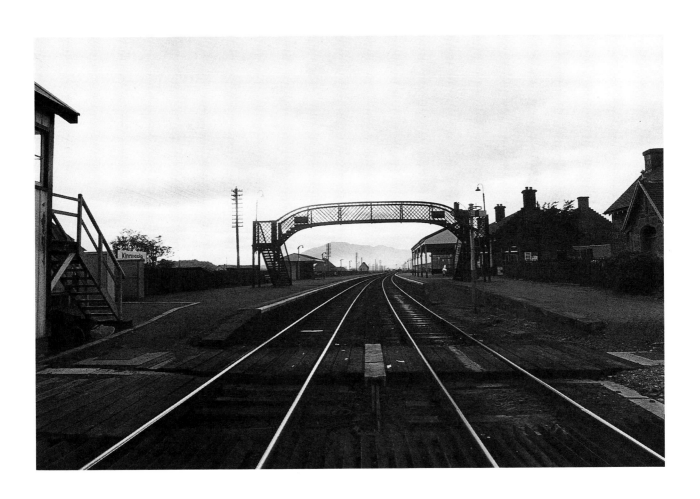

RAIL TRACK AT KINGUSSIE STATION, October 1980

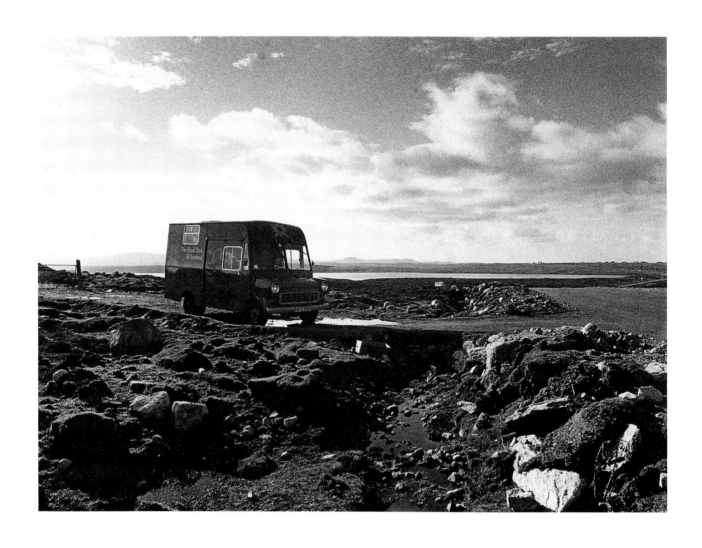

MOBILE BANK, BALLANTRUSHAL, LEWIS, October 1978

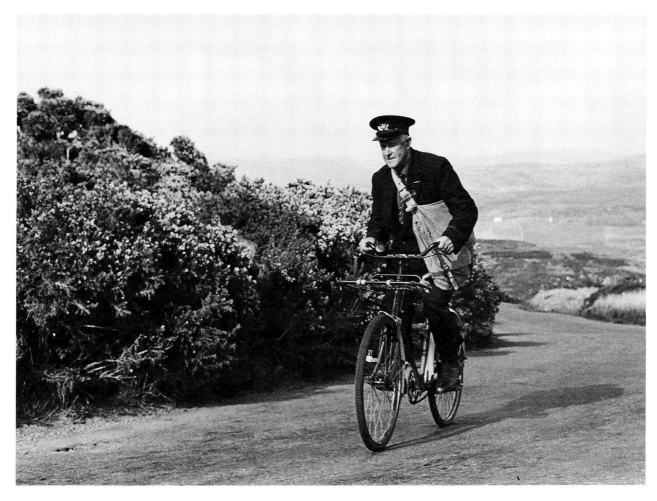

Upper
POSTMAN, VATERNISH, SKYE, 1971
Lower
ED THOMSON, POTTER, RODEL, ISLE OF HARRIS, 1971

"BOB FELL HERE", ISLE OF LEWIS, 1979

ST CLEMENTS CHURCH, RODEL, HARRIS, 1979

Upper
BEAULY PRIORY, 1983
Lower
ST CLEMENTS CHURCH, RODEL, HARRIS, 1979

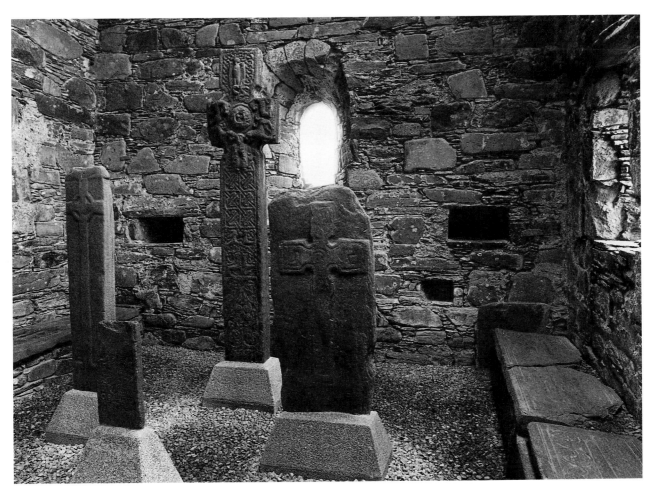

Upper
CARVED STONES, KEILLMORE CHAPEL, ARGYLL, 1984
Lower
GRAVESTONE, KILCHOMAN, ISLAY, 1984

185

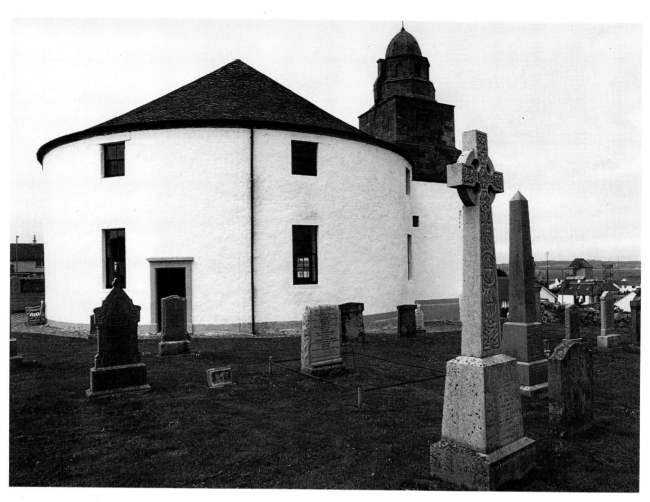

Upper
ROUND CHURCH, BOWMORE, ISLAY, 1984
Lower
KILMORICH CHURCH, BONAR SAND, 1984

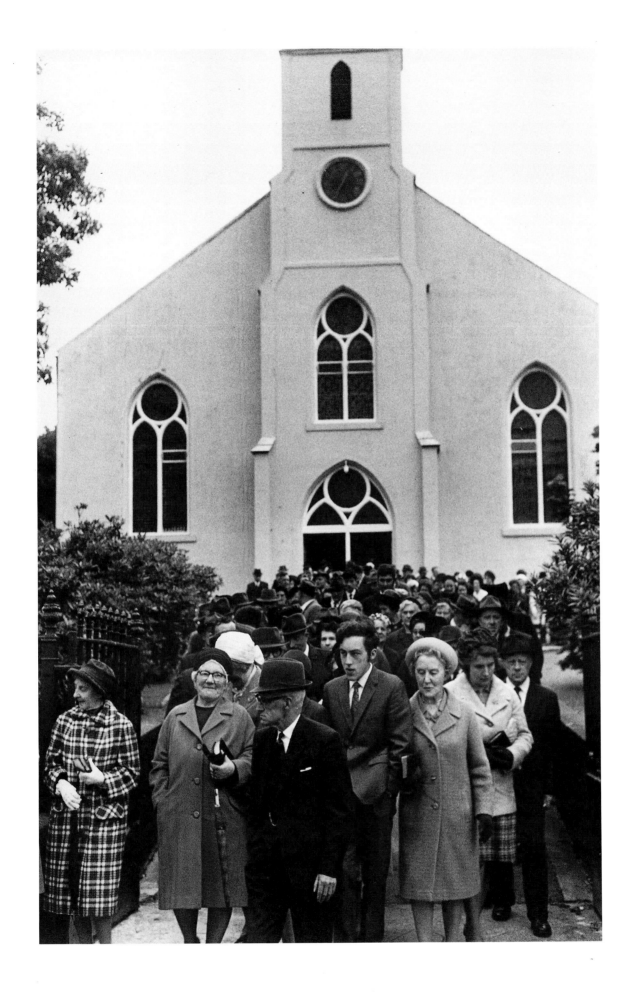

CHURCH CONGREGATION, STORNOWAY, ISLE OF LEWIS, 1973

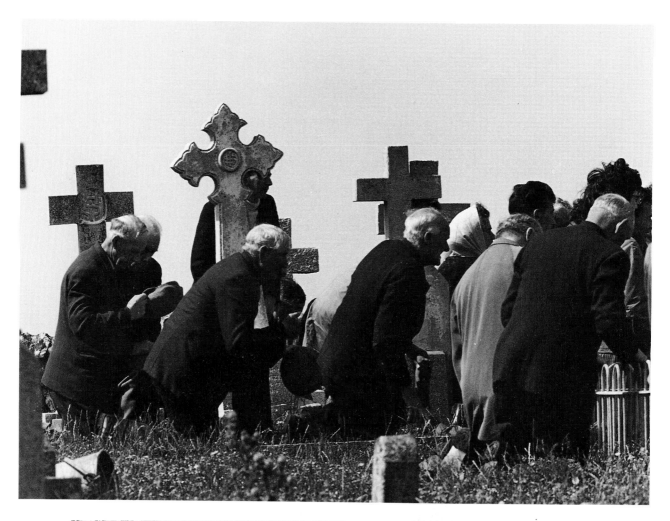

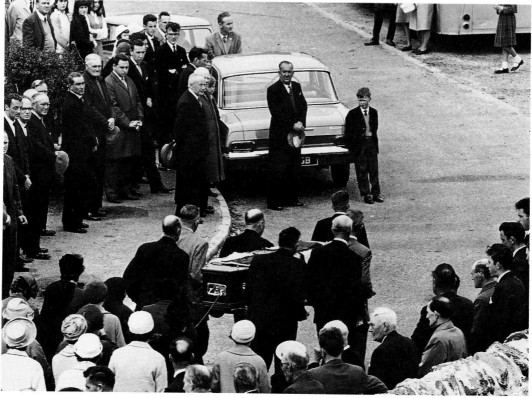

Upper
AT THE GRAVESIDE, FUNERAL, ISLE OF BARRA, 1964
Lower
FUNERAL PROCESSION, ISLE OF BARRA, 1964

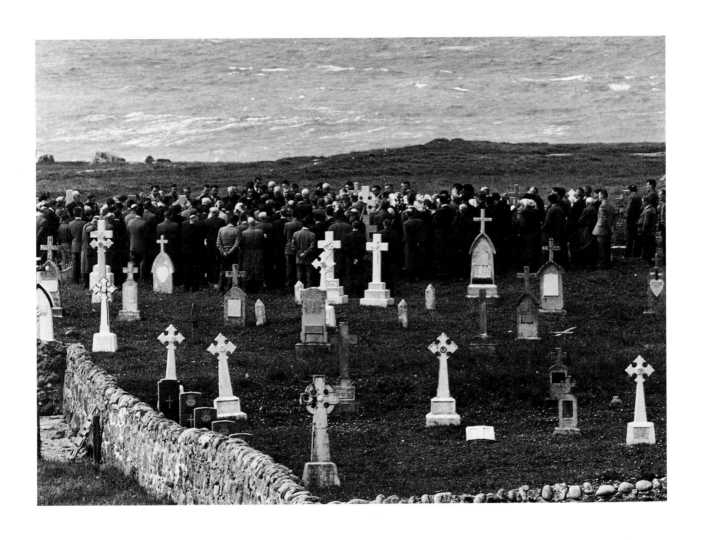

LAST RESPECTS, ISLE OF BARRA, 1964

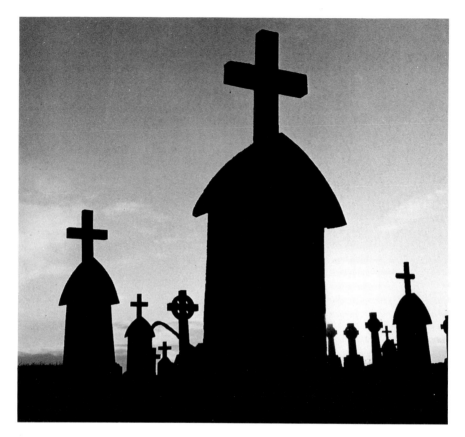

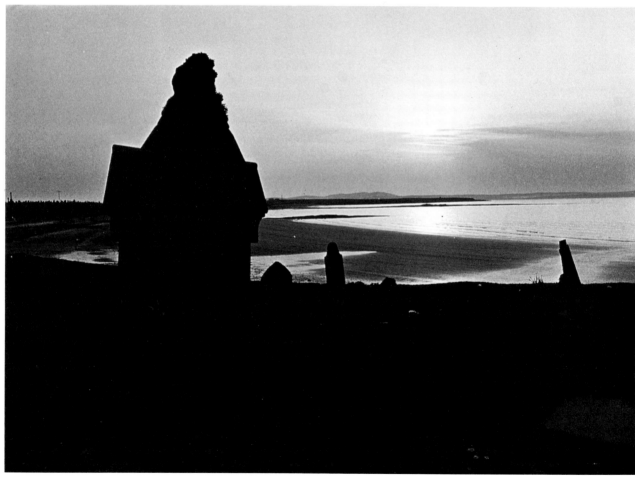

Upper
OLD CEMETERY, STORNOWAY, 1979
Lower
CEMETERY, BREIGH, LEWIS, 1979

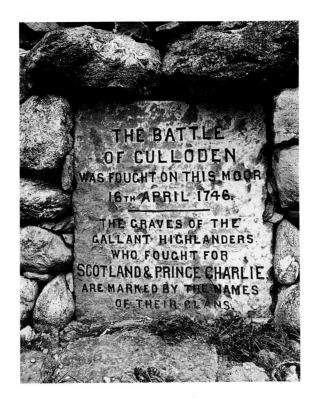

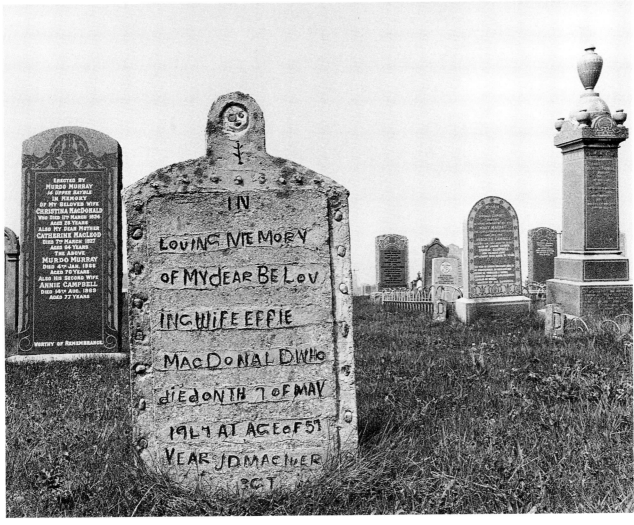

Upper
THE PRINCES STONE TO THE DEAD OF CULLODEN, 1981
Lower
CEMETERY, BREIGH, ISLE OF LEWIS

EDINBURGH

GLASGOW

*The Cities
And Their People*

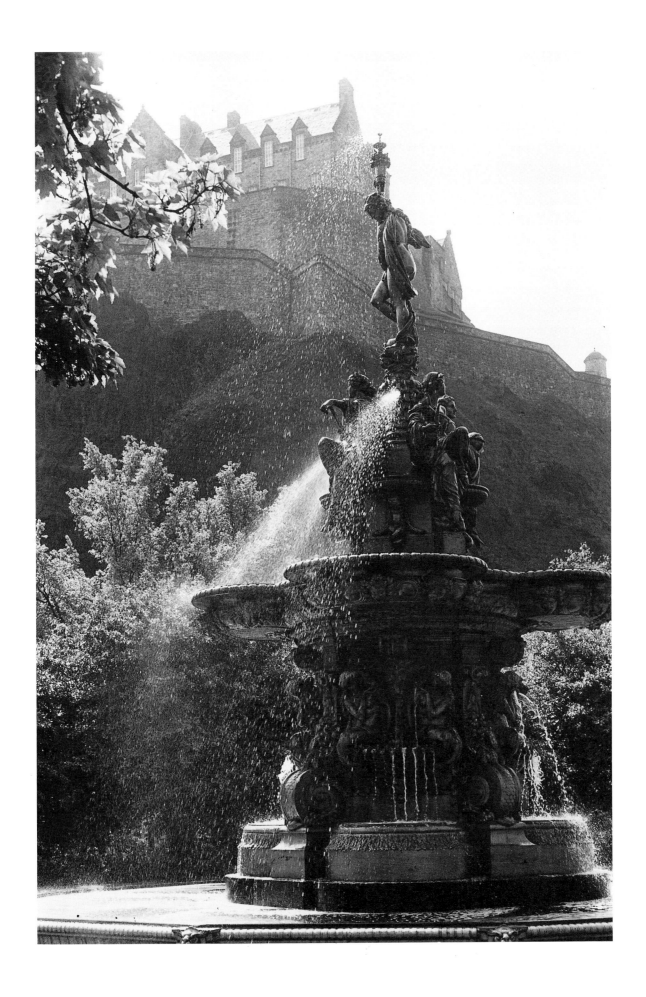

PRINCES STREET GARDENS, 1985

195

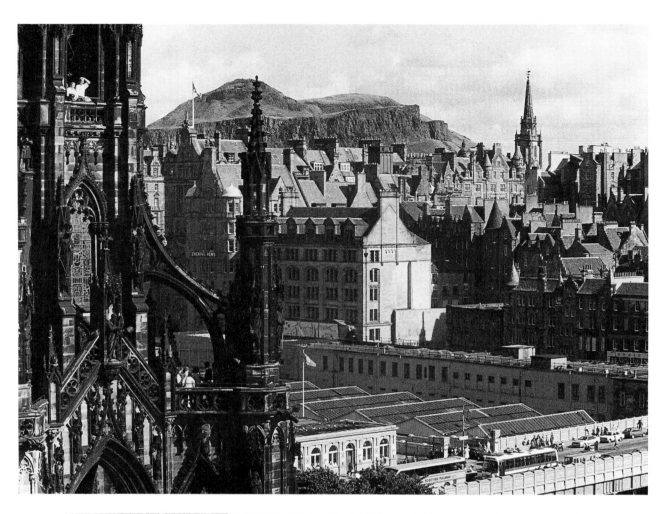

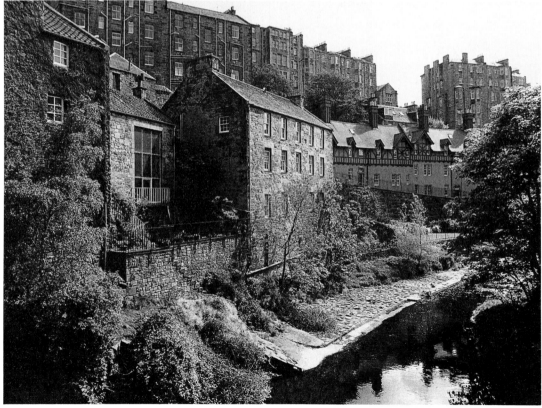

Upper
EDINBURGH SKYLINE FROM THE MOUNT ROYAL HOTEL, 1987
Lower
DEAN VILLAGE, 1985

Upper
GLADSTONE'S LAND, LAWNMARKET, "A CHILD'S EYE VIEW", 1985
Lower
DOWN THE SLOPES OF WEST BOW TOWARDS THE GRASSMARKET, 1985

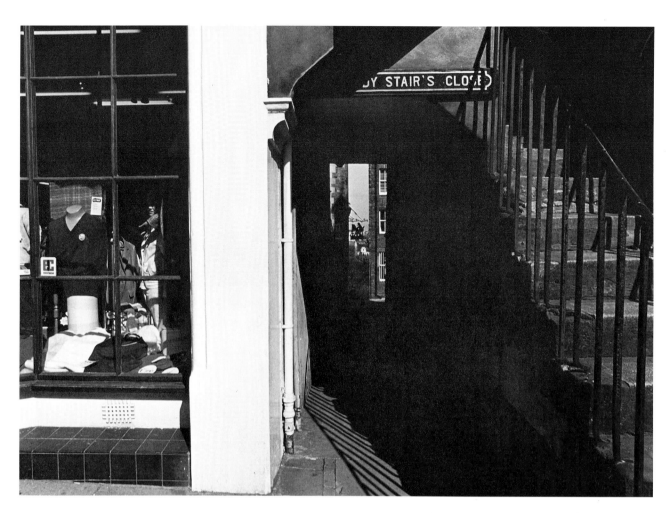

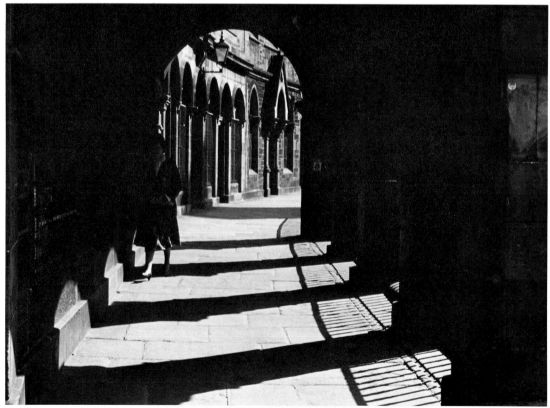

Upper
LADY STAIR'S CLOSE, 1985
Lower
CASTING SHADOWS ABOVE VICTORIA STREET, 1985

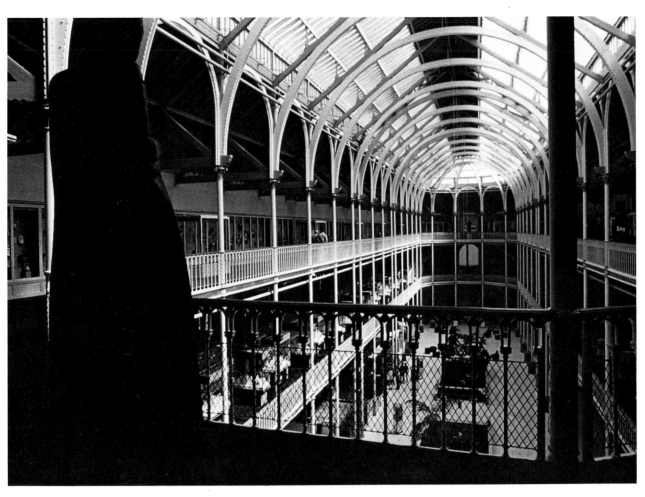

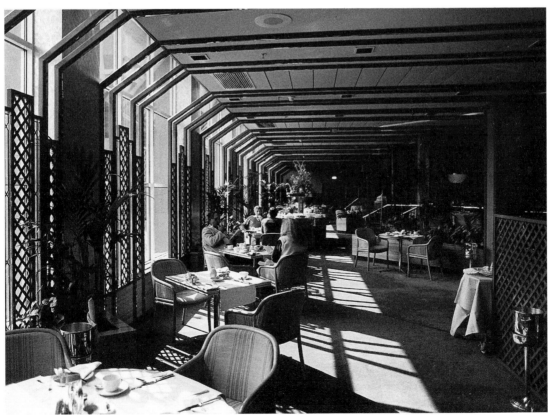

Upper
INTERIOR OF THE ROYAL SCOTTISH MUSEUM, 1985
Lower
INTERIOR OF THE SHERATON HOTEL, 1985

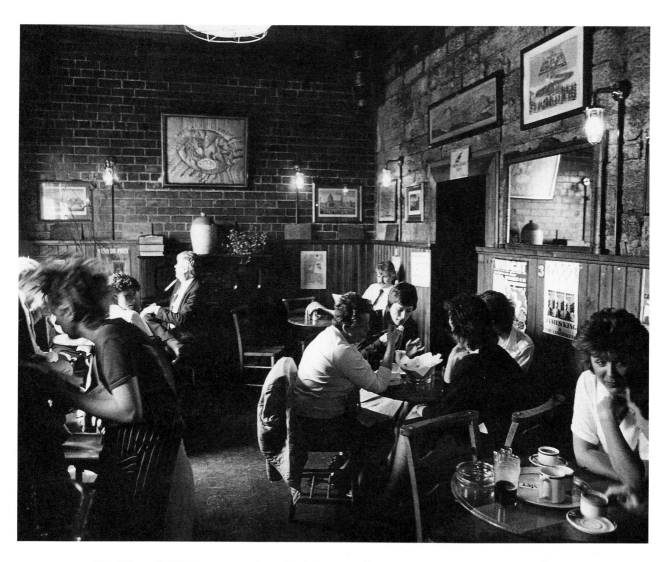

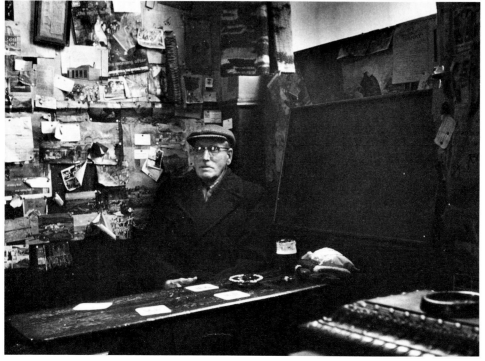

Upper
BAR, LEITH, 1985
Lower
MAN IN LOYAL EDINBURGH PUB, 1971

200

CAFE ROYAL, 1973

Upper
FESTIVAL PARADE, 1985
Lower
EDINBURGH FESTIVAL PARADE, 1985

RECEPTION FOR MUSICIANS

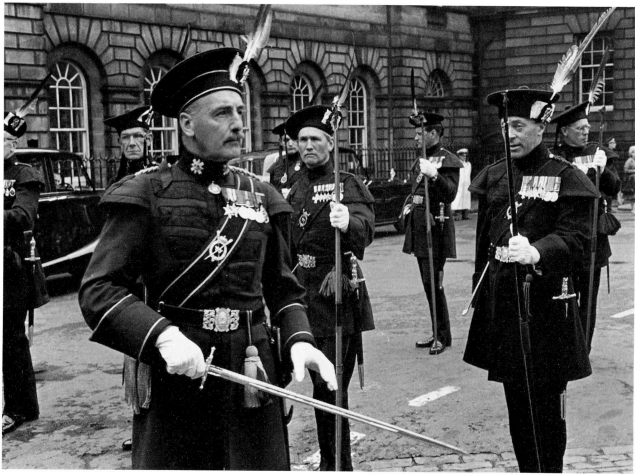

Upper
THE MILITARY TATTOO, 1964

Lower
THE ROYAL COMPANY OF ARCHERS, 1985

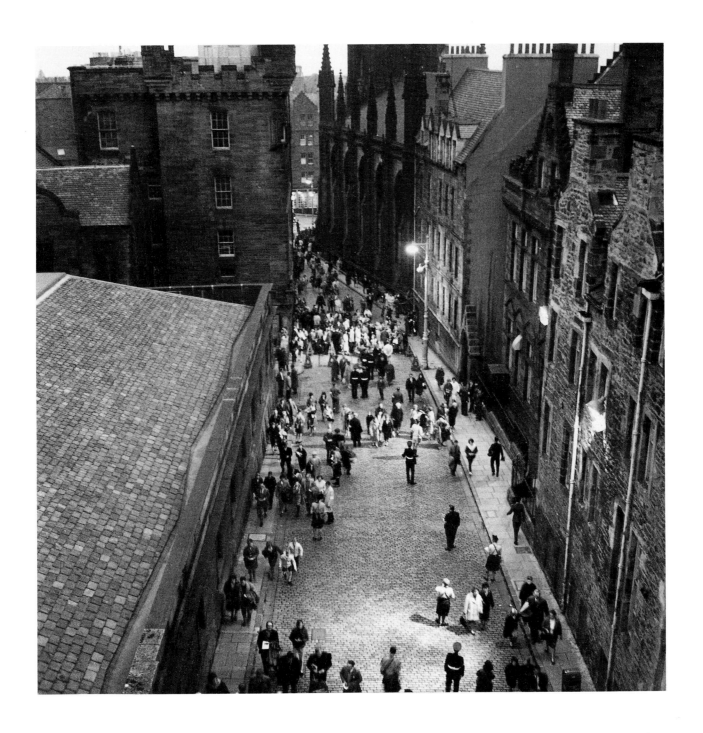

HIGH STREET AT DUSK

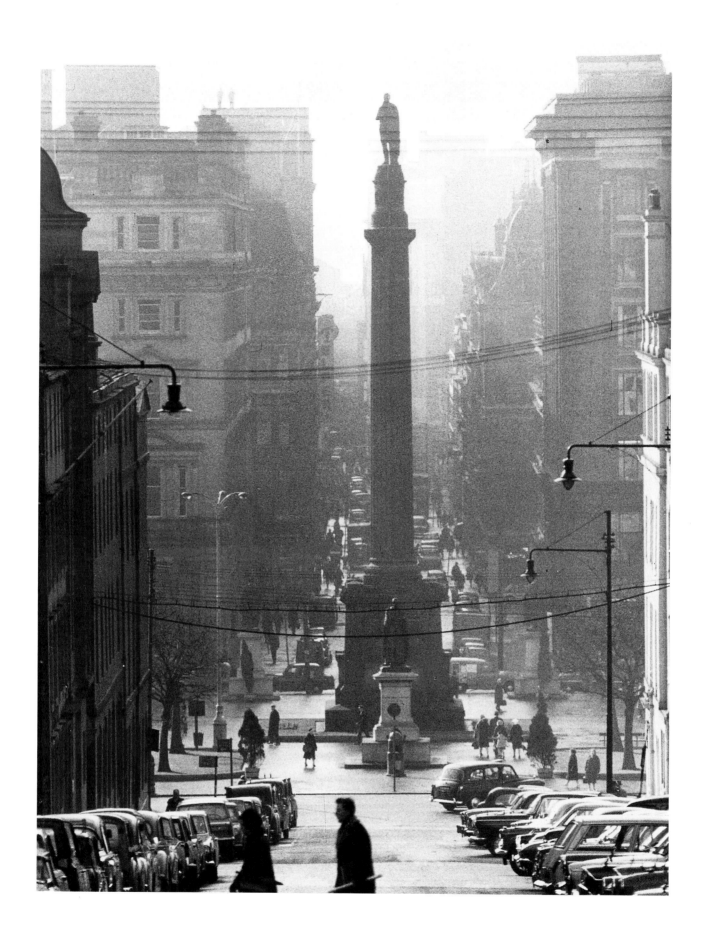

GEORGE SQUARE, 1966

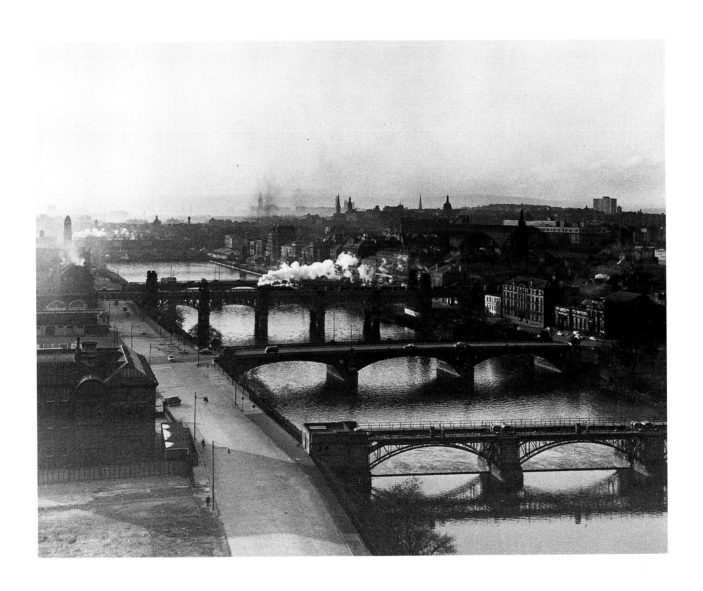

BRIDGES OVER THE RIVER CLYDE, 1963

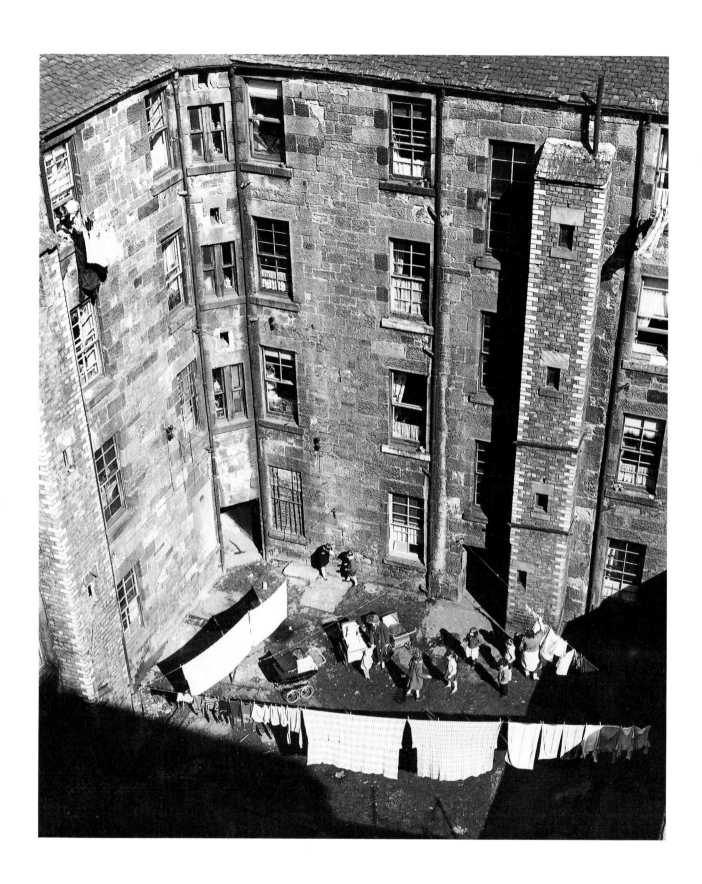

BACK COURT, GORBALS, 1963

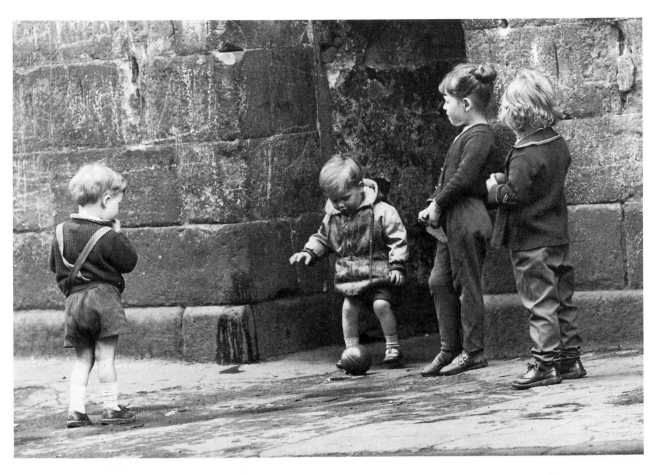

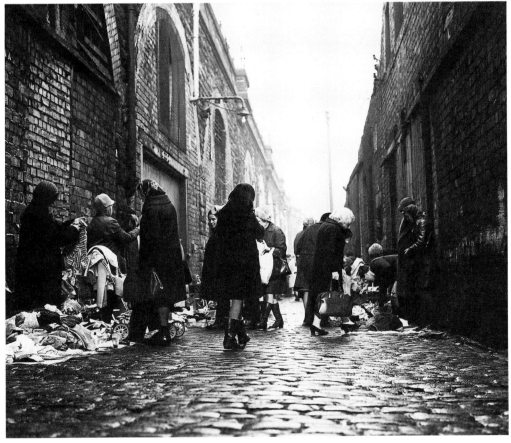

Upper
CHILDREN ON STREET, GORBALS, 1962

Lower
PADDY'S MARKET, 1972

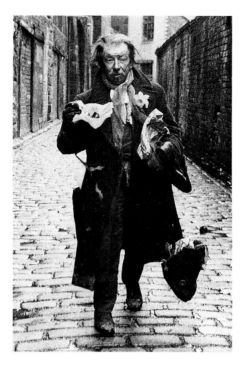

Upper
"DAFFY", ALONG LANE, 1968
Lower
WEE JEANIE, "NO NEWS IS GOOD NEWS", 1968

MAN WITH PIGEONS, GEORGE SQUARE, 1964

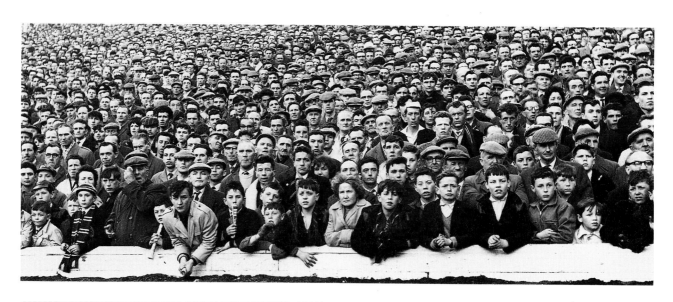

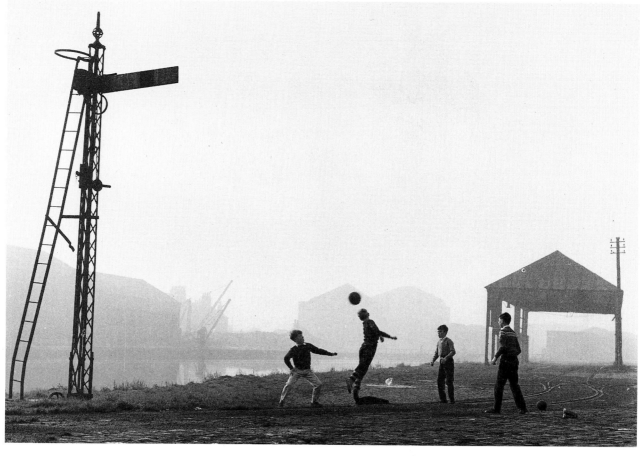

Upper
CELTIC END, CUP FINAL, HAMPDEN PARK, 1963
Lower
FOOTBALL, FORTH AND CLYDE CANAL, 1962

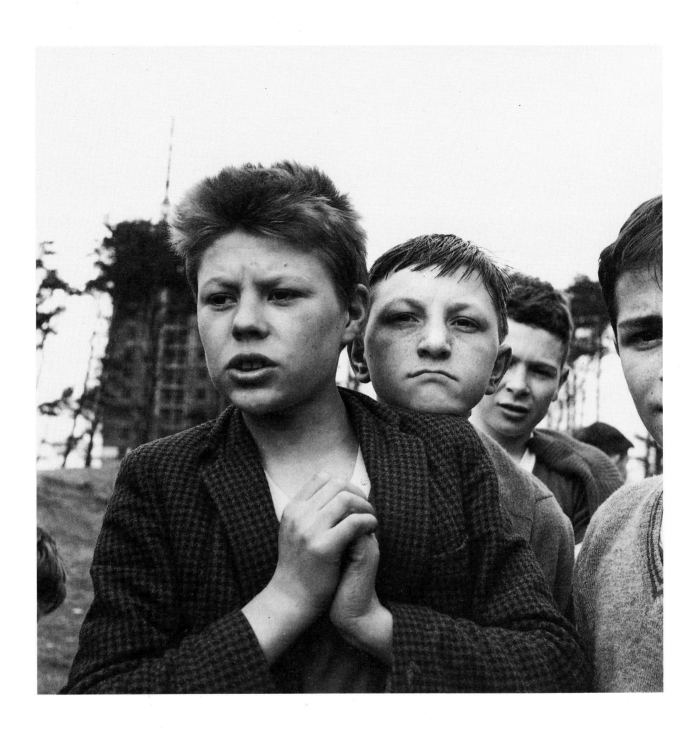

CASTLEMILK LADS, 1963

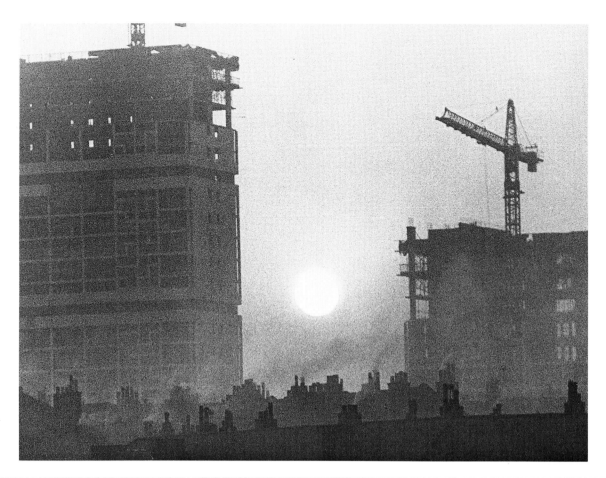

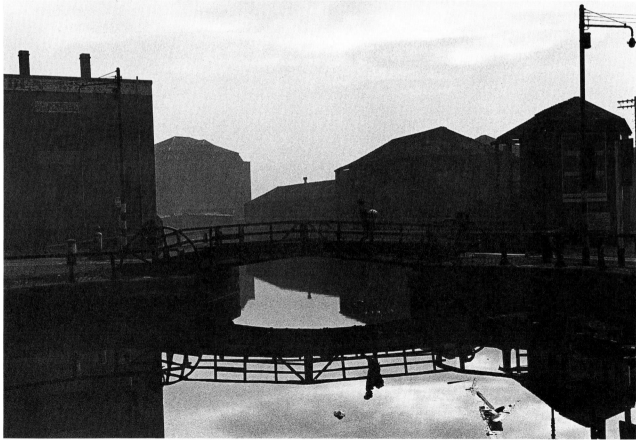

Upper
GORBALS SUNSET, 1965
Lower
WOMAN ON BRIDGE, FORTH AND CLYDE CANAL, 1965

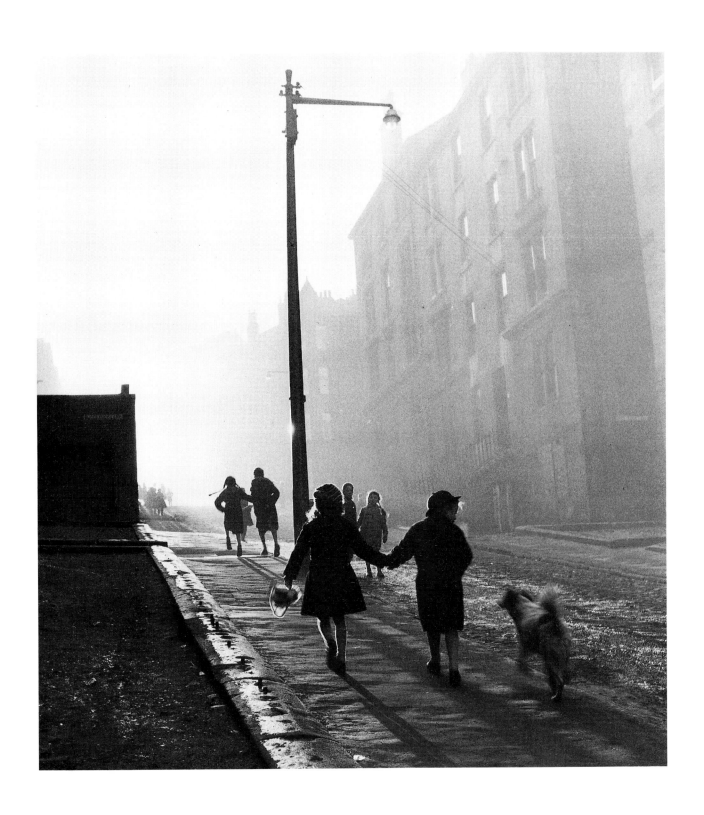

HILL STREET, GARNETHILL, 1956

NOTES

A COMMENTARY ON THE PHOTOGRAPHS

page 42

SALMON FISHERMEN, SKYE

This shot of fishermen netting salmon from the inshore waters off Staffin always strikes its admirers with its biblical quality. The simple routine of their work, and its dependence on the elements, though not stated, are realised by the viewer. They went to their task amid some of the most spectacular scenery in Skye – so dramatic is it that it was used by Allan Campbell McLean as a setting in his novel, *The Hill of the Red Fox*. Unsuspecting visitors, on the road from Portree to Staffin, impressed by the relics of mineral workings in such a lonely spot at Invertote, might drive on, unaware of the spectacular gorge down the slopes of which the fishermen went to work, finally chancing a rickety, badly maintained wooden bridge across the tidal mouth of the Lealt to gain the safety of their bothy. That is not the only building on the floor of the gorge; there, too, are the remains of the engine house used to power the business of extraction which last had life in the 1950s.

For Marzaroli this was one of his favourite places. He took his family there while filming a sequence of *A Pride of Islands*. Hauling in their nets on that occasion, the fishermen found they had trapped a seal, a rival which they usually dispatched with a club. Out of deference to Marie Claire, Marzaroli's eldest daughter, who was present, that day they set their unsought captive free.

page 52

ANNI ELISABETH

The *Anni Elisabeth* was one of the key pieces in the attempt by the Highland Board to exploit the fishery resources of the north-west Atlantic. Purchased from Scandinavia in 1978 by Willie John MacLeod and his three sons, and skippered by Robert Mackinnon, it was equipped with automated lining. This method of fishing, the modern version of the long-lining practised for so long by the fishermen of Fife's East Neuk, preserved the quality of the fish which were not gathered up and squashed in a huge net but caught on individual hooks on lines that were miles long. The *Anni*'s catch, concentrating on ling, was destined for a new £700,000 processing plant at Breasclete on the west coast of Lewis; run by a Norwegian company, it would dry some 5,500 tonnes of fish a year, selling the finished produce mainly to markets in East Africa. After completing several successful voyages, the owners of the *Anni*, dissatisfied at the prices they were being offered by their sole customer, reverted to the Scots fisherman's customary practice of catching a number of species in order to protect themselves against the fluctuations of the market. They started to run with them to ports other than Breasclete and, on one such trip to Fleetwood, the hull was damaged in the course of taking a short cut through the Sound of Barra, an exploit that cost the insurers some £50,000 for repairs. Such was the misfortune that dogged the whole imaginative enterprise; the main player, Lewis Stokfisk, the Norwegian company which ran the drying plant, went into receivership as the 1980s began.

page 58

A PRIDE OF ISLANDS

A Pride of Islands was the second film made by Marzaroli and his Ogam production team for the Highlands and Islands Development Board. A companion to the first, *Highlands*, it managed to encompass within its brief 30 minutes every major group of islands off Scotland's

northern and western shores but the Inner Hebrides. The two documentaries provided the broad background against which much closer-focused and more detailed records of Highland and Island life were planned. Although a start was made to the latter programme, the board could not maintain the momentum, its chairman, Sir Kenneth Alexander, deciding in 1979 that film-making was not its business.

page 60

OUT SKERRIES

Filming in the Highlands and Islands is a chancy business. Weather and geography – and, at times, even geology – can conspire against the execution of a smooth production schedule. For Marzaroli and his Ogam crew, the Out Skerries proved such a location.

It took almost two years, from commissioning to first print, to produce the film. The initial reconnaissance by Marzaroli and his writer, Allan Campbell McLean, was, at two weeks, speedy enough but the business of writing the treatment and obtaining approval for it took so much longer that shooting had to be delayed several times, the last occasion in order to secure the best weather conditions. Even then the crew ran into problems, with the constant wind blowing sea spray into almost every corner of the islands – and into the delicate camera and sound equipment they were using.

They made the last step of their journey to the Skerries by means of a local fishing boat. As they landed and unloaded their gear, Marzaroli sealed the date for the vessel's return to pick them up by presenting its skipper with a bottle of Black Label. During the shoot Ogam's crew were almost overcome by the islanders' hospitality and sociability, both conducted in the closed-tight comfort of their cottages to the background provided by the wind, the click of the women's knitting needles and the steady phut-phut of the small generators that provided domestic power. The customary physical challenge, this time in the form of a cricket match, was played, the atheist McLean was persuaded by the island "missionary" to read the lesson from the pulpit and Martin Singleton, Marzaroli's business partner and cameraman, got more than one soaking from the sea. Knitwear and processed fish provided the islanders' livelihood, the local boat, the *Comet*, negotiating the two narrow entrances to the harbour – its choice depending on the weather and the tide – with a skill born of long practice and familiarity. As the day of departure approached, the weather broke and opinion on the island was that the Whalsay skipper and his men would not risk the journey to pick up the Ogam crew. But he did. His boat pitched and tossed its way back in a Force 10, his guests grimly hanging on to every protuberance that made itself available as a harness against the wild sea. After that, Marzaroli swore, any journey, anywhere, was easy.

page 61

PEAT STACKS, LEWIS

Though the subject here is in Lewis, the photograph contains one of Marzaroli's favourite views of Harris. The croft house and its stacks lie about half way between Stornoway and Breasclete, just off the A858. The hills of Harris are over ten miles to the south.

page 63

STANDING STONES, CALLANISH, LEWIS

For Marzaroli and his writer companion, Allan Campbell McLean, no visit to Lewis was complete without a pilgrimage to the Callanish Stones. They saw them, over the years, in every light and weather – except dead of night, for Marzaroli thought a visit in the witching

hours would interfere with forces that were better left undisturbed. Otherwise the pair shared an enchantment with the location that refreshed their spirits. To visitors from all over the world the Stones were perhaps huge monoliths, no more than brooding reminders that even primitive man needed to measure the world around him, but to Marzaroli and McLean they spoke of distant endeavour, enterprise and technology and were a powerful refutation of the notion that early man lacked either imagination or skill. No wonder the site could reinvigorate them, repair a long broken light meter or seem the ideal spot for McLean to set a pedometer recently purchased by mail order.

page 70

CALUM'S ROAD

For ten years from 1963, Calum MacLeod, using his own muscle and the simple technology of barrow, pick and shovel, built a single track road from Brochel to his croft on the northern shore of Raasay at Arnish. The route had been planned for him by officers of the Royal Engineers and he had obtained help from the local authority roads department when it came to the occasional need to blast his way through rock. But the enterprise was his. Though Arnish had once supported 92 people, only Calum and his wife, Lexie, remained when he began; by the time he had finished another couple had joined them and other cottages in the community had been purchased for holiday purposes. Finally in 1981 plans were announced to bring Calum's fulfilled ambition – two miles of twists and turns over hills, around bogs and across burns – up to the standard that would allow Highland Region to adopt it as a public road.

page 74

BULBS, VALLAY STRAND

Despite the hand-made appearance of the notice board, this was one of the most ambitious proposals the Highlands and Islands Development Board ever placed before the Secretary of State for Scotland. The project itself, from initial research through trials to eventual closure, lasted some five years from 1966. It envisaged, on Dutch advice, the damming of the Vallay Strand in North Uist to reclaim about 1,600 acres of land, about half of which would be given over to bulb production. Trial growing, which Marzaroli recorded, took place around Paible, its daffodils, hyacinths, tulips and crocuses bringing unexpected and striking colours to the machair. Though the results, in quantity and quality, were judged "excellent", the advisers to the Scottish Secretary (Gordon Campbell) in the Department of Agriculture and Fisheries did not accept them as evidence; what was needed, they argued, were trials on reclaimed land. But these could not be achieved without first damming the Strand; a St Andrew's House version of Catch 22 to which there was no answer. Work on the scheme went on until 1972 but the board had formally withdrawn its proposal from the Minister's desk a year earlier.

page 88

RATAGAN FOREST

Ratagan is one of the Highlands' great forests, sitting astride the road that strikes off from Shiel Bridge at the head of Loch Duich to run over the hills to Glenelg, Bernera and the crossing to Skye at Kylerhea. It is a route tramped by Johnson and Boswell, as well as by thousands of black cattle and their drovers on the way to markets in the south.

page 92

JOHN MACGREGOR

To Marzaroli, John MacGregor was living proof that, contrary to majority urban prejudice, cosmopolitanism is second nature to islanders. This ought to be no surprise for islanders, through choice or force of circumstance, have always gone out into the world to find their livelihood and, on occasion, their fortune; and as a stay in a gale-battered Lerwick would demonstrate, given hospitable shelter to strangers to their shores.

MacGregor's keenness to converse, his humanity and his craftsmen's skill helped forge his initial professional relationship with Marzaroli into a deeply personal one. A painstakingly made tweed – and driving a pedal-powered loom is no relaxed exercise – was no stranger to the Marzaroli household in Glasgow's Baillieston, though its arrival could be preceded by careful telephone checks from Lewis about the colour required ("Lilac" MacGregor would ask Anne Marzaroli, "just what would you be meaning by lilac?") and the use to which it was to be put. Anne's husband, it seems, had been surprisingly vague about these crucial matters when discussing the order in MacGregor's weaving shed.

page 98

SHIPBUILDING

Once Glaswegians could proudly boast that "Glasgow made the Clyde and the Clyde made Glasgow", reference to the laborious conversion during the 18th and 19th centuries of a shallow unnavigable stream into a deep channel down which sea-going, Clyde-built, ships could make their way to the world's oceans. On its north bank the Stobcross hammerhead crane, 175 feet high, is a mute reminder of the river's past glory, while the P.S. *Waverley* is the last witness of the fleets of the Clyde paddle steamers with their multicoloured funnels which once raced each other "doon the watter" to the flourishing Clyde resorts of Dunoon, Rothesay, Largs, Millport, Helensburgh, Campbeltown and beyond. Even the six-vessel fleet of little ferries which braved the debris-laden waters of the city river disappeared off its face in 1977.

page 123

SKI SLOPES, CAIRNGORM

This photograph, which looks like the work of R.S. Lowry, was first seen when Marzaroli was completing a selection of pictures for use in a book about the Highlands and Islands. He had a long association with the Spey Valley, spending, as a young man, a year in a sanatorium in Kingussie recovering from tuberculosis. (Even then his camera was not far away – see p 139 for a portrait of one of his nurses.) Later his work frequently took him back to the area but he was always inspired by the impression he first obtained as a convalescent – that of the constantly changing appearance and mood of the enduring Highland landscape.

page 135

BELLA

Bella Connelly and two young friends. Anne Marzaroli's aunt, Bella became almost a second mother to him. This photograph was taken on the Marzarolis' wedding day in 1961.

page 136

GOLDEN-HAIRED LASS

One of the most enduring and popular images associated with Marzaroli. Its combination of innocence and determination, mystery (where is she going in such a hurry?) and humour, seems somehow to capture an essential aspect of Glasgow's character and that of the unseen photographer, too. It is an excellent example of Marzaroli's ambition to capture the moment. Taken in the 60s its popularity later posed serious questions for him. Who was she, this little lass who epitomised so much? Where was she now? Would it not be interesting to track her down, find out how she has grown, what she has done with her life since that unexpected magical day when her path innocently crossed that of a photographer about his business? Marzaroli would have none of that. The snap itself was an intrusion enough, he felt; that it recorded a moment in a way that ensured it a place in Scotland's annals was in itself sufficient and was no ground for launching an investigation that would satisfy only mere idle curiosity. That would have no moral justification. The Marzaroli archive, which now holds the copyright of the priceless negative, shares that view.

page 141

COMPTON MACKENZIE

Marzaroli was involved in making films about several leading members of Scotland's literary establishment. Sir Compton Mackenzie was one such and this portrait was taken as he relaxed at the end of shooting, an occasion which the writer marked by presenting Marzaroli with one of his pipes.

page 144

FILM-MAKERS

The film-making community in Scotland in the 60s, as it is today, was very small and tight knit. Despite this, its members had to compete fiercely with each other for the documentary work that was channelled almost entirely through the Films of Scotland Committee. Those who were tempted to take an independent route to potential sponsors were not encouraged. Most formed small companies and partnerships, like Marzaroli's Ogam – where both Bill Forsyth and Charles Gormley cut their teeth before they set up Tree Films. Murray Grigor and Pat Higson joined forces, as did Lawrence Hanson and Eddie McConnell. Paddy Higson and Iain Smith then were learning the production skills they later brought to bear on features that were produced during the 1980s.

page 146

THE STEAMIE

The runaway theatrical success of Glasgow's Mayfest 1987 was the production, by Wildcat Stage Productions, of Tony Roper's play, *The Steamie*, a nostalgic comedy about Glasgow's communal wash-houses (the photograph was taken at a performance in the now disused Govan steamie) in which a group of experienced comic players – Ida Schuster, Ray Jeffries, Elaine Smith, Katy Murphy and Dorothy Paul – recalled the days when the steamies were virtually the social clubs of Glasgow's working-class women. To these steamies, almost daily,

the tenement housewives trundled their washing in a variety of conveyances, mainly broken-down prams and go-chairs; the élite had custom-built bogies with noisy little iron wheels. Here the family's clothes could be washed and dried with the aid of huge sinks, abundant hot water, giant spin-driers and long drying racks which pulled out from the wall. This was very much a woman's world; the language and topics would have brought a blush to the face of a Glasgow "polisman", hence the phrase used to describe some piece of particularly scabrous gossip – "the talk of the steamie".

page 150

JOAN EARDLEY IN HER TOWNHEAD STUDIO, 1962

Joan Eardley, who died in 1963 at the age of 42, was one of the finest painters in the history of Scottish art. Her working life was divided between town and country, with bases in this studio in Glasgow's Townhead and a clifftop cottage in the Kincardineshire fishing village of Catterline. Her Glasgow studio, a small eyrie with a glazed wall and roof, formerly used by generations of photographers, became the focus of years of activity when Eardley drew and painted the street urchins in a ramshackle environment which was a figurative painter's paradise, but which has now disappeared under the bulldozers.

page 151

JOAN EARDLEY

Joan Eardley was one of Marzaroli's early heroines. He and his wife Anne, whose training had been in sculpture, were among her circle of friends, enjoying her vibrant company and watching her work in Glasgow as well as in her seaside studio at Catterline near Stonehaven. Her early death in 1963 was a personal loss to both and, for Marzaroli, it was a matter of sadness that, because of his own illness, he could not attend the 1988 exhibition of her work in Edinburgh's Royal Scottish Academy which was accompanied by a display of his portfolio of photographs of the painter.

page 164 and 165

RODEL HOTEL

These shots were taken at the end of a long Sabbath car journey from Stornoway. Gales had prevented the Saturday sailing of the Ullapool ferry which had been forced to try to ride out the storm anchored in the bay outside Stornoway harbour. It was to make the return trip to the mainland on the Monday, leaving Marzaroli and his small party to face a Lewis weekend. Adversity he turned into opportunity when McLean suggested, on a bright Sunday morning, making the trip to Rodel in Harris. The hotel chef, a Harris man, was persuaded into not only providing a packed lunch but also to joining the expedition. All the way the journey was interrupted frequently as Marzaroli responded to the photographic opportunities around him but the highlight, he was promised by McLean, would come at Rodel. The hotel, he claimed, was unique in location and in character; why, in its bar, could be purchased a dram that could be had only in one other place, the House of Commons.

All of that may have been true but, to Marzaroli, not in the way implied. What unfolded on his arrival was premises that might have been designed for a Hammer movie; the air of

desolation was not mitigated by the apparent lack of other guests in the hotel nor by the damp that seemed to haunt the atmosphere. Hospitable and informal though his reception was, Marzaroli could not bring himself to share his companion's enthusiasm. But, as this selection of shots show, he left his camera to do the talking.

page 170

ED THOMPSON

Marzaroli first visited the motor cycle-riding potter, Ed Thompson, in his island studio in the company of Allan Campbell McLean. The latter's recollection of the encounter was dominated by references to Thompson's Siamese cat. A cat-lover himself, McLean appreciated this particular specimen's aloofness and disdain, characteristics which it shared with all of its breed, until the moment it casually urinated on his trousers.

page 174

ST MONANS

For 11 years Marzaroli and his wife Anne, had a second home in St Monans. It was not only a holiday place where their daughters, Marie-Claire, Nicola and Lisa did their summer growing-up; it was another life. Leisurely, relaxed, full of days walking the coastal paths, sharing the sun with visiting friends, their time in the East Neuk saw them become part of its community. Marzaroli recorded much of this, his camera a regular observer at the village's busy boatyard, its festivals and its harbour.

page 195

EDINBURGH

A Glaswegian in all but birth, Marzaroli enjoyed the rivalry between his adopted city and Scotland's capital. Glasgow got things done, he frequently mused, while Edinburgh only thought about them. It was from Edinburgh, nevertheless, that he drew much of his awareness of Scots history and culture and the possibilities of his own place within the latter's stream of photography. His record of the capital may not have the continuity of his Glasgow work but it shares its strength and its capacity to reveal. His photograph of Edinburgh Castle from West Princes Street Gardens contains a completely fresh perspective while his observation of the High Street skyline from a lofty perch above the north side of Princes Street captures the capital's stable, solid and enduring conservatism. But the people his camera sought out in the streets and gardens clearly share the same emotions, pleasures and problems as those he found in his travels elsewhere through urban and rural Scotland.

page 206

GEORGE SQUARE

It is difficult to get to grips with the urban landscape of Glasgow. Edinburgh flaunts her charms, saying, "Regard me, am I not beautiful?"; although shyness is not a usual attribute of Glasgow, her architectural attractions are somewhat elusive, fleeting and accidental, but

nevertheless visible to the discerning eye; and increasingly so as stone-cleaning removes layers of industrial grime, and the beauty of much of its surviving Victoria architecture is revealed.

Much has been lost through her attitude, utilitarian not to say Gradgrindian, of "Not needed, knock down!", but nevertheless her 13th-century cathedral still rises from its surrounding clutter, although its neighbour, the cupola'd Royal Infirmary, is a poor replacement for its predecessor: a classic Adam building. While the fantastic and grandiose Art Gallery building (1892-1900) confronts the University of Glasgow across the airy valley of the wooded Kelvingrove, Charles Rennie Mackintosh's masterpiece, the austere Glasgow School of Art (1897-1909), fights its way out of a huddle of nondescript roofs. The Park Circus area came into being between 1830 and 1870. Built to house the city's professional and business aristocracy it is now given over to offices, clubs, consulates, schools and studios. Its skyline is still, miraculously, intact – one of the most exciting the city has to offer.

Other aspects of the city's past have also disappeared. At one time the Kelvin, as it flowed past Partick, drove many mills – paper, flint, snuff, wheat and barley – but the very last of them, the Regent Flour Mills, no longer perches on its east bank below Dumbarton bridge.

Glasgow's layout has been strongly influenced by its physical setting, by the river with its many bridges, road and rail, which stitch together the city's north and south sides, by its uncounted drumlins, glacial mounds of clayey soil, seen here rushing vertiginously down to Sir Walter Scott, aloft on his column in George Square.

page 208

GORBALS

Once a tiny community clustered about the south end of the old Glasgow bridge, then a high-class residential district planned and laid-out by the Laurie brothers, still later a centre of Glasgow's Jewry, by the end of the 19th century the Gorbals had become one of the most "tenemented" areas of the city. Restless change has removed most of this Gorbals along with the way of life it bred – the hundreds of small shops and street-corner barrows which supplied the tenement-dwellers with their daily needs of both provisions and local news, the "steamies" or communal wash-houses, visited daily by countless superannuated prams piled high with household washing, the expressions of religious beliefs, encoded in enigmatic graffiti, "Rangers for the Cup and League, F.T.P." – all gone, leaving nothing behind but the whisper of dusty wind between high-rise tower blocks.

page 209

PADDY'S MARKET

We first hear of a Glasgow Clothes Market back in the 1850s. It enjoyed an eventful life, moving from Jail Square to the old City Slaughterhouse then transferring in the 1870s to Greendyke Street on the north side of Glasgow Green, being taken over with the Corporation at the end of the century and finally closing down shortly after the end of the First World War. Parallel to it, however, developed another somewhat different clothes market, where customers found that even the established market was too expensive for them. The position of the Highland immigrant at the bottom of the social pyramid was taken over in the first half of the 19th century by the Irish immigrant, and when an *alfresco* old clothes market started up in Great Clyde Street, it was well-nigh inevitable that it should be given the name "Paddy's Market". Between the wars it moved into a cul-de-sac off Shipbank Lane, up against the massive wall of the railway viaduct leading into the now-vanished St Enoch Station. There it still leads a vigorous but precarious life, constantly under threat of official eviction.

page 212

FOOTBALL

Football was one of Marzaroli's continuing passions. As an Italian-Scot perhaps he could hardly avoid that. Though a staunch supporter of Celtic – God had been kind, Father Daniel Hennessy told mourners at his funeral, in taking Marzaroli the day before the team's defence had been penetrated five times by Rangers, and thus spared him at least the anguish of that result – it was the game itself he enjoyed. Thus, going to an important match was a kind of ritual as well as a great social occasion. The crowd might have been company enough but, within it, there usually was a closer group of friends and colleagues for whom such contests were special outings that required foregathering for a meal or drink, a fortified coffee flask or two, good seats in the stand and conversation that concentrated on the match, the clubs, players, officials and playing conditions.

On occasion Marzaroli had to foresake that conviviality to go to work with his still and moving cameras. Capturing his sporting heroes on film, of course, was more pleasure than duty as his portraits for the 20th anniversary celebration of Celtic's European Cup win in *One Afternoon in Lisbon* testify. Into the same category he put the numerous challenge matches in which he pitted the ageing limbs of his crews against the agile muscles of local children in the island locations to which he had been brought by his filming schedule. These were played in school playgrounds, the tarmac and concrete slabs a constant brake on the crew's physical ambitions which, in any case, usually far outran its abilities. But these encounters were a practical expression of Marzaroli's belief that football, its sectarian blemishes in the west of Scotland notwithstanding, was not only the people's game but their language, a means of building bridges and surmounting barriers anywhere it was played.

page 215

GARNETHILL

Perched high on one of the city's many drumlins and lying to the north of Sauchiehall Street, Garnethill began as a high-class residential district. Later it became known as an area of theatrical digs, and now is an Oriental enclave where the schools carry notices in Chinese ideographs and the Bank of China offers its services.

It also has several good examples of an art form extensively used in Glasgow – gable-end paintings, many of which manage to combine graphic art, wit and poetry. It also has a tiny church building which began, before the First World War, as German Lutheran, continued as Free Presbyterian and is now Tridentine Catholic!

These notes were prepared by Anne Marzaroli and James Grassie. Additional notes forming part of this commentary were originally compiled by Cordelia Oliver and Joe Fisher for the companion volume, *Shades of Grey*.